Minghella on Minghella

Minghella on Minghella

Edited by Timothy Bricknell

Preface by Sydney Pollack

faber and faber

First published in 2005
by Faber and Faber Limited
3 Queen Square London WC1N 3AU

Published in the United States by Faber and Faber Inc.
an affiliate of Farrar, Strauss and Giroux LLC, New York

Photoset by RefineCatch Ltd, Bungay, Suffolk
Printed in England by Mackays of Chatham, plc

A CIP record for this book
is available from the British Library

ISBN 0-571-20711-1

2 4 6 8 10 9 7 5 3 1

Contents

Preface

Here's what happened: In 1992 I saw the film *Truly, Madly, Deeply* and knew I wanted to meet the guy who made it. A few weeks later, mutual friends hosted a party in Los Angeles for Anthony and his wife, Carolyn. He and I began a conversation that lasted most of the evening. That conversation's been going on for eleven years now. We became friends, then professional associates and are now partners in Mirage Productions. But that's out of sequence.

In 1993 I asked Sherry Lansing at Paramount to buy the rights to Patricia Highsmith's novel *The Talented Mr. Ripley*. Years later it was still waiting for the right auspices to bring it to life.

In the meantime, Anthony was preparing to shoot *The English Patient* when Fox, the financing studio, backed out. While Saul Zaentz searched for new financing, Bill Horberg, my colleague at Mirage, suggested that we ask Anthony to write *Ripley*. Anthony agreed, and in the process of writing he grew attached to the characters and asked to direct the film. This was still before *The English Patient*, and though Paramount didn't exactly say no, they weren't terribly enthusiastic.

Miramax finally agreed to finance *The English Patient*, and while Anthony went off to shoot the film, Bill and I continued to press Paramount, and a deal was finally made for Anthony to direct *The Talented Mr. Ripley*.

Several months later I went to San Francisco to see *The English Patient* in its first cut. It was a big experience that left all of us at the screening dazed and moved. As much as I loved *Truly, Madly, Deeply*, I wasn't prepared for the emotional 'size' and complexity of this film, and I was obsessed with trying to understand how he got there. The fact is, I am still trying to understand it.

Anthony invited me up to the cutting room in San Francisco the following weekend to look through the film with him. Directors are,

for the most part, more territorial than lions, growling at interlopers and pissing on every corner of their property, so I approached the session with a great deal of caution. But within minutes we were honestly having fun – playing a kind of creative ping-pong that was exhilarating. It's still the best part of our partnership, and makes up for the hard and often boring parts of having a film production company.

I'll try to pick up the pace here and just say we decided to become partners after living through the trials and pain of the early previews of *The Talented Mr. Ripley* and then agreeing to do *Cold Mountain* together. We had, in a way, become creative partners already and it seemed natural to make it an official business arrangement.

So much for the facts of Anthony's and my acquaintance. His skill as a storyteller is not something that can be so succinctly described. I'm inclined, at this point, to direct you to his body of work, which tells you everything you need to know about his uncanny ability to grab your gut and heart as a film-maker. But that would be cheating, I suppose.

There are many approaches to adaptation, most of them mathematical and quantitative, defined by deciding what should be kept in and what should be left out. Anthony's process, on the other hand, is one of literally reimagining the entire work. When you see one of his films after you've read the book, you still feel like you don't know what's coming next. You're still having a 'first-time' experience.

His characters are full of yearning, full of a sense of loss, capable of great joy and deep feeling – and I say *his* characters, because even though they have often been originally created by someone else, in his films' final form, they have been reimagined and fleshed out in ways that are uniquely his. He manages this, by the way, without violating the original authors' intent.

But I don't want to speak as though the 'it' of him as a director is his ability to adapt a book. It's in the final realization of the film that his extraordinary talents really shine. His movies are often lengthy, often lavish, sometimes epic, always complex. He is not in the business of visual or visceral economy. Instead he lavishes his viewer with story and scope, nuance and emotion, agony and beauty. The gamut.

About the man: He is a realistic romanticist. A kind of poet, disciplined by reality, an academic by training, a musician by nature, a compulsive reader by habit and, to most observers, a sunny soul who exudes a gentleness that should never be mistaken for lack of tenacity and resolve. He is capable of taking great blows without weakening.

The cliché that you don't know anyone well until you've lived through wars with them is an absolute truth. Sometimes making films is a form of war – with yourself, with an audience, with the film itself. Having weathered several with Anthony, I will tell you that his dignity never softens, his artistry never suffers and his mind remains as sharp and clear in wartime as it is in quietude.

I have only met a couple of people in my life who really understand how to 'think'; not fantasize or free-associate unconsciously, but volitionally initiate a process that solves a problem. Anthony is one of them. I imagine his mind would be a terrific place to knock around in for a while. With this book you'll get a chance to do just that, and while you're in there you'll get a taste of the precision and grace that is a hallmark of his thinking.

Sydney Pollack

Editor's Note

The majority of the text in this book has been taken from many interviews that Anthony Minghella has given over the past four years. It is, therefore, necessarily conversational in tone.

Interviews were held mainly with myself but also with Maura Dooley, Stephen Lowenstein (for *My First Movie*, Faber and Faber) and Jed Dannenbaum (for *Creative Filmmaking from the Inside Out*, USC). My thanks to them.

Thank you to Brigitte Lacombe for the use of her wonderful photographs. And thank you to Walter Murch for his contribution to the editing chapter of this book.

Special thanks to Walter Donohue, Janet Johnson, Judy Daish, Alice Bragg, Tom Edmunds, Laura Bushell, Kevin Conroy Scott, Caroll Hodge and, for her patience, Laura Luchetti. I would also like to thank everyone at Mirage – Karen Cattini, Cassius Matthias, Donna Ostroff and Keri Wilson especially.

TB 2004

1

Beginnings

My clearest memories of the opportunities afforded me by a creative outlet, are connected to a piano that I had in my bedroom as a teenager. I was often a miserable teenager – extremely dislocated from my family. I grew up in a very small seaside resort, on an island off the south coast of England.

In retrospect, it was a wonderful place to grow up, but at the time, all I could think about were ways of escaping. I remember seeing a Fellini movie, *I Vitelloni*. It's about a group of kids growing up in Rimini, an Italian seaside resort, dreaming of Rome. I would stand with my friends on the beach in Ryde on the Isle of Wight, dreaming of going to London or anywhere where there was some outlet for our interests and appetites.

I abandoned playing the piano when I was a young child, and later slowly returned to it and realized that I could unwind my frustration in some way by banging the piano and singing. I started to write songs, and I felt incredibly empowered by that, however bad they were. Somehow this groaning and moaning that I did while playing the piano for hours made me feel better. It was something that I could do that nobody had any authority over. It was something that was mine. I didn't do it very well, but I did it with enormous gusto and enthusiasm.

I had one instinct, which was to escape my father's ice-cream business. My father is Italian – and is still a very hard-working, typical immigrant, somebody who's made his way through his own efforts, with my mother. They still go to work every day, and they still sell ice cream on the Isle of Wight.

All I could think about was finding some escape route from wearing a yellow nylon jacket and selling Minghella's Ice Cream for the rest of my life.

I think the circumstances of my childhood are connected to what I'm doing now in two ways. Firstly, I was raised in a small café. We were a large extended Italian family living above the café. We spent our time in the kitchen – which was also a thoroughfare for visitors and customers – so there was no defined private life. Secondly, my grandmother was a real figurehead in my life. She was a tiny peasant woman from Valvori near Monte Cassino in the south of Italy. My grandfather left her after fathering three young girls very quickly, so she'd led a difficult and complicated life. She'd run a café in the Gorbals in Glasgow, so she spoke this coarse Italian/Scottish. She liked paddling on the beach. Most mornings I'd walk with her on my way to school and listen to her talk in a very superstitious, Catholic way about men and women and how the world worked: men are weak, women are strong; women survive, men are helpless and stupid. So, on the one hand, there was this extremely livid and colourful oral tradition, and, on the other hand, I'd come from this background of noise, very warm and typically Italian. The one thing I remember absolutely vividly about the first day of *Truly, Madly, Deeply* was being surrounded by what seemed to be hundreds of people who were involved in the film. I was trying to talk to Juliet Stevenson and Alan Rickman about a rather critical, delicate moment, and people just kept walking by, talking and moving things, and I thought, 'I feel quite comfortable with all this noise.' Suddenly I was a boy sitting on my parents' kitchen table talking about some pain or triumph.

Our café backed on to a cinema called The Commodore. We had two derelict cottages, one of which was a storeroom where we kept our cornets and tubs and various other things; the other we rented out to the cinema's projectionist, Vernon Cook. There was one room there that I was allowed to have and I decorated it with film posters that Vernon let me have from the cinema. He also let me come into the projection box whenever I wanted. So my introduction to cinema was through a sort of mini-*Cinema Paradiso* experience. But I would be lying to you if I said that the effect of this was to make me obsessed with film. I was obsessed with music, particularly American music.

I think my interest in stories came from music. When I was about thirteen or fourteen I started to write songs. I began playing in clubs and lived to write music and lyrics. I thought that was what I would do with my life and wasted a great number of days in my school career playing in bands or hanging around studios. The other great liberating arena for me as a schoolboy was the art department, which was the place where weirdos, creeps and loners traditionally ended up.

I left school in 1972 and was supposed to go to university. How-ever I was in a band that had a record deal, and I fantasized that I would go to the recording studios and never come home. And then in the middle of trying to make this record the band fell apart. We were at the Olympic studios in Barnes. It was our first trip to London, we were actually making a record and we just couldn't deal with it. So I applied to five universities and an art college. Hull University invited me up for an interview, and it was an absolutely formative moment in my life because I went there thinking, 'Hull is the last place I'm going to go. I don't even know where it is!' But they had a new performance centre, so I went up for the selection weekend. And the experience suddenly opened up the possibility of doing something that could be called a degree and might be absolutely extraordinary. I was lucky that my enthusiasm about what went on that weekend was matched by the staff's curiosity. I must have appeared very unlikely to them. I had some music and art skills which, I think, was what attracted them to me. They called me the day after I'd been up there and said that if I accepted the place they would give me an unconditional offer. Which, given how badly I was doing at school because I was so seldom there, seemed extremely appealing. So I had a place at a brand-new performance space with an extremely inten-sive staff–student ratio, and almost everything I know and feel about dramatic art comes from the luck of landing in this place at a particu-lar time in history when it was in a new building with an amazing energy. In the space of a year I went from being the least academic, least industrious type of student to becoming the most diligent, library-bound enthusiast.

My parents were very dispirited by the choices I was making. My father would obviously have preferred that I went into his business as an ice-cream man, a manufacturer. All immigrant families are pre-occupied with survival, and it seemed such a capricious course that I was following that at the beginning they didn't see how I could make a living. I was also a typical adolescent who felt that anything con-ventional was unacceptable. And then later, when I turned into this swot and suddenly got a First, they were mystified, because having been given a job at university, a secure base for life, I quickly gave that up and decided to pursue a career as a playwright.

I don't think I tried to write a piece of original narrative until I was in my last year of university. As a final-year student I was allowed to offer a piece of practical work as a third of one paper. I wanted to offer eight songs because all the way through university I'd been hired to

write incidental music for plays like *Troilus and Cressida*, *Pelléas et Mélisande* and *Twelfth Night*. I thought they probably wouldn't accept a score, but perhaps they'd accept a series of songs with a thematic connection. So I found a tiny short story and strung together the songs by writing some dialogue that would support them. It was called *Mobius the Stripper* and was based on a brilliant short story by Gabriel Josipovici, a rather metaphysical postmodern story about stripping which I found one day in the library. It was about a man who took his clothes off to make a point. I was interested in directing, so I thought it could be a performance piece: I could do the music and direct and perform. I had an idea of how to do it, which was to transform the space into a strip club. It was called *Mobius the Stripper* because the 'Möbius strip' is a mathematical phenomenon where if you keep following a plane around you end up on the other side of it. For example, if you take a ribbon and twist it into a figure of eight, you end up on the other side of where you began. For this reason the story was a circle: you began it and at the end you came in at the beginning again. It was an immediate success at the university and sold out, and people kept coming back to see it again and again. It then transferred to the Humberside Theatre, which was a local professional theatre, and they gave me a commission to write a play.

At university there was a film society, and I studied film in my last year. Just as I happened to collide with a music environment in the late sixties as a teenager, in the seventies my formative film-going years coincided with some of the great years of American cinema. I just happened to open my eyes to film when films were extraordinarily adventurous. I was recently looking again at *Midnight Cowboy* and *Annie Hall*, and what struck me immediately about both films was that they couldn't have been more different as movies. But both are deconstructed in terms of their narrative; they're so wildly ambitious in the way they tell a story. Nowadays people would be so preoccupied with previews and market testing that I'm sure many of the wonderful narrative wrinkles would be ironed out. When I was a student in the early seventies, mainstream cinema was so much wilder than it is now. But I was also discovering and relishing Italian cinema: Rossellini, Visconti, de Sica, the Taviani brothers. I remember seeing Olmi's *The Tree of Wooden Clogs* and Fellini's *I Vitelloni*, which are still two of my favourite movies.

Films appealed to me partly because music has a much clearer relationship to film than theatre. If you were going to make the step from music into a literary art form, it would be to film. I think the

4

musical form and the film form are very clearly related. I also found that the cinema was a much closer venue for texts that suited my sensibilities. The kind of theatre I wanted to write was not at all the currency of British theatre. The British theatre at that period was fascinating and rather brilliant. It was Edward Bond, Howard Barker, David Hare: really substantial writing that was analytical in the sense that these writers were looking at how the world worked. With great authority, they were bringing together social and political behaviour, whereas I was trying to write about people through their personal behaviour. I could admire the sound of British playwriting in that period enormously, and be in awe of it, but when I came to write, I couldn't make that noise myself. Even people who were interested in my writing were rather disappointed in how politically unanalytical it was. However, when I started to watch Italian movies more care-fully, I realized that the sensibility that I felt was organic to me was much closer in disposition to the temperament of the Taviani brothers or Visconti or Fellini. I began a very intense love affair with those films that has never left me. So, from very early on, my plays were often criticized for having cinematic aspirations. However, if you were in your early twenties in 1975 to 1978 and were looking for a profes-sional apprenticeship as a writer, the cinema wasn't an option. You couldn't say, I'm going to go and work as a movie-maker. You got a job writing for a studio theatre. That's where you got your opportun-ities. It wasn't that I thought I was most suited to the theatre. It was just where you went to learn. When I saw *The Godfather* for the first time in 1975 it seemed to me the greatest film that had ever been made. It was accessible, moving, individual, psychological, wild. The music was amazing. It was about Italian people, it was about immigrants. What better kind of event could there be? But I could never dare even imagine that I would be able to make a film like that. Instead, I got a job writing a four-hander at the Humberside Arts Centre.

I suppose I had nearly ten years at university thinking about how plays were made, looking at them, making them, directing them, being in them, lighting them. Just playing around. We had so many spaces to work in, so many opportunities to work. The more I think of that period, the more extraordinary an opportunity it seems. Because we had no money, one thing I learnt was how to make do – which I think is something all film-makers have to deal with. It's no different from when Saul Zaentz and I were faced with no money to make *The English Patient*. All I knew was that I wasn't going to give up because I was determined to see that film made. However I was going to do it, it

was going to get made. I suppose I'm not proud enough to give up. I'm prepared to humiliate myself by going to everybody I know, saying, 'You must help me because I want to make this film.' And just because somebody's saying you can't make it, you don't say, 'I'm going home.'

When I first came to London I tried to make a living as a playwright. I had just given up a job as a university teacher and was thinking that I was going to live in a garret and write plays. The week that I arrived in London I got a call from a man called Kenny McBain, who was going to have a huge impact on my life. He'd found me because I'd been working on a television series called *Maybury*, and the producer had recommended me. So it was one of those 'I have a friend who knows someone' stories. Kenny asked me if I'd be interested in script editing the BBC children's drama series *Grange Hill*. I said, 'No, I've just given up my job as an academic because I want to be a writer.' Besides, I'd never seen *Grange Hill*. But I had no money, and he said, 'It's just for one series and it's part-time.' So I met him and liked him enormously. He was an extremely sophisticated, erudite and interesting man, a mercurial character. And he gave me eighteen cassettes, which were of previous series, and eighteen screenplays for the coming series. Two days later I was a script editor for *Grange Hill*. I'd no idea what a script editor did. They were just about to go into the studio with scripts that they didn't consider were ready. So I was plunged into this fantastic experience of seeing this material turned round very, very quickly and, by the by, forming a profound friendship with Kenny.

He and I formed a partnership to try and find other things we could do together. He found a book by Colin Dexter called *The Dead of Jericho* and said, 'Why don't you adapt this for a television film or it could even be a series?' Then the next thing that happened was that Julian Mitchell and I had a Colin Dexter book each and we tried to write the pilot episodes for *Inspector Morse*. I couldn't find a way of cutting my script into two one-hour parts, so I delivered a screenplay that was two hours long. Central TV were horrified at first, but they said they would do it as a pilot, and then they decided that the *Morse* slot would be a two-hour one. So there I was, having never intended to do this job. I was at a period where I really wanted to concentrate on my plays, but this series became the most successful drama series on television at that time. And every year they would come back very nicely and say, 'Would you do one more?' and I would say, 'Umm, I don't think so.' And they'd say, 'Please,' and I'd do one more.

*

I write by hand, but I type subsequently. I write in notebooks and then I type upon a screen. For a while, I had a strange computer which had an 'A' and a 'B' screen. I was writing *Inspector Morse*, which had become quite successful and was very much my day job. And I was trying to write a radio play, *Cigarettes and Chocolate*, on the 'B' screen. It was incredibly liberating because I thought, 'This doesn't count – I'm not really getting paid anything for it. I'll just do this thing on the 'B' screen, and it doesn't matter what it is. It's just mine.' And, perhaps as a result of this self-delusion, I wrote something unmediated, highly personal and important to me. It remains one of my favourite pieces of work.

I wrote so much between 1980 and 1990 that I completely lost my inhibition for writing. I was writing constantly, and because of the metabolism of that period, I was writing and then seeing things being done, seeing the turnaround of my writing. This was incredibly useful because you could create a scene and within a few months see it acted in one form or another. If you look at the metabolism of my work in the following years, it's been slow by comparison. For example, I started working on *The Talented Mr. Ripley* before I made *The English Patient*. If I'd known when I was starting that I wouldn't be looking at any images from it until 1999, it would have been painful. I don't know if you can bear the pain of that, the sluggishness.

I became very involved with a series called *The Storyteller*; the producer Duncan Kenworthy and I were the constants in that series. I suppose we became the editorial staff as well as the writing and producing staff. We worked with directors and worked in the cutting room. It was my first experience of working on post-production as much as I worked in pre-production, and I rewrote in the cutting room. We were finding the series as we went along. I was ready then to start directing. I felt my interest in directing didn't come from impatience with the directors I was working with; it came from a feeling that I was working continuously with a group of actors and it was odd that someone always interposed themselves between me and them every time we got to a certain point in the work. Also, I loved the post-production experience, loved the rhythm of the whole filming process, which begins in isolation and ends in a kind of isolation. So I was jealous to have some of that experience and I was lucky to have had repeated experience not only with actors but also with some production people, such as Mark Shivas and Robert Cooper, who directed a whole series of my plays on the radio. They were sympathetic to this ambition of mine to direct.

I wrote a piece for a ballet called *Hang Up*, which was a telephone conversation. I wrote it for a great friend, Jonathan Lunn, who was choreographing at the London Contemporary Dance theatre. They had no money, so I asked Juliet Stevenson and David Threlfall if they'd come in and record it for me. I directed them, using a home tape-recorder. It was an enormously low-tech weekend event. This play was then remade on radio, with Robert Cooper taking over the directing reins because he was a staff director and I was a writer. But he admitted my input because he had already known that I had directed an earlier version. It worked particularly well and won a Prix Italia. After that, there was an appetite for this collaboration to continue, though Robert was also alert to the fact that I wanted to see the whole process through myself. So he set up a situation where I could write and direct a play with his supervision. This supervision would give the BBC some sort of security. So I finished *Cigarettes and Chocolate*, directed it and had a wonderful time. For many years I hoped that if anybody happened upon one thing I'd done, it would be that. After that, I realized I'd found something I wanted to do.

At that point Kenny McBain became very sick with Hodgkin's disease, gave up *Inspector Morse* and died soon after. And I felt enough was enough. But they came round to the fifth series and asked if I would do one more, and I said no. So Chris Burt, who was one of the producers, said I could direct an episode. They'd obviously known that I was flirting with becoming a director, that I'd done *Cigarettes and Chocolate*. About a week later Mark Shivas and Robert Cooper called me and said the BBC was starting a series called *Screen Two*. Would I like to write a screenplay? And I said I would love to write an original screenplay for a film but I'd been offered an opportunity to direct *Morse*. And they said, 'Why don't you direct this screenplay?' So I was in a dilemma. I couldn't do both jobs. One would have been an extremely well-paid and prestigious job and the other one was for the new, small, low-budget *Screen Two*. So I thought, everyone will watch *Morse* and think what a terrible, amateurish job I'd done. At that time the series was getting about fifteen million viewers or more a week, so I'd be actually standing naked in front of a large audience. Whereas, I thought, nobody would watch this *Screen Two*, which I can make with my friends very, very quickly and it can be personal. And it can be a continuation of some of the things that intrigued me about *Cigarettes and Chocolate*. So I did the *Screen Two* project – which ultimately became *Truly, Madly, Deeply* – imagining that this could be a rehearsal for a future as a film-maker, not realizing the impact it would have on my subsequent life.

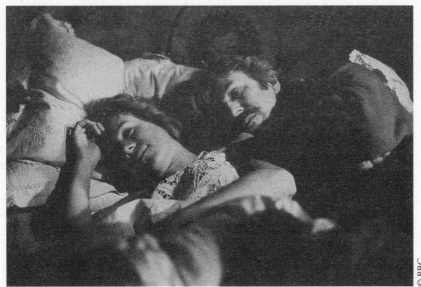

© BBC

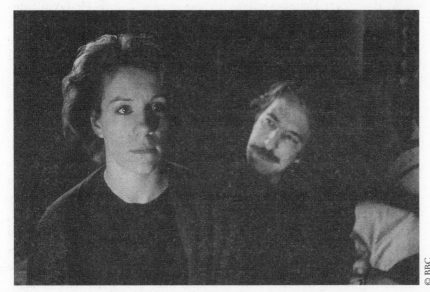

© BBC

Juliet Stevenson and Alan Rickman in *Truly, Madly, Deeply*

2

Writing

However long it took me to come to writing as an activity, that is
the activity which has most defined me and still most defines me. I
love writing. I find it very difficult, but it's the time when I'm most
comfortable with myself, oddly, or I feel most like myself.

I feel like such an amateur film-maker, but not an amateur writer. I
will always feel like a writer who directs and not the other way round.
However, it's of no interest to an American audience that I'm a writer,
or to an American studio. They don't understand why I feel I need to
write my own work because they don't respect that the screenplay is
everything. The screenplay is the notes, and then you play them.

Directors like Scorsese, who are not writers, have created a brand
but, although I am a writer, I'm not sure if there is any identifying
characteristic in my work. I'm not sure whether there should be or
shouldn't be, or that it's good or bad. I just don't see a pattern. I
always find it interesting to set stories against some kind of landscape –
the landscape of war or of a country at a particular point in history –
but, even as I say this, I feel like I'm trying to retrospectively analyse
what stories have intrigued me. Almásy, Ripley and Inman are all
people on the edge of things, people who don't fit, but I think this is a
characteristic of fiction rather than a characteristic of my fiction. I
think you could extract from any film-maker's work a principle of
drama rather than a principle of authorship – as somebody said,
there's only three stories in the world, or four, or two or twenty-one.
You have to have points of entry into a story – strangers or alienated
characters or some purchase on an environment. If the characters are
integrated into an environment and the environment itself is not
flexing against the characters, then there doesn't tend to be any story.
So Dostoyevsky, Dickens, Charles Frazier, Michael Ondaatje, Patricia
Highsmith always tend to use the same devices that I have to. There

has to be some rupturing of the status quo or equilibrium to have the beginning of a story. A man going on a journey, somebody dying, life events or world events tend to be the components that allow you to begin a story. I don't think there's anything particularly idiosyncratic about the stories that I've elected.

The theatre is geared more towards writing that you could call 'epigrammatic': writing where people say what they want to say in rather elegant lines. Film writing is anti-epigrammatic. In other words, writing dialogue – the thing I find easiest to do – is the least significant part of writing for film. I don't mean that what comes out of people's mouths isn't important in film; I just don't think that it's about meaning in the same way that the epigrammatical line is. What I say to you in a film is ultimately neither here nor there. The fact that I'm making noises at certain points in the scenes is extremely significant. But because what makes you look at an image, what makes you listen to an image, is so specific in film, it doesn't really correlate in any proper way with writing for the theatre. Nevertheless, once you have learnt to organize a scene as a playwright, the same kinds of components fall into place in a screenplay. I don't think writing a nice speech is particularly good preparation for becoming a good film writer, but I do think having experience of *mise en scène* is very important. If you look at most movies, people come into rooms and leave rooms; they go on journeys. It's exactly the same structural syntax as the theatre. In theatre, when they come into the room they stay there a lot longer, but that's the only difference – how long they stay in. It's still made up of entrances and exits, arrivals and departures of strangers, of conflicts. It has the same conjunctions and devices. It's just that they tend not to be able to accommodate as many in a play, and film wants to eat up as much of those things as it can. One of the things I like best in film is the stacking of events vertically – which you're forced to do in the theatre because you can't move. In *Ripley*, for example, there's an opera scene which is organized so that all of the characters collide in a public setting, and the public setting itself comments on this collision. In the original version of the screenplay all these collisions happened over time, and I squeezed them all into this theatrical moment in an opera house. So there are a lot of clues in the dramaturgy for the theatre that can be properly and usefully employed in the cinema as well.

When you're writing for a theatrical environment, there's a mathematics to it. How do you bring people on and off stage? How do

you make narrative occur? Essentially characters tend to get marooned in a room or in a space on the stage, and so part of the architecture of writing for the theatre is about bringing people on and off stage, changing scenes elegantly, making things happen in a scene which are not entirely linear. There's a terrible tendency to write in a linear way in the theatre; if you change scene, the characters have to change themselves, change time. That's why I think that the Aristotelian principles of dramaturgy have been so long celebrated, because the unity of time, place and action means that you just get people on and they stay there, and the play happens in something approaching real time. In the twentieth century, people have come up with interesting ways of intensifying their dramaturgy. One obvious way of doing it – which is actually Shakespearean – is to have more than one thing happening on stage at the same time – something that Edward Bond called 'double centring'. You have an execution and a love-making scene happening simultaneously, and the two events somehow change and intensify each other, as in Edward Bond's play about Shakespeare, *Bingo*. This is a technique that translates to film extremely well. If you look at a scene like the opera scene in *The Talented Mr. Ripley*, it uses these theatrical devices. Ripley is enjoying and experiencing his life as Dickie with Meredith, but then collides with somebody who actually knows Dickie. Then he walks around the corner and bumps straight into Marge, who knows him very much as Ripley and is looking for Dickie. Then, to make it worse – to intensify it more – her friend, Peter Smith-Kingsley, whom we haven't met before, knows Meredith and sees *her* there. Also, I wanted to write about the beginning of the relationship between Peter and Ripley, so why not make them meet at the hardest moment, which is the moment when Ripley is potentially confounded by trying to be two people at the same time. The scene is also intensified because the opera itself – the end of the second act of Tchaikovsky's *Eugene Onegin* where Onegin is lamenting the fact that he has just killed his best friend – is commenting on the film. It's not a filmic architecture. It's me borrowing some ideas from my work as a playwright.

I used the same devices in the Piazza di Spagna scene in *Ripley*, where all of the characters are brought together in one location. The location serves as a kind of stage setting, and they all come in. It is oddly very filmic, even though it doesn't really pursue the most muscular quality of film-making – the cut. It's actually anti-cut. You don't want to cut because you want to bring people into the frame. Nearly all the principal characters are contained within a single

frame. It's not obviously cinematic, and yet it's powerful and fun for the audience to see everything.

The opera scene and the Piazza di Spagna have farcical constructs to them. All the doors open at once and people come out with their trousers down. Marge and Meredith meet and discover they were both at the opera and that Dickie was there as Marge suspected, except we know he wasn't. Ripley ends up on his knees proposing marriage – as Dickie – to Marge as far as Meredith is concerned. As far as Marge is concerned he's having some strange aberration. These are elements of Molière rather than Spielberg.

The theatre has also informed, of course, how producers think about film. I think that distributors and studios are so nervous of the cost of film that they're constantly looking for ways of making what can never be scientific into a science. So being able to find a lexicon that helps them approach a screenplay has been invaluable in two ways. Firstly, they have a vocabulary with which they can talk to writers about a screenplay, and secondly, they can use that syntax to try and examine whether a film is going to work or not. It gives them a noise they can make and an index they can use. I remember somebody whose opinion I valued a great deal read the screenplay of *The English Patient* and said, 'Where is the second act?' Although it's a film that has an antipathy towards act structures in general, this doesn't mean I'm not extremely sensitive to the idea of structure in a screenplay. I think it's absolutely intrinsic. In other words, I don't think a screenplay comes in three sections any more than a house needs two bedrooms or five bedrooms. It depends on who is living there.

The writer has to be indifferent to the realities of filming. The well-behaved film writer, the writer who's writing for his or her director, is of no use. There has to be a kind of antic level to writing, which the director then has to formalize in some way. But if you're already surrendering to the pragmatism of making a film, then the film necessarily will be extremely easy to shoot and, consequently, undemanding. What is fun is when you create something which doesn't bear any scrutiny as a practical, physical idea.

There has to be, at some point, a handover, but I try never to censor myself when I'm writing. The madman should be writing and the sane person should be trying to work out how to do it. You can't be sane and insane simultaneously. So I think that I'm a very rebellious writer of screenplays and a quite conservative director of them.

I'm the tortoise. It takes me a hell of a long time to do things. I'm a

writer, and I'm not going to make films I don't write. I tried it and it doesn't work. So the only option for me is to write and direct, and that takes a long time. The metabolism is incredibly lethargic. If I have to give myself the time to write an original piece, that could add another year to the process, and I think I just have to accept that. The reason I've been tempted not to write my own work, but to adapt existing material, is because I've only made a few films and I want to make forty. And I want to get better at it. It's a job you can't practise; you have to do it. Having said that, I spent a year rewriting *Ripley*, and it was more than a year after *The English Patient* was finished, delivered, dusted, awarded and paraded before I was ready to shoot *Ripley*. So, ironically, the quickest screenplay I've ever written was *Truly, Madly, Deeply*, which was an original piece and which I wrote in about four months.

You have to reconcile yourself to your own writing process, but without letting yourself off the hook as well. If somebody said to me, 'You know what? It takes you so long, we're not going to give you a deadline,' that would be fatal.

In some way it's a phoney distinction – the writer and director of a film. I don't go into a telephone booth with a fountain pen and come out with a Panavision camera. There is no such transformation that takes place. But, by the same token, the period of imagining the film is very different from the period of collecting or witnessing – whatever the right verb is. And it's quite hard for those two to jostle too closely together, particularly if you have the tortoise metabolism that I have. I can't write on the spot. I'm not an inventive human being. So I have to sit and brood.

As a writer, if you were taking time-lapse photographs of me writing, it would be the most boring sequence in the world because there'd probably be absolutely no movement whatsoever. I have to sort of freeze myself to write because it's about focus, it's about concentrating as hard as I am able to in a creative space. You're trying to inhabit a series of fictional environments with fictional dynamics, and you have to surrender to them absolutely. The route into how you write the next line or create the next action is to somehow inhabit the virtual reality of that scene.

I always find it difficult to get up to speed. When I am at speed I can really work quickly, but getting to speed can sometimes be heart-breaking. I am so easily derailed. If I have to break to do some business on other films, for example, it can take me three days of quite grotesque lassitude before I can actually get going again. So I have a practical and pragmatic reason for my preoccupation with the

beginning of the film. It's the barrier that I have to somehow break down in order to write and it's also the introduction of the film for the audience.

There are many jobs that have to be done at the beginning of a film. You have to know the period, you have to know the place, you have to know the circumstances and you have to know who the central character is – who you are supposed to be paying attention to – as quickly as possible.

With *Cold Mountain*, I always had this notion of the dialectic between nature and the mettle of man. This is predicated on a hero, Inman, who carries with him William Bartram's natural history writings, and on the novel in which Charles Frazier celebrates the landscape of North Carolina. He celebrates a pastoral ideal which is obliterated by the war. The elegiac nature of the novel is in its description of a beginning of a deterioration; that, post the war, somehow everything was changed and lost.

There is a particular issue in *Cold Mountain*, which is that our hero, obviously connected to Odysseus, is in a different circumstance to Homer's hero. This hero is deserting, and his side of the war has not been successful. So the unsuccessful war and his deserting are two strikes against the character from the very beginning, and what I wanted to do was to establish certain credentials for Inman. One of them is that he is extremely courageous; an experienced and professional soldier, he is somebody who has done his share of fighting. However, one of the problems with film is that you cannot handle tenses very well. If I were writing the novel I could say, 'For four years Inman had fought with the best of them; he killed more men and finally he had had enough.' That is a sentence which is almost impossible to achieve in a movie. When you handle exposition that way, the audience sees it coming and ducks. In the opening of the film I had to try to establish the history of Inman's valour, as well as the fact that he has had enough of it, that he is exhausted by it.

It is the nature of the story of *Cold Mountain* that you never really go back to the Civil War, in the same way that *The English Patient* is set during the Second World War but has no 'war' in it. Both are much more about the chaos at the end of a war – in *The English Patient* you see a country, Italy, beginning to deal with the unravelling of the conflict. In *Cold Mountain* we see a country that needs to deal with the fact that the war is coming to an end and we are following a group of characters who happen to be on the losing side.

I wanted to establish that Inman is a great soldier, that war is

horrible, that this war was particularly vicious, that it was brother against brother, that it was a war people did not thoroughly understand the terms of. The more I researched, the harder it became for me to say what anybody was fighting about. And, certainly at the point of the war in which *Cold Mountain* is set, it is clear that people had forgotten the purpose of the conflict. We didn't have many opportunities in the movie to establish any of this, so I created, in the first ten minutes, quite a complex choreography in which you see the randomness of killing, you see Inman's exhaustion – and then you see him take his wound after the main battle because I wanted to show the irony that so many people got injured outside of the main conflicts. Once you have seen the Petersburg battle, then it stands in for the whole war, it stands in for every reference we make subsequently as to what it was like and why it is perfectly reasonable for Inman to give up on it.

Like Ada in *Cold Mountain*, I can play the piano and I can draw a bit and read and live the life of the mind, but if a farmer came up to me and said, 'Come and help me birth this lamb' or 'Can you plant that field?', I would be completely at a loss. Part of the fun of film is to learn a little bit, to say to yourself in an imaginative way that you are Ada and you are going to be forced to understand that the sun sets here and rises there and that that tells you where you are: the rudimentary business of surviving in nature. I enjoyed writing those scenes a lot because I connected to her. She is also an outsider in a very small community, and I know exactly what that feels like. I grew up in a very small community and felt very much that I was a slightly exotic member of it. I wanted to be as integrated as I could, but didn't know how to be. So I saw her very clearly. However, Ada has an elegance that I certainly don't possess but that I have always been attracted to. So I could step outside of her and also be the local yokel who's terribly intrigued by the real exotic, instead of my own extremely slight exotica.

There is a Ruby part of me as well, which is not at all intrigued by the life of the mind, and I found I could easily inhabit her. I also know what it feels like to be a part of a culture which is deemed unsophisticated coming into contact with the sophisticated and being enormously seduced and beguiled by it. My grandmother was a Ruby and that is the person I thought of all the time when I was writing. My grandmother said exactly what was on her mind and was a small feral woman who had grown up carrying water up and down a mountain.

Inman, however, is as far from me as possible. I know who he is because he takes up the negative space of my personality. I can imagine what it is like to be Inman because he is against all of my instincts. He is someone I imagined to be long, slender, lean, focused, purposeful and probably a little stiff. A man who is very distrustful of language, whereas I have invested all my life in language.

When writing, you are neither objective nor subjective. You are neither absolutely Ada nor absolutely not Ada. There are times when I have been writing when I have been so moved. When I was writing the scene where Inman crosses the Cape Fear river – 'the mighty Cape Fear river' as the character says – the ferry girl is shot, and when it came, it was a surprise. I could physically feel the moment when the bullet hits her, because I was both watching it and feeling it. The intrigue of writing, particularly when I know I will be filming, is that I am watching and feeling simultaneously. When it is working I am completely feeling and completely watching. You can see sometimes where people have overconcerned themselves with the organization of a scene and nobody is living it. And other times people get too taken with the living of it and are not organizing it. I have been guilty of both. I am always trying to get the synthesis of feeling and observing.

I don't want to know everything, because then you are a mortician. I don't want to know what is going to happen, but I also have to know everything that is going on. But there is no magic involved. It is just writing, it is just work. I don't believe in it as some kind of holy, transcendent experience.

Often, I've thought so much about a scene that there's no way to write another version of it that I understand. I don't elect for somebody to get up and move and do something: they are doing that, and I am just witnessing it, trying to keep up with whatever it is that I know is the right thing to happen. I don't think of it as remotely mystical or spiritual. There's nothing precious about it.

Years ago I played in a jazz group, and although I was not very good at it, it was fantastic because there were times when I understood what improvisation was. You're playing with friends and you know what they are doing and they know what you are doing, but then you surprise yourself, you play faster or you find a chord. If you were sitting by yourself trying to plan it, you would never find that progression. It has to do with the momentum. You keep playing and it is given back to you, the chord changes and suddenly you are in new territory. I feel like I have seen the film many, many times when I sit down to write, but I don't remember it all and it ends up different from

the film I think I have seen a hundred times. That's the mysterious thing, to both stay on course and be delighted to lose your course.

As a writer, I always insist on the reality of the characters. I try to understand that everybody has a story to tell and that when the central character gets out of a taxi he may not be as interesting as the man driving the taxi; that when the taxi driver parks his car and walks into a café, the person serving in the café may be more interesting than he is. I try to insist that a whole life exists and that the drama is only choosing to lasso a small portion of it. You might pass by the most interesting character in a film. Silvana, in *Ripley*, for example: to all intents and purposes she serves as just a native love interest, but suddenly she insists that it's her film and drowns herself.

In *Cold Mountain* there are two things which are different from anything I've done before: you have absolutely identifiable heroes and absolutely identifiable villains. Something which has been a denotative aspect of the work I've done before is that there's always been a blurring of protagonists and antagonists; as Ripley says, 'Nobody thinks they're a bad person inside their head.' In *Cold Mountain* people behave very, very badly and very well, and you're allowed to attach your allegiances to three characters at least who try to live well. Ruby, Ada and Inman are all in some ways trying to do the best they can at all times; they don't really surrender to their own personal temptations, whatever they are. And Inman, in particular, is a genuinely heroic character, a person of integrity and dignity; in some ways he presents the audience with a template of aspiration. It has some of the qualities of myth.

When I was writing *Truly, Madly, Deeply*, I was so enthralled with myth and fairy tale and wanted to move away from the fractured dialogue that I'd become slightly identified with. I had kept on investigating, in my plays, how incoherent most communication was. An archetypal Minghella speech was one in which you could find the meaning by landing on every fifteenth word rather than following the logic of a sentence. There were no perfect sentences in the plays I wrote, and if I ever found one, then I would scrub it out because I was interested in how the ellipses in sentences and repetition of words conveyed meaning. Often, when people are struggling to communicate something, they hover on sentences, constantly remake the same sentence or try to rephrase an idea repeatedly until they're satisfied that either they've buried their meaning or they've exposed it. It's very rare that the sentence simplifies into an epigram, so whenever I hit on an epigrammatic moment, I would immediately remove it because I didn't

trust it. So the writing, in some ways, got poorer – in the formal sense – in order for the meaning to feel more authentic. I was trying to learn how actors could use words like movement and gesture. When I came to write *Truly, Madly, Deeply*, I wanted to fasten that technique to a more mythical structure or fantastical idea because, implicit in the technique of behavioural writing – mumble writing – is that it leads to domestic scenes and domestic rhythms. So, in the case of *Truly, Madly, Deeply*, one of the characters would be dead and yet behaving as if he were very much alive and present. I was trying to use the heavy rhythms of naturalism on top of the bolder designs of fantasy.

The first idea I had for *Truly, Madly, Deeply*, was the image of a Bach duet, because I thought that people coming together to make music was very interesting. A friend of mine had been very sick. He was a pianist and he would meet once a week with a clarinet player to play a duet. I've never experienced the same kind of joy as when you are able to play music with other people. It's such an intense, egalitarian and wonderful experience to sit down and make music with somebody else. So, the first idea was not about a relationship. It was not about bereavement or ghosts. It was about music. I'd begun to have a real interest in Glenn Gould at that time and had started to collect his music and recordings – he'd recorded a series of Bach cello and piano pieces. And so it grew out of a musical idea.

I play the piano a lot when I'm writing. I listen to music a lot. But just as you have to make peace with your voice, you have to make peace with your process as well. When I look at the madness of the way that I write, it would be very easy to get enormously irritated. Even if I did one page a day, that's only 115 or 120 days of work. So, why does it take me a year and a half? What is going on with me? But I realize that the time spent reading the Book of Job for a day is not specious. It's because that's where my own particular journey requires me to be. Or when I'm spending two days examining the Smithsonian collection of early American folk music, it's not just indulgence. I know that there's going to be a clue there somewhere that's going to feed the film. When I was writing *The English Patient*, I walked into a record store because I wanted to listen to Hungarian music, and found a disc by a band called Muzikacz. I put the disc on and the second or third track I listened to was called 'Szerelem, Szerelem' and that became the voice of the film for me. And I listened to that music repeatedly throughout. But I have to give myself permission to do that. There have been times when I haven't and I got very exasperated with myself and with everybody, and I didn't work well.

Something, I think, that is common to all writers of fiction is that, at the moment you're writing a novel or a play or a poem, it appears as if all random events are feeding the piece of work you are making at that time. Everything, when you're focused, seems to feed the particular piece of work. When I'm open, I'm dialled into writing. Everything comes at you as if it were a message. About a year before we started filming *Ripley*, I got an invitation to go to Capri to receive an entirely specious award – the Capri Hollywood award, which I think is awarded to anybody in the entertainment business with an Italian name. I thought, 'Well, I'll go there and do this, whatever it is, and then probably spend a day having a look at the Amalfi coast, which is the location of Mongibello in the book.'

That weekend in Capri was one of many experiences I've had with Italian television where I find myself at an award show which is essentially an excuse for bringing on as many women in as few clothes as possible and punctuating – as rapidly as possible – their singing and dancing routines with an award. Nobody knows what's happening and it's entirely chaotic. And the prizes are always prizes that even your mother wouldn't be happy to accept. There were about forty young girls who had been chosen from the surrounding area, who wore various swimsuits and short skirts and dresses, and kept parading round and round and round, and every now and again Armand Assante or me or somebody else would show up and get a piece of strange crystalware.

However, in the middle of all of this, interesting things began to happen. One was that the producer, who proved to be an interesting and fun man, said, 'I have a friend here tonight who wants to say hello to you.' So I met this Italian man and we started talking, and I was saying, 'I'm making this film set in the late fifties. Do you know of any kind of music, a hit single of the late fifties, that would have been known around the bay of Naples area? What would be the sound then?' He said, 'Well, it's funny you should say that because here in this room tonight is a guy called Renato Carosone, who had a song called "Tu Vuo Fa L'Americano". You should say hello to him.' So I met this chap, and it transpired that the song was a hit in Naples at the end of the fifties and the song said, 'Do you want to be an American?'

Then the producer, after this hilarious event, said, 'There's a club in Capri. It's great. It's like a cave. It's a divey, wonderful place. You must come.' I said, 'I never go to clubs. Thank you very much. I'm just going to go back to my hotel.' 'No, no, no! You must come. Just come for a

20

few minutes.' So I followed the herd down to this club, where all these teenage girls came in their various states of undress, as well as the producers and their girlfriends and some bewildered holders of crystal. I thought, 'There's no way I'm going to stay here for very long.' But the music was quite fun. And then another friend of the producer showed up – very funny and very charming – and said, 'We're going to sing tonight, you and me.' I said, 'Unfortunately not. I'm actually going home soon, but thank you.' He said, 'No, no, no, no! We're going to sing tonight.' He got up on the stage and started to sing, and he was wonderful. And the crowd seemed to like him very much. Then he started to sing 'Tu Vuo Fa L'Americano' for me . And then he said, '*Sul palco! Sul palco!* Anthony Minghella, Anthony Minghella!' And I'm suddenly dragged up onto the stage covered in humiliation. But because I used to sing a lot, within a few minutes I'm singing. And then I can't stop singing and spend the rest of the evening having a great time with this guy . . . singing. Armand Assante and I were singing 'The Long and Winding Road' at four o'clock in the morning. It was very weird.

When I got to the hotel I started to wonder if I could have a character like the Italian singer in *Ripley*. I wondered if I could cast him. I could just write a part for him. He's a local. Anyway, this man's name is Fiorello and it transpired that Fiorello was one of the biggest stars in Italy. He was such a part of Italian culture that when he damaged his penis trying to take a piss against a wall it made the front page of the newspapers. He only has one name in Italy, Fiorello ('little flower'). But he's actually a very clever and a very good guy. And so I wrote a little part for him.

This whole event started to build in my mind, and it transformed itself into the visit to the jazz club in Naples where Dickie is performing and persuades Ripley to come up on stage. Somehow Ripley is able to demonstrate to Dickie in that context something which enables Ripley to be welcomed as a guest in Dickie's house. It's like a proving ground for Ripley because this work he's put in trying to learn jazz pays off in a splendid way. I'd been thinking about the musical arguments of the film because in the novel Dickie is a painter and Ripley, who is a connoisseur of painting, sees very quickly that Dickie's not a very good painter. It seemed to me to be a particularly jaded idea filmicly to have Dickie in a smock and looking out of the window with not very good paintings. Watching paint dry is not a pejorative phrase without reason, whereas music to me is always dynamic and energizing.

As is often the case with music, more is communicated in a couple of bars than maybe several scenes could have done. Dickie looks at

Ripley in a completely different way. Also, you get a sense of the period very strongly because of the song and because of the strange way it corrals American and Italian values in one piece of music. So I suppose what it did was remind me that no trip is in vain. No journey that you enter into with a fairly open heart isn't rewarded in some way. And that weekend gave me this huge chunk of stuff for the film.

When I'm writing, I'm often in some form of trance and can write for eleven hours. I can just go into a zone, and that zone has taken me so long to get to that I get very pernickety about it being invaded in any way. Nowadays, I go away to write. I've given up trying to be in my own environment. I go to a place in the country where I have a little house. I lock myself in there and don't come out.

When I think I'm writing well, it's because I'm in a place where I've tripped myself up so I can't watch the process too much. It's just happening. And sometimes I can write as fast as I can, and you wish that every day was like that, where you just can't go wrong. I know every writer has had those moments, where you know that it's right and you just have to go, go, go for as long as you're allowed to.

It's rather like having a hard drive. When you're in the trance-like state of writing you've suddenly got some software (sorry I hate using computer terms) where it's almost like you have access to banks of memory that in normal consciousness you simply can't access. That is typical of the way that creative self-hypnosis seems to work.

Names – a whole book should be written about the allocation of names in drama. A name is totemic, and if you get the name wrong, you can't write the person. There was something I was writing where somebody said that they couldn't get clearance on a name, and it was catastrophic because it was like having to call your wife or your child by a different name. I do know that names have very particular connotations and resonances for me. For example, even the names of the cafés in *Ripley* are not there by accident. They have meaning to me. The fact that they don't communicate that meaning elsewhere is absolutely irrelevant. It gives me a sense of verisimilitude and gives the film an additional undercurrent. It may elude 99 per cent of the audience, but that doesn't mean it's not important and valid to do it, because you want to make the film worth revisiting.

Oddly, I'm very secure about screenwriting; I don't know why and I don't want to find out because it would paralyse me. The issue is that I don't have to please a director, so I never meet my nemesis when I'm writing. I like my writing in the sense that I have to like it, I have to

believe in it and I see it as a part of a process. At a certain point, I can't cry 'Process' any longer; I have to say, 'Well, here's the result.' When I submit a screenplay, I'm submitting it to myself finally and I know that I'm happy with where I am because – with all of the caveats of incremental drafts – I know that I feel I'm ready to get to work on something as soon as I start writing it. So I don't have that schoolmaster's grade at the end of my screenplay that most writers who are not directors have to deal with; that's their nemesis: when they've done their work and a director comes in and says, 'Well, this is completely not what I want,' or ' . . . not what I imagined'. I meet my nemesis in the first preview, where I'm with a faceless, nameless audience who pass judgement. The truth is that I'm always very frightened, but the level of fear is intrinsically connected with the level of hope: it's not that I worry I've made a bad film; it's that I'm hoping that people will see the virtues of what we've done, and the more I hope for that, the more I worry.

I resist certain things when I'm writing and when I'm thinking about film, and then go looking for them like a madman when I'm editing. That always happens to me. In *Cold Mountain*, Ruby says, 'Every bit of this is men's bullshit. They call this war a cloud over the land but they made the weather and they stand in the rain and say, "Shit, it's raining." ' We long for that moment in a film of somebody voicing a position. When I'm writing, whenever I feel I'm getting to that place, I just go round it because it seems to me to be close to epigrammatic writing. When I'm working with Mark Levinson on ADR (additional dialogue recording), we have this odd, quirky relationship with each other, very combative. He's a fantastic ally but he's always gravitating towards the epigram or the line saying what the line should say, while I am working to find ways of degrading the line. It's a very odd process because in prose you'd be looking at ways of polishing the line, but with film I'd be looking at ways of degrading it until the meaning sits carefully. It's like that particular sort of glaze on Japanese pottery which is full of cracks; it's a fissured glaze rather than a smooth one. So if the idea of the line is to say, 'The Home Guard are out and about,' and maybe that's the line that you need, I'll do everything I can not to say that. Instead I'll write, 'This war is a cloud over the land and they just stand in the rain and say, "Shit, it's raining!" ' I believe the joy is in giving the audience this fissured, cracked surface which they then scrub and clean up themselves.

Sometimes, however, all you need is an assertion of the situation and ADR, for me, is often a kind of corrective process where I go through

the film and think, 'Actually, I do need to say this or that.' For example, we constructed a letter in *Cold Mountain* in the ADR studio, which became a carpet bag for a whole sequence in the film of Ada's isolation after her father has died. We pull together elements of maybe seven or eight scenes, which were fully realized before, into this portmanteau that's supported by a letter. And, of course, the letter was the first thing the trailer company used to tell the story of the film because it's the one bit of the film where the dialogue says something that has a narrative meaning – 'I'm still waiting as I promised I would. If you're marching, stop marching. If you're fighting, stop fighting. This war is lost on the battlefield, it's now being lost twice over by those of us who stayed behind. So now I say to you, plain as I can, come back to me. Come back to me is my request.' The line tells it like it is, whereas in my screenplay I'm always trying to avoid telling it like it is and hoping that the audience will extract what it is. I end up having to go back in and put some captions in.

ADR has two functions to me, one of which is darning: you remake your jacket to fit the new person; you've cut into a lot of scenes and then you've tried to make them fluid and you realize there are little imperfections. ADR can straddle those imperfections and join them up. So the first principle of ADR to me is to darn the cloth. The second one is to help fleck the film with larger clues. It could be as much as putting in one line – for example, one tiny line which is a perfect illustration of ADR in *Cold Mountain*: 'Can you at least tell me where the Cape Fear river is?' says Inman when he's in collusion with some runaway slaves. Initially, in the writing of the scene it was 'I'll give you a dollar for an egg' and they run off, and now it's ' . . . at least tell me where the Cape Fear river is' because we realized that the movie is light on any geographical information. Given it's a long walk, we were looking for ways of saying where he is on that walk: where does it start and where does it end and how far did he walk? The Cape Fear line is one of the very few times when we can get in a landmark. Later on in the film, when Inman's at Junior's, he says, 'I've got miles and miles and miles to go before I reach the Blue Ridge,' because that's something again that gives him a destination beyond the particular name of Cold Mountain and it was another line we added in post-production. So ADR is good at dropping in some signposts. They can also be character signposts: 'It's my farm,' says Teague off-screen now when he's frightened Ada by the scarecrow. It can be used to beef up an idea, to dilute an idea or to pull an idea over more than the two scenes it's currently working in. It's very useful glue.

On set chaos: AM talks to Matt Damon on the set of *Ripley*

On set rewrites at lunchbreak in Cold Mountain Town

Adaptation

[The following section is from a piece that Anthony wrote for the *Observer* in 1999.]

Studio executives in Hollywood have a good deal in common with football managers. It's hard to understand exactly what they do. They're inevitably fired. Presiding over a creative activity in desperate pursuit of industrial theory, these bosses are revered when the results are good, reviled when they're bad. They pay millions for the wrong players, they find talent on the street. They either have no strategies or else they are gurus. And just as the best time for any manager, the safest time, is pre-season, before a ball has been kicked in anger, so it is manifestly true that in Hollywood the only really dangerous activity is to actually make a film. The rest is marvellous.

From any rational business perspective, making films makes no sense. Movies cost far too much, there are no prototypes to test, they're impossibly unwieldy to manage, there is no relation between effort and result, they're in the hands of regularly insane people called directors, they refuse to conform to a pattern, there is no safety net, what worked last year won't work this year, the creative participants will often celebrate their indifference to commercial success, the audience is fickle, the marketing costs prohibitive, the stars crippling in their demands, and again, like soccer, the general public – the fans – obsessive in their collection of information and minutiae, evaluate and analyze the weekly results, the grosses, with a withering eye. What is to be done when, in this current season, a film-maker has delivered a film for more than one hundred million dollars in excess of its original budget? In another industry he might well be in prison. In this one he's collecting awards. He's also, of course, created the most financially successful movie of all time. In Los Angeles the denials, the distancing, the disavowals are hastily traded in for celebrations and bonuses. The bewilderment and the tearing up of the rulebook occur in private, the rewriting of history in public. Success has many fathers, the adage goes, failure is always an orphan.

This is to put in context the film producer's comfort with adaptation. In an industry where the odds are so absurd, anything which reduces them is attractive. Adjudicating a new idea is a rigorous and dangerous activity. If it's true of literature that the only real critic is one who judges new work and is exposed in that judgement, so it's true that in movies people generally prefer some clues as to what

they're supposed to be thinking. It's less difficult to admire a piece of material which has already earned the endorsement of a publisher and comes with a quote on its cover heralding its genius. It's much less difficult to admire a piece of material which has topped a bestseller list. It's sometimes not even necessary to have read it. I recount this without jaundice. It's a wonder any project gets through the sieve of angst, suspicion, secondguessing, calculus, flirtation and fear which is known in Los Angeles as 'Development'.

When a project has an established literary credential, it makes it easier for everybody to imagine the film, to talk about the film, to participate in the evolution of the film. There's already a putative audience, although the book's readership alone cannot sustain a movie's needs – however well a book might have sold – so great is the negative cost of an average film, so small is the population of readers. And so the movies go to the library – to ransack and pillage, mostly acknowledging sources, very occasionally celebrating them, sometimes disguising them. In a collection of short stories published under the banner *No, But I Saw the Movie*, there is a tacit lament for the appropriation of credit by film directors for creating something which is, in fact, borrowed from another medium. Hitchcock's *Rear Window*, Capra's *It Happened One Night*, Francis Coppola's *The Godfather* all began their lives with the possessory credit allocated to the novelists who created these stories, not to the directors who either brilliantly reimagined or plundered them, depending on your point of view.

Readers are unsurprisingly proprietorial. They are frequently indignant at the mess films make of their favourite literature, appalled at casting choices and compromises, irritated by the conflations, amputations and distortions which movies regularly employ in translating books to film. So much of the pleasure in reading a novel is the creating of an inner landscape in which the book plays out, with each reader providing face and voice to a character, dramatizing events in the mind's eye, placing emphasis and finding in memory visual correlatives for scenes set in places beyond our own experience. Reading is personal and private. Movies make prosaic the poetic, flatten everything out and cast movie stars whose age is rarely within ten years of the stated age of the fictional character. Tragedies become comedies, endings change, equivocations yield to certainties. It's shameless.

Wisdom used to have it that only bad books made good movies. Such dispiriting theories stem from Hollywood's fear of literature and literary figures because, of course, the pillage I've described can only succeed in a climate of mutual suspicion. The studio view is that films

which aspire to the conditions of art, the complexities of a really good book, the equivocations and debates, the edginess or, worse still, the melancholy, will necessary be limited in their appeal, consigning them to that circuit of dungeons known as the arthouse (a place which has always held a sneaking appeal, even in its name). *The English Patient* is a prime example – a period story, thematically burdened, with a central character burnt beyond recognition, European, elegiac and tragic. It was impossible to find a backer. Successful movies aim low, is the studio mantra, aspiring to the atmosphere of the fairground, not the salon. Even those who've asserted and achieved the poetic in cinema are at pains to distance themselves from books. Bergman insisted that movies had nothing to do with literature and that the character and substance of the two forms were generally in conflict.

Having undertaken a trilogy of adaptations, which began with *The English Patient*, continued with Patricia Highsmith's *The Talented Mr. Ripley* and ended with Charles Frazier's *Cold Mountain*, I must deduce, then, that I, too, have fallen prey to the same desire to steal a march on the elusive process of getting a film made; it makes great sense, I think, to be the writer of the films I direct, but the metabolism of film-making is slowed accordingly. Years can pass before I can walk back onto a film set. If I want to make a film, I have to have a subject. Starting with a book accelerates the process. I am afraid it may be as banal as that.

So it behoves me to make a case for the value of movies based on what the Academy of Motion Pictures quaintly calls 'previously published material'. Books are books; films neither improve them nor are the contents of a novel mysteriously changed by the alchemy of a movie adaptation, successful or catastrophic. Books are to hand, on bookshelves, to be read. And reading remains the most poignant, personal and important of activities. Nevertheless, some movies based on previously published material are works of art in their own right. The synthesis of the constituents of film – darkness, light, colour, sound, music, movement; the appalling intimacy conjured from the lens's ability to suggest a point of view or focus on the particular; the power of a smile enlarged a hundred times; its selection of images; what in *The English Patient* allowed me to shift effortlessly from a tiny pulse on a woman's throat to the yearning emptiness of the Sahara; the ability to situate the private event in the public landscape – makes it the most powerful art form of the century. And the most frequently trivialized.

At the very least, good film adaptations become a pungent

advertisement for their source material, like hearing a friend recount their excitement at having read a new book. For that is what the role of the film-maker seems to me to be – the enthusiastic messenger, bringing news from somewhere else, remembering the best bits, exaggerating the beauty, relishing the mystery, probing the moral imperative of what he or she has read, its meaning and argument, watching for gasps or tears, orchestrating them and, ideally, prompting the captive audience to make the pilgrimage to the source. The adaptor must attempt to be the perfect reader. But, as Italo Calvino said of storytelling, the tale is not beautiful if nothing is added to it. Nothing gave me more pleasure than to see Michael Ondaatje's magnificent book perched an top of the bestseller lists, his other books reprinted, a whole new audience discovering for themselves the power and delicacy of his prose. I had a similar frisson from the sight of Herodotus enjoying a revival in a new edition, or Marta Sebestyen's music finding its way into the charts. I think my work has always carried an encoded catalogue of what currently delights me, be it Bach or Beckett.

The screenplay, closer to an architect's drawing than it is to literature, exists as a blueprint for the film. Film-making is first of all, like architecture, contingent. A building must fit on its lot, must be practicable, must accommodate people and their needs. Most certainly aspire to beauty and to longevity, but they are hostage to what is possible within the discipline of the form.

This is the way it is with movies. Experienced in real time, intended for public arenas, they must fill in what a novel can merely suggest, provide the whole face where a novelist may be content with an eyebrow, the room where the novelist need only describe a chair, the whole street where on the page was simply the mention of a pedestrian. Kurosawa once memorably explained that a developing shot which appeared in one of his films had its idiosyncratic design, not for reasons of aesthetics, but because it had to avoid a petrol station and an apartment block. The metonymical quality of prose fiction gives way to the literal in films. The camera is a recording device. I must have something to look at or else nothing appears on the negative. The cost of creating these worlds – a Cairo souk in 1939, the Piazza di Spagna in 1958, a battle in Virginia at the end of the American Civil War, the landscape of the moon, a huge ship smashing against an iceberg – can be astronomical. But it must be done before an audience will surrender to the convention of its fictional experience, before it will settle into its strange collusion with the film-maker where it accepts a projected two-dimensional image, a mosaic of dots, a series

of still frames running through a projector at twenty-four frames per second, as real enough to pass for the truth.

The cinema can manage its own poetry. Often this is achieved by manipulating the grammar of film, where shot size, camera angle and movement, the length of a shot, the amount of light on a subject, the palate of colours and, most significantly, the edit replace the syntax of noun, verb and adjective. More mysteriously, when the camera looks with purpose at an image, it seems capable of transmitting that purpose, subcutaneously, to the viewer. I wrote at the start of *The English Patient* screenplay, 'The desert seen from the air makes the dunes look like bodies pressed against each other,' and no matter that I had never been to the desert, when we flew above the Sahara and the camera pointed down, it brought back images of sensual curves and voluptuous mounds which, when placed in the film, without comment or caption, spoke to the audience of bodies.

In the novel, exposition can be achieved in the baldest way – *it was Saturday, he was dying*; tenses can be manipulated – *ten years previously, the next month, when he was four something strange happened*; the globe navigated with profligate ease – *he flew that morning to Naples and then drove down the Amalfi Coast, before returning to the airport and taking the night flight to Tokyo*. The film-maker has to work within more rigid disciplines – most audiences tire after a couple of hours, get confused by a decentralized narrative, can't tolerate fractured chronology unless it is transparently presented, need to spend time with characters simply to recognize them and situate them. They cannot stop the film to check some information from a previous scene; they have to form opinions about characters and events without the novelist's ability to guide them – *nothing he said had been true*. And none of this takes into account the way a film is read, what happens to a movie when an audience recognizes an actor from a previous role, has a vestigial impression of that other character, or is only there because they want to see that actor again and have very strict notions of how he should behave in any story. Contingency obtains.

In *The English Patient*, for example, my original draft was over 200 pages long, about twice that of a standard screenplay. Reducing its length meant eliminating precious material and also involved rationalizing its structure and geography. I don't regret this particularly, but acknowledge that every choice I made – of what to dramatize, what to omit, what to invent, what to change – said as much about my own preoccupations as it did the novel's. The film had to stand alongside Michael Ondaatje's book and not as some kind of book-on-film

experience. In our test screenings, fewer than 4 per cent of the audience had read or knew of the novel. Similarly, in *The Talented Mr. Ripley* successive drafts eliminated the New York element of the novel (hugely expensive) and, although it was restored to the shooting script, the film takes place almost entirely in Italy rather than the three European countries Highsmith took her readers to. Coherence is everything in these decisions, just as it is in architecture. Form, the consonance of form, is at least as telling as content.

Michael Ondaatje handed me a proof copy of Charles Frazier's *Cold Mountain* with a recommendation from its publisher. Destined for a modest hardback release, the manuscript – the work of a first-time novelist – had attracted no serious film interest (the same had been true of *The English Patient*). When I returned to London another copy of the book was waiting for me, this time from Bill Horberg at Sydney Pollack's production company (now also my own), Mirage, in Los Angeles. I took this as an omen. I read the book. The prose is like denim, made for work; serious steadfast sentences which talk of the land, of loss, of a terrible damage to the country, the end of something. There's a resolute man walking home to find the woman who waits has also changed, irrevocably, in his absence. It's a story which makes you want to go walking. Nature is brought into the reader's room with visceral power. I can't ever remember having been made to feel so alert to changes in temperature, altitude, the seasons. Flakes of snow fall in the pages with tragic consequences. It announces itself as a masculine book, reverent about the workings of guns and tools, about the way to skin a hog, hunt a bear, read a trail. But it is the women who stay in the mind, Ada and Ruby, remarkable and original creations, flinty, clear and funny. I was mesmerized.

A week later a sudden rally of interest led to an auction in which the price for the film rights escalated. In a telephone conversation I spoke to Charles Frazier about my passionate regard for the novel and my profound ignorance of the period it rehearsed or the landscape in which it was set. I knew nothing either about the causes or effects of the American Civil War. This seemed to amuse him, and the next day United Artists acquired the rights for me with Mirage to produce. By Christmas there were a million and a half copies of *Cold Mountain* in print, it stood at the top of the *New York Times* bestseller list, had won the National Book Award, and was a publishing phenomenon. *Cold Mountain* fever had gripped America.

Frazier's genius had been to cast his account of a deserting Confederate soldier's journey home in the shape of the *Odyssey*, or rather

to see in the true story of his ancestor's walk through the state of North Carolina at the end of the Civil War resonant parallels with Homer's epic poem. The book has the quality of myth, as if it has always been there, as if the book itself had been discovered on the trail to Cold Mountain (a real place, incidentally, and once partly owned by Frazier's great-great-uncle, W. P. Inman, who gives the protagonist his name). It is, by turns, unflinchingly violent and intensely tender. It's a very cruel book. I took advice before I committed to taking it on. One friend recounted how, after reading it, she had wailed so much in the night that her children had come into her bedroom to see why she was crying; another was so incensed by the events of the last pages that he threw the book across the room. This seemed promising.

Boiled down to its bones, the book makes an irresistible case for adaptation to the screen: an honourable man, a journey, a purpose, a series of obstacles, someone waiting with forbearance, and Cold Mountain itself, a place which becomes more than a place, becomes a goal, stands in for a time and way of life which have been lost. At its heart the book has a question: is it better to have tried and failed than not to have tried? A blind man finds Inman's notion of a few minutes' gift of sight to be an appalling one. For Inman there is no question this is preferable to never seeing and he sets off, deserting the rebels and a pointless, hopeless war to get sight of Cold Mountain. In a lawless world, the violence stunningly casual, nature indifferent, only an indomitable cussedness pushes Inman forward. In its effortless flexing between epic sweep and the minute details of the landscape, in its insistence on the relation between the private world and the public one, *Cold Mountain* goes a long way towards earning the instant classic status it attained in America.

I went to North Carolina and visited Frazier. During the course of an inspiring week I discovered a man as careful with the words he speaks as he is with the ones he commits to paper. He had walked Inman's paths and showed me some of them. Looking out at Grandfather Mountain, the most distinctive of the Blue Ridge peaks in western North Carolina, we discussed the movie. At this point I was in architect mode. I had made a breakdown of the key scenes and sequences in the novel, but if each one was allocated only five minutes of screen time, the film was already four hours long. There would have to be amputations. And the chronology would have to be simplified. Some characters would have to go, some amalgamated, some would have their functions altered. I had to work on the book with a tape measure, a compass and a scalpel. Sitting with Charles Frazier on the porch

where most of his novel was written, the mountains in front of us shrouded in mist, I was conscious of a strange moment, as if I were adopting someone's child. I was starting the long and painful journey to make Anthony Minghella's *Cold Mountain*.

*

The fact that I've become rather bogged down with adaptation indicates that when I'm not working, I tend to read more than go to see movies. However I'm irascible when I think about an adaptation as having some responsibility to the source material because it's not a public service that I'm doing. I'm not animating a book so that people don't have to be bothered to read it.

I think it's perfectly honourable to adapt material for film, because in the end the story is both the spine of every piece of dramatic fiction and also the least significant thing about it. I don't think the film-maker has any responsibility whatsoever to the novel. That's at the root of what I feel. And that could, I'm sure, get me stood up against a wall and shot.

When it comes to choosing a novel to adapt, I think it's about a day and a particular predisposition to something. You don't really know whether it's a good idea or a bad idea until you are much too far down the road to turn back.

The English Patient I read in one go. The last thing I was doing was looking for a job. I'd read everything that Michael Ondaatje had written. I'd read his poetry, and then he started writing novels, and I'd read those. And I'd saved up *The English Patient* as a present to myself.

Sometimes there's silt in the bottom of the read which never goes away; there are certain ideas that you live with and luxuriate in and that you work from, and there were stars in the constellation of *The English Patient* that glittered immediately. One was that new lovers smash everything – the carelessness of being that deeply in love with someone, and the cruelty involved; then there was this dialectic between attachment and independence, its playing around with ownership, lack of ownership; boundaries, lack of boundaries; communities, the damage of communities; the value of tribes, the damage caused by tribalism. That's such a rich seam to mine in a film. There was an absolute certainty in my mind before I'd finished reading it that I wanted to get involved with it in some way.

I could try and disinter all the reasons why I felt that. I think that there is an enormous number of similarities in Michael's and my tastes, and in the way that we look at the world, and in our sensibilities,

insofar as he is an uprooted Sri Lankan man who's become a Canadian via England. I have a rather over-elaborated sense of being a foreigner in England. I don't know how true it is, finally, but I've certainly fed myself from that. When I was a kid, I was very conscious of the fact that we had a completely different culture to all of my friends. It was an extremely homogeneous society, except for us. There wasn't any kind of mixture, and there was no pluralism at all. That made me feel intensely foreign, in a way that, I think, Michael has always felt intensely foreign. I've also been very interested in nationalism – what it means to be nationalistic.

The English Patient fed all kinds of interests I have, not least the fact that it was essentially a poem disguised as a novel and was enormously lyrical. And like a lot of readers, I fell in love with it. I don't think it was very complicated. There is a kind of greed which takes over, which is: 'I don't want to let this pass.' That's how I felt about that book: I didn't want it just to be something I read along with everybody else. I felt greedy enough to want to attach myself in some way to this beautiful thing.

In the process of adapting *The English Patient*, I defaulted to a method I had used for television. The *Inspector Morse* adaptations were largely inventions in that, apart from the first book, *The Dead of Jericho*, all that was really useful was the central relationship between Morse and Sergeant Lewis. I had to riff off that relationship and come up with some sort of plot. It was a vehicle for a character. So it wasn't perversity on my part to try to reimagine the events of *The English Patient*. They simply had to be reimagined because they were so deconstructed in the novel. The book is more of an extended poem than it is a conventional narrative. I loved the book, but the book has characteristics which are in many ways absolutely resistant to film adaptation. What you would normally do would be to boil off all the flesh of the narrative and have a look at it and see how to lay out the story. In *The English Patient* there really isn't a story; whenever I sat and contemplated the design, it just got more and more discombobu-lating. The qualities which make the book so interesting – the decentralized narrative, shifting points of view, shifting chronologies, glancing evocations of place or thought – are all enemies of storytelling in terms of the film narrative. They resist it.

The book also focuses on different chronologies which are not related to each other. You can be with Kip in England with a whole set of hermetically created characters whose stories don't impinge upon other narratives at all, so you can't join them together. One group of

people live in England, work in England, act on Kip in England and then you don't meet them in Italy. Another set of characters are in Canada, and the film would ask you to make attachments to those people and then forget about them. There would be no continuity or coherence if one were to set about the adaptation in a conventional way; the material would be like sand, it would just all fall through your fingers.

I wrote fifty pages of Kip's life in England in the first draft and invented a huge amount. It wasn't simply collecting what was in the book; I actually expanded on what was in the book, found new characters and new events and was very happy with a lot of what I was doing, but I knew it wasn't a film. I had needed just to start writing, because initially it's like those paper worms that you put in water which then expand and fill the glass: as you took these pellets of ideas they expanded in order for you to make sense of them and turn them into stories. The screenplay was in danger of becoming even longer than the book, rather than a concentration of it.

Michael Ondaatje is the most delicious person I think I've ever met; the most self-effacing and elusive and mysterious character who would flit in and out of my life, and still does, with no assertion of ego whatsoever. So he often felt like a stranger to his own book; his modesty about the book, his advocacy and respect of the screenplay was absolute. He would talk about the film like a stranger to it, rather than as somebody who owned the ideas and the people. That was incredibly liberating for me.

We'd go to Saul Zaentz's place and go through the screenplay together. Saul is not an intellectual in the sense that he's not somebody who's going to analyse the scenes. We would just read the scenes and talk about them. He would say, in an extremely intuitive way, 'I don't like that, that's boring,' or 'That's great, don't ever lose that.' Michael would benignly sift through the script with me, never, ever arguing with an idea or defending the novel. There was no ego. Saul had these mantras, which, at the time, seemed rather nebulous or self-evident: 'No me, no you, just the film.' But he believes that and he insists on it and has a very good antenna, a nose for good faith. If he feels there's a manipulation or something that's not properly grounded, then he will go at it remorselessly. I loved that. There was never a time when I felt beaten up: sometimes you go to a script meeting as a writer and within ten minutes you feel like you could never write another word, even with people who like you and like the material. The process of examining the screenplay is annihilating. In *The English Patient* the process of

examining the screenplay was always empowering and always positive.

With *Ripley*, I loved the character more than I loved the book. That may be ultimately why the film doesn't work. It certainly explains the whole access to the adaptation process. I'm still trying to make sense of the novel, which I felt was very much of its time and showed its age a little bit. You get the impression from reading Patricia Highsmith's novels that she wrote the books very quickly; that in the fifties she didn't consider herself to be an important writer and that she was financing her life through her books. This is speculation. But the book isn't, to me, particularly carefully written or constructed. What it does have is this absolute authority and atmosphere and the ability to conjure up a world that she clearly knew. She was living in Europe at the time, and you could easily extrapolate from the novel that there were correspondences with her own experience in Europe. You feel like there's very little skin between Ripley and Patricia Highsmith in the way that the character observes the world. I know he's her favourite creation. The sense of anomie in the novel seems to be in every one of her novels.

I'm sure if I looked again at Camus, I'd find some real correspondences with that book: the person always on the outside of things, on the outside of society. It's a necessary condition of the American in Europe. The American is never going to be entirely at ease with European cultural life and will be creating a life over the top of that existing culture. So there's the American set or the ex-pat set over an existing culture, which is one of the tensions and most interesting aspects of the book: how foreigners make their life in a strange country.

I loved the tone of the novel: airless, alienated, uncomfortable, claustrophobic, lonely and also quite harsh. All Highsmith's books are rather judgemental. Her characters are adjudicated by the way they order a drink, the kind of drinks they order and their sense of form. Although she was an extremely eccentric woman who notoriously kept snails in her handbag, she seemed quite short with people who didn't know the right jacket to wear or what time to have a drink. That really spoke to me. I'm sure it's also the same reason that Hitchcock was so intrigued by *Strangers on a Train*. The ideas in her books, irrespective of the way that they're realized, are always dangerously filmic. The idea of two strangers on a train meeting and exchanging murders; the idea that a man could want another man and his life so badly that he would kill him and exchange his life: those are very strong and rather mythic narrative ideas.

Ripley has a sense of self-loathing laced with hubris. It is a strange contradiction that he dislikes himself and, at the same time, thinks that he's superior to a great number of the people he collides with, which I think is a very common conundrum of personality. He feels unworthy and yet more worthy than a lot of people he comes across. That's a rather unholy cocktail. At the heart of Ripley is a yearning for all the things that he is and all the things he'd like to be; there's such a longing to experience. He keeps putting himself in front of objects, art and music to try and experience them. If you read the book, you'll see that he has great taste, but somehow he struggles to feel.

In the novel, Ripley has premeditated the murder of Dickie, and everything is about how he can organize an opportunity that gives him enough cover to kill him; for me – and this was my major departure from the novel – the reverse had to be true. The centre of the film was this idea of a child who spills a glass of orange juice on a tablecloth and tries to cover up the mess with a cup, which he knocks over, and then there's broken crockery on the floor, so he tries to sweep it into a corner and cuts himself, and so he tries to find a bandage and eventually ends up setting the house on fire because it's just this accumulation of one mistake.

Ripley's lashing out at Dickie was intended to stop what was coming out of Dickie's mouth, which was so lacerating to Ripley. What Dickie describes is Ripley's worst sense of himself: 'You're boring. I've seen enough of you. I don't love you. You're a mooch. You just hang around, you know that. It's boring.' The things that you least want to hear are those things most true about yourself. So it was imperative to me that the moment when Ripley hits Dickie wasn't intended to be a lethal blow of any description. If it had been a newspaper in his hand, he would have flung the newspaper at Dickie. If it had been a glove, he would have thrown a glove.

In the scene where he's alone at Christmas giving himself presents, you see there's nowhere for him to go. He goes from basement to basement; that's one of the reasons why I tried to evoke this idea of somebody in a basement who's frightened of his own basement, of his own demons. And that's not in the book. There is no such remorse in the book. But, to me, it's what gives the film its meaning.

The Talented Mr. Ripley had already been adapted and mangled rather well in another version – René Clément's *Plein Soleil*. His version subverts the three things which are the foundation stones of the book: an American in Europe, an American who commits murder but is not caught, an American who so hates himself that he wants to trade

himself in for somebody else. So when you cast Alain Delon as Ripley, it's very hard to imagine him ever wanting to be anybody else, particularly as everybody who watched the film wanted to be him. And he's not an American in Europe, he's a French man in Europe. He also gets caught by the police at the end. So it gets those three things completely wrong in terms of the novel and yet is extremely interesting as a movie, which only goes to show that they're not the same thing and proves Robert Bresson's observation that if the work of art in the process of moving from one medium to another carries with it any of the qualities of the previous medium, it can't succeed in the other. *Plein Soleil* is a perfect example of a film which flies in the face of its source material and somehow has a life all of its own.

When approaching an adaptation, in the time that goes by between first reading the novel and writing the script, I imagine the primary scenes again and again. In however desultory or random a way, there is no moment I haven't thought about already before sitting down to write. There are some discoveries and some surprises. The actual construction of sequences often completely renavigates the route you thought you were going to take through the story but, essentially, the moments of the film are already known to me so writing them is not so much working in the dark but meeting old friends.

With *Cold Mountain*, when I first started writing an Ada and Inman scene, I could imagine a sort of mental constellation. I could imagine gestures and movements. The dumbshow of the film was clear to me, but how they would talk to each other, what kind of music they would make was completely unknown before I began to write. The duet of them, the music, rhythms, the spikiness of Ada, the taciturnity of Inman, what alchemy there would be between these two instruments was unknown.

I was elated, when I began to write Ruby, Veasey and Stobrod, that there would be some relief in the film from the rather relentless difficulties, cruelties and sadnesses of the story. There is an exciting change of rhythm and pace when you encounter characters that have vividness. The most impressive achievement of the novel, is how fresh its characters are. I don't think I have met Stobrod before, I don't think I have met Ruby before, or Veasey. I shouldn't include Inman and Ada because I think Inman, as his name suggests, is 'everyman' and I think Ada is an idealized type of civilized woman. But the characters who augment their story are wonderfully distinctive. I had to take these defined characters, rearrange the way in which the story is revealed to us, improvising with characters that someone else has created.

The hardest things for me to write in film are often the things that end up being the most important – the intimate moments between people, getting the details of the central characters' exchanges correct. When I say 'exchanges', I don't mean dialogue; I mean their dramaturgy, getting the architecture of their scenes correctly in place.

In a good novel there is, as it were, a freeway and all sorts of side roads. Often the side roads are more satisfying than the freeway. In *The English Patient* there wasn't a freeway at all and I had to invent one. In *Cold Mountain* there are a hundred side roads, but there is certainly an overarching narrative of a man returning home to a woman who is waiting and changing. However, many of the novel's marvellously rich characters are introduced in their own parenthetical narratives. For example, Stobrod's story of how he was a six-tune fiddler who becomes an encyclopaedia of music and a reservoir of invention is a very urgent story in the novel but has nothing to do with the main, freeway narrative. I had to resituate it. A lot of the business of adaptation is mathematical; it's like music, you just have to get it in there. If you don't meet Stobrod in the first few scenes, you are hard pushed to find out when you *can* meet him before he turns up at Black Cove Farm.

What I do, if you were being crass about my style or technique, is raid the book for events, fillet the book's key moments and then redistribute them amongst key characters or new characters in a tighter structure. I'd like to dignify it, but that's probably what I'm doing. Or I try to take one illustration and use it to gather in a whole series of events in the book. Repetition in film is really, really dangerous. You can have repetitions in novels, which intensify your pleasure, but in film it feels like treading water. What film likes is visual rhyme and not narrative rhyme.

When adaptation works it has a wonderfully symbiotic relationship with literature. Instead of stealing from the literature it actually nourishes it, it invites an audience to go back and look at the book in its original form. It happened with Michael Ondaatje and *The English Patient*, it happened in a really spectacular way with *Ripley*. The books are back in print, and there's a lot of talk about Patricia Highsmith now as a significant and very substantial novelist of the twentieth century, whereas when we started working we couldn't find a copy of *The Talented Mr. Ripley*. I'm not claiming any credit for that; it's just the nature of film – it shines a light on the source material and in the best situations it can revive an author's reputation. So I think any anxiety that readers have that somehow their wonderful novel's

going to be squandered by the crassness of the movie world has no legitimacy because quite the reverse happens. In the best circumstances, the film breeds a reading audience – and not only amongst fans of the film.

Adaptations are like John Coltrane playing 'My Favourite Things'. It's the same song, but it's not. It's John Coltrane. I want to believe it's possible to take a tune like *The English Patient*, *The Talented Mr. Ripley* or *Cold Mountain* and personalize it completely, without it becoming destroyed in any way, or diluted. There can be an equally rich experience that's particular to film and which isn't just genuflecting in front of a piece of literature.

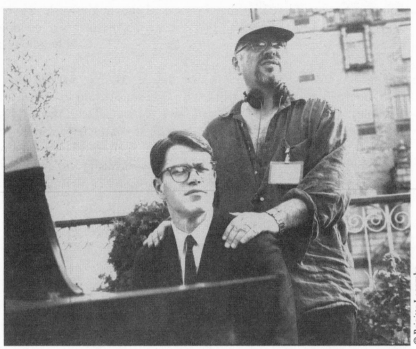

AM and Matt Damon as *The Talented Mr. Ripley*

Charles Frazier, producer Ron Yerxa and AM, *Cold Mountain*

Jude Law as Inman. *Cold Mountain*

© Brigitte Lacombe

Research

I am absolutely dependent on research. One of the great joys of being a film-maker is the obligation to keep learning. I think I have often elected to fall in love with projects because of a profound ignorance about them.

My obsession with research is also, finally, about avoidance. I was on holiday some time ago with my family and a friend. It was a very sunny place, and we had a pool. In the morning, everybody would go down to swim: my son would go running in and dive bomb the pool; my wife, who is very elegant, would sort of slide into the pool and go up and down; my friend would do a beautiful swallow dive; and I would walk around and around and around, contemplating. Then, eventually, when everybody had had their swim and gone, I would get in and stay in for a very long time. That's how I am as a writer: I can't just belly-flop in, I have to keep plodding around and around the subject until I feel I know enough to start.

When I do start to write, I'm quite quick. But the research process is really one of just getting the courage up to go in the water. You can't have any instincts about anything unless you're educated. There is a whole mythology of what instincts are, but I believe they are entirely educated activities.

When I began work on the screenplay of *The English Patient*, a number of things were completely evident: I was completely ignorant about Egypt, had never been to a desert, couldn't use a compass, couldn't read a map. I remembered nothing from my schoolboy history lessons about the Second World War and embarrassingly little about Italy, my parents' country. I promptly borrowed a cottage from my friend Duncan Kenworthy in Durweston, Dorset. I loaded up my car with books (I began adult life as an academic and nothing gives me more pleasure than the opportunity to tell myself that reading is a serious activity). I waded through eccentric books on military history, letters and diaries of soldiers in North Africa and southern Italy, pamphlets from the Royal Geographical Society written before the war. I found out about the devastation visited on my father's village near Monte Cassino, and discovered that we had a namesake who was a partisan leader in Tuscany. And I learned about the incredible international crucible that was Cairo in the thirties. I felt that I had been drowning for a while under the task of trying to adapt the novel, and

all this information helped get my feet on the ground. I hadn't been planted in any way and, until you're very firmly set, it's very hard to begin.

The one book I didn't take with me was *The English Patient*. I had been so mesmerized by the writing, so steeped in its richness, that I decided that the only possible course available was to try and write my way back to the concerns of the novel, telling myself its story. I adopted the same practice when adapting *The Talented Mr. Ripley* and *Cold Mountain* as well.

I emerged from my purdah with a first draft of *The English Patient* of over two hundred pages (twice the length of a conventional screenplay). It included, even after my own rough edit and much to the bewilderment of my collaborators, episodes involving goat mutilation, scores of new characters and a scene about the destruction of a wisteria tree in Dorset, which I swore privately would be the most memorable in the film. Needless to say, none of these inventions survived to the first day of principal photography.

The process of creating a visual language for the film is largely done through reference. I have tried to accumulate and compile as much photographic source material that I can find for each of my films. For *Ripley*, for example, I pulled images from books with photographs from the fifties and found documentary material from which I could pull images that seemed to me to have something to tell us about how to approach the film. I ended up with a book of photographic references which I showed to all the principal collaborators – to John Seale (the director of photography), to Roy Walker (the designer) – so that we all had a way of isolating certain things that I liked: for instance, being able to say I like the way that people are walking in that photo, or I like the way that people are sitting in this one.

Whilst researching *Ripley*, I also went back to Fellini's *I Vitelloni* and *La Dolce Vita* and watched them very carefully, particularly for the human landscape of the films. I felt that one of the tortuous, tormenting things for Tom Ripley about being in Italy would be that there's a way that men behave with each other there which would be so tantalizing to him and so elusive – men hold hands in Italy, men walk with their arms around each other, men touch each other in places which would provoke a fist fight in England or in New Jersey. There's a very famous Cartier Bresson picture which I allude to in the film, of a man sitting on another man's knee tugging at his tie. I quote that photograph very clearly in the film because, at that moment, Ripley feels dissociated from Dickie and would be terrified to touch

him in that way. And yet, sitting outside are two people who quite clearly feel comfortable about caressing each other while they're looking at a woman. It's the confusion of sexual signals and of physical signals which would have made Italy so tantalizing and terrifying and exciting to Ripley. That was the world I really wanted to create.

With *Cold Mountain* I knew nothing about the American Civil War. I knew nothing about that part of the world – which shamed me into thinking, 'Well, maybe I could learn something about that now.' It was, again, an opportunity to plunge into a lot of books, to be allowed to listen to a whole new world of music, which, of course, is one of the key elements of *Cold Mountain*.

I also liked the fact that it's very palimpsestic as a book. It is written over a series of personal documents from the Civil War, as well as Homer's the *Odyssey*. It has many, many layers, which you can fiddle around with as a film-maker. So I went back to the *Odyssey*. I went to the Bible. I went to a lot of medieval journey stories, Everyman stories, *The Pilgrim's Progress* – anything to feed and to nourish the undercurrents of the film.

The first major battle of Kurosawa's *Ran* is accompanied by music, and all the other sounds are taken away. You see people floating around in this awful ritualized warfare. The idea has suffered a whole sea of copycat use, for example in Oliver Stone's *Platoon*. I had similar ideas about the beginning of *Cold Mountain*, but they were theoretical and rather detached from the storytelling. I had been looking for a way of earthing those visual ideas to something properly narrative. When we were researching the real battles in which this fictional character receives his wounds, we began to read a lot about this enormous crater that was caused by the Union army burrowing under the Confederate lines, making a tunnel, putting a huge amount of explosives under the ground and then blowing it up. Unfortunately, there wasn't a great deal of coherence to these schemes. Having made this enormous crater they didn't quite know what they were supposed to do with it. The Union soldiers flooded into the void, which was thirty feet deep, couldn't get out, and were massacred by the Confederates, who turned their mortars into this crater and obliterated the Union troops. The Confederates then charged into the hole and a great deal of carnage ensued. In the novel, this is the battle where Inman receives his wound and it occurred to me that it could be, literally, the 'big bang' at the beginning of the film. Audiences love the lighting of a fuse in films, both literally and metaphorically. It is exciting to see the beginning of something and then anticipate the end result. Also, if you were going

to have your fill of this war, as Inman does, then this would be the event that would satiate you. It was a disgusting event to have been on either side of, and it is evident that there were many Confederates who were shocked by the carnage. There are descriptions of soldiers slithering in the viscera of people's organs and layer cakes of bodies. I felt that if I managed to shoot that correctly, then the audience itself would be satisfied that they had been to war and would not want any more of it.

Cartier Bresson, *Naples 1960*

The reference to Cartier Bresson in *Ripley*

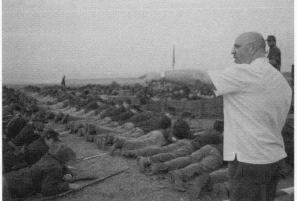

AM directs the Union troops at the Siege of Petersburg, *Cold Mountain*

3

Preparing

Pre-production is all about communication. Besides the screenplay, you have to begin sharing the images and thoughts you have in your mind about the film with your team.

There's a day when I sit down with Steve Andrews, the first assistant director, and he says, for example, 'OK, we're in the Piazza di Spagna for three days. How many extras shall I call in that morning?' And I can say one or one thousand. So then what you do is just sit with your eyes closed and you play that scene as you imagine it might be staged, and imagine the size of the shot and imagine how many people would make sense in that shot, and make a calculation which then is subject to all kinds of vicissitudes of budget, availability and everything else. But you have to populate the film from scratch. There's nobody there until you say, 'I want seven priests.'

There's a shot in *Ripley* where a group of nuns walk down the stairs. The director has to say, 'I want Ripley to walk up the Michelangelo steps next to the Campidoglio while three nuns are walking down.' You have to find those images in your mind, then populate them.

Here's a perfect illustration of the requirement for clarity of communication for a film-maker, particularly a writer–director. In the screenplay of *Cold Mountain*, there was a scene where a series of killings take place in a clearing. In the heading I called this clearing 'The Killing Field' without really contemplating why – obviously in relation to Cambodia, because it was a scene of some carnage. In the actual text I described very carefully that the location is a clearing in a forest; however, when we got our first batch of photographs from the scouts who'd gone out, there were a lot of pictures of fields. They had photographed fields because they couldn't get past the word 'field' into the text of the stage direction. I was totally bewildered. I said, 'Why are they photographing these fields? It's up a mountain, this scene.'

And then I realized what it was. I went back and looked, and of course, it's a terrible scene heading. But it only reminds one of the requirement to be as clear as possible. When I go to make a film, particularly if I've written my own screenplay, I know everything about the movie. I know, because I've seen it from every angle in my mind as I'm writing. It's impossible to underestimate how much of that can stay inside you and not get onto the page or not get into a meeting.

Location and Design

I've been blessed to be able to work with some of the great production designers: Stuart Craig and Roy Walker are both magnificent designers, both of them British, both of them with a long history of really important pieces of production design, both of them splendid collaborators and instructors. Stuart took me to design school on *The English Patient*, just as Walter Murch took me to editing school and John Seale took me to cinematography school on that movie. And, continuing this run of good fortune, on *Cold Mountain* I worked with the designer Dante Ferretti, whose work with Fellini, Pasolini, Scorsese, Neil Jordan and Terry Gilliam are all astonishing pieces of production design.

One of the things I will retain from *Cold Mountain* – and want to employ again if I can – is the rigour with which Dante insisted I was involved in the creation of the world of the film. It wasn't enough that I went with him and tried to imagine where we might build a house or a barn, or what shape the farm might be, but he insisted that I physically staked out the plots and staked out the rooms and witnessed the development of the construction. I began to imagine how it would be shot, as the buildings progressed, and was able to change the layout of a building as a process rather than theoretically, so that on many occasions we would visit the Cold Mountain Town site, view the putative layout and move the church twelve feet or move the Castlereagh General Store up two buildings.

It would be galling sometimes that he would demand that I constantly revisit these locations and be actively involved in the growing of them. However, it was a fantastic insight to be obliged to participate in the creation of those sets. We would shift and move buildings with a viewfinder until we could imagine that certain key events were perfectly aligned. I was creating a shot as well as creating a location. I can remember standing outside on a plank as if I were Inman looking inside the window to see Ada playing piano at Black Cove Farm, trying to triangulate the position of the piano and the window on what was essentially just a piece of Romanian hillside, but then imagining Ada at the piano looking down on Monroe, through another window, who would be sitting outside at the table before he dies. All we had was a green field and some tape, but it made me keep visualizing the film and not simply flexing into the shapes that had been given to me and then

trying to work out how to shoot. That's one illustration of the efficacy of that process but another would be Sara's cabin, which seemed to me to be such a straightforward piece of design, but then as it was being built I realized that we had a great opportunity to create a moment between Sara and Inman by putting an interior window between her cabin and the corncrib so, as she was getting into her bed, there was a direct relationship between her and Inman getting into his. As Inman is trying on the clothes of her dead husband, she is undressing, and there's a little exchange through this square window which became enormously valuable (you could feel the proximity) and wouldn't have happened had Dante not required me to visit this wooden structure so many times. He made me focus on being there with actors and what we could get from it. So just on a practical level, his method of collaboration was one that I found very useful.

The other thing that was exhilarating to me about our collaboration was Dante's refusal to refuse. He always wants to say yes and to find a solution, however absurd the request might be. Here's an example: Inman, after the shoot-out with Teague and his gang on the mountain, rides off after the fleeing Bosie and finds himself stalking Bosie through a copse of trees where it is difficult for them to get a clear view of each other. Because of the usual contingencies which obtain when you're shooting – bad weather and trying to remain on schedule, in this instance – our ability to run a set too far from the home base got increasingly difficult, so we consolidated the locations, bringing them closer and closer to the hotels and the infrastructure of the production base. When I went to re-scout the location for this scene with Dante, I realized that images I'd had in my mind for some time were not going to be possible because there were so few trees. We'd already developed the area by creating access roads, fake snow and tracking lanes; for every single external location we had to do quite extensive preparation. So, two days before we were due to shoot, it was clear to me that the shots I wanted weren't feasible simply because there weren't enough trees to interfere in this choreographed exchange between Bosie and Inman. The idea I'd always had was that the camera and the horses would be in this tripartite dance where the cameras would be always moving between trees and the horses, so you'd get this sense of stalking. It was such an important duel, the equivalent of the one in the middle of town in *High Noon*. Dante and I discussed the notion of creating a couple of artificial trees that could come between the camera and Inman or Bosie. He scratched his head and said, 'Well, we'll try and build two or three trees but there's so little time,' and we had

nothing else to shoot so there was no delaying this sequence. So we left, with Dante going off to think about whether he could make a couple of trees that could be moved quickly – full-size trees which would have to be moulded, built and then painted perfectly to fit in with the ones that existed. An hour after that conversation, Dante called and said, 'I've thought some more, maybe we could make four trees,' and four hours later he called back and said, 'Well, actually we can make six.' And two days later, when we showed up on the set, there were eighteen of these movable trees – which meant essentially I had thirty-six because I could use them on the reverses – and they are absolutely indistinguishable from the real trees, so much so that I couldn't tell you which ones they were. The scene is beautiful because of that contribution, and I have no idea of the pain he had gone through to create them.

He's buoyant and positive in his way of working. I think it comes from enormous experience of very demanding directors, so he's very used to having to pull rabbits out of a hat with no notice; he's come through the quixotic and capricious appetites of Fellini, who would ask for sets to be redesigned on the day. I guess, in comparison, I was very easy to deal with. I've only given you a simple, practical illustration of his design energy and stamina, but beyond that, what goes into his design – which begins with the most extraordinary paintings – is meticulous, perfectly realized and so cinematic.

The design of a film cannot be random; it has to be about storytelling. I remember having an argument with Bruno Cesari, who was the marvellous and really brilliant set decorator on *Ripley*, but who had such a developed aesthetic of his own that he found things ugly or beautiful irrespective of the meaning of their role in the film. So he would say, 'That is not a very pretty thing. That's a distasteful item.' And I would say, 'Well, it's a distasteful moment. Don't confuse beauty with what the film requires, with the film's beauty.' A film can be beautiful with ugly things in it. When we were decorating Dickie's house, he would say, 'Why do you want to keep that? Or why do you want that? And why are you asking for a dentist's chair? Shouldn't you be having something that is more elegant?' He found it very difficult to understand that it wasn't about decorating the film, it was about storytelling. And eventually – because we'd not worked together before – we found this place where his superior aesthetic met my clumsy insistence on story, and we helped each other.

It didn't surprise me to discover that we'd used the same places in Italy for Mongibello that the René Clément film had. Notwithstanding

the fact that we'd trawled up and down the Italian coast, we ended up arriving in exactly the same places that they did, or rather similar places. I had a filling drop out when we were shooting and went to the local dentist in Ischia Ponte. As the dentist was putting me in the chair, he said, 'Oh, maestro, welcome to this chair. Thirty years ago Alain Delon lay here for an emergency dental treatment when he was shooting *Plein Soleil*.'

That was the first time I realized that *Plein Soleil* had been shot there. In fact, I then disputed it because one of the reasons we chose the location was for this landmark of the castello at the end of the peninsula, and I couldn't see it in *Plein Soleil*. But I was wrong – they just didn't use it. I think that teaches you something, just apropos of making a movie. If you are making a period film, instinctively you collect landscape to reinforce period. It doesn't mean you go around looking for something which dates the film, but if you are making an American film and you are shooting in Europe, Europe becomes fascinating to you. So you do two things: one is to look for period information, and you also look for ur-European images and textures. They are fascinating. As a British director in Italy, every time I see something which looks to me Italian, something which separates itself from my own cultural experience, I want to photograph it. If you are making a contemporary film in London and you're British, you don't do any of that. You don't feel you have to collect London because you live in London. So your antennae don't whirr around ur-London architecture. You don't feel any obligation in a contemporary film to date the film. You're just shooting. *Plein Soleil* wasn't photographed for the period because it was contemporary. So it had no interest in cars, scooters, shops. There's very little period information in the film and there's very little geographical information, because they weren't selling Europe to themselves. Which is not to say that I felt that my obligation was to sell Europe to American audiences, it's just that I'm absolutely fascinated with Italy and that period.

I don't like the idea of decorating the film with a landscape: taking a story and throwing it up against a beautiful landscape, as if you could take a story and set it anywhere and it would be exactly the same story, just with different scenery. On the contrary, I think the scenery has to impose itself on the narrative. The landscape of the film has to bite back at the storytelling. *Ripley* is a good example of a film where the landscape bites back at the story, interrupts the story. It's as if all of the secondary characters are insisting that there's another story to be told, it's their story and they matter.

I knew, of course, because of my reading and my visits to Italy, that there are various festivals of the Blessed Virgin and that the more remote parts of Italy have the more exotic festivals. There are all kinds of wonderful, vivid manifestations of the worship of the Virgin Mary, particularly as an intercessor: for harvests and safety and community aims. I suppose that what happens is that when you come to try and make those things in films, you're dealing with speculation, with dim recollections of historical events and photographic references, with recollections of your own participation in festivals. When I was a child, I was involved every year in the Corpus Christi festival as an altar boy. There was a parade through the streets with the Eucharist, and I remember them being very important, rather exciting days. And when we found Ischia, I thought that it lent itself very well as a fishing port for a fishing festival – a festival of thanking Mary for interceding on behalf of the community for providing fish. I drew a little sketch of a possible way of using the location, with a circle of fishing boats and the Madonna being carried down from the church to visit the water, as it were, and then being returned to the church. And there was a ramp that seemed to accommodate a journey to a church, which you could just see on the horizon. So it all seemed to fit rather well as a staging idea, and often that's what you have to do when you find a location – you have to make the idea fit what you've got as opposed to fit what you hope for. It was all slightly smaller in scale than I'd ever imagined the geography of this place would be.

But I talked with Roy Walker about how we might stage this and how many boats we might need and what it would look like and whether it seemed deep enough for the Madonna to be walked up this ramp to shore. And that all seemed to work. I went back to Rome, and two or three weeks later, Bruno Cesari, the set decorator, arrived with photographs and a painting. The painting, done in a naïve style, depicted a religious festival in a small harbour, with a statue of the Madonna being taken to the water, where a small circle of boats waited for her blessing. The scene corresponded almost exactly to the sketch I had made. I was excited by this reference, and by the photographs, which showed a procession of a local community, led by a group of men carrying the Madonna on a palanquin down a ramp. When I asked where he'd found these references, he told me they'd come from Ischia, that the ramp was the very same ramp we'd selected.

From a production standpoint, it was an absolute folly to try and shoot in those metonymic locations in Italy. However much the film-maker keeps insisting on their production value, the obstacles to

getting a good day's work out of Piazza Navona or Piazza di Spagna are the same that would face somebody making a film in Times Square, in Piccadilly Circus, in the Place de la Concorde, wherever. You're dealing with a city which is working every day, which is at the centre of a communication system; people are commuting through these thoroughfares, which are the absolute arteries of cities. And when you want to not only shoot there but to try and make those areas conform to a period, you make things even more difficult for yourself. For instance, in the Piazza di Spagna, I can't remember how many outlets there are of shops and offices and who owns them and how you get access to changing the shop fronts to make them conform to a period, how many exits and entrances there are into the Piazza (I think there are thirteen). The depth of field in that place is huge because you can see right down the Via Condotti, which runs away from Piazza di Spagna. I wanted to see right down it, and I wanted to see right up the steps and beyond, and I wanted to see to left and to right. Because there's a 360-degree arena and it's all open so that you have to control visual information for such a distance. These things militate against the logic of trying to film there.

Nevertheless, it appealed to me enormously because the scene was written for that location. I needed to fit a lot of visual information in a frame – that was part of why I wanted to use it. Ripley's at the top of the sunny steps looking down on this event he's created. Meredith walks away and then comes back, and you can see her walking towards the café. I needed to have a café as a fixing point. It had to be an outdoor café so that Ripley could see what was going on. That already starts to limit the places you can shoot because obviously Ripley can't be standing across the street as he'd be too close. So you have to have distance, a place which has a good vantage point, and which has got something to say about Rome. I refused to believe there was anywhere better.

I handed Sandy Von Normann, our legendary line producer, an impossible task: to get the agreement of all of the people of the Piazza di Spagna to let me shoot there. In fact, what happens is that your film compass starts to reduce by degree after degree: you can shoot from north to north-east, from west to north-west; but not in the south-west quadrant between that shop and that one. In the end, there were only three stores that wouldn't let us make any adjustments to their façades or wouldn't let us shoot them. Often somebody walks away and they just walk out of shot because we couldn't pan with them. The production designer, Roy Walker, made a masking to create the café, but that

masking also hides a couple of store windows that we couldn't shoot. All of the staging had to fit into the available usable environment. So it became very tricky to shoot. Also, because he was an extremely pure and aesthetically refined human being, Sandy felt that to put a café in the Piazza di Spagna was a violation of the architecture, because it never had a café. Nonetheless we designed this café and called it Dinelli's because that was the name of the café on the Esplanade in Ryde when I was growing up. There were two cafés in Ryde owned by my relatives – one was called Spinelli's and the other was called Dinelli's – and they were landmarks of my youth. As with every name that you summon in fiction, a name has to have some meaning. It has one whether you know it or not. As I had Italian relatives and they had Italian cafés, I named the cafés in the film after them. So the café in the Piazza Navona is called Arcari's, which is my grandmother's name, and Dinelli was my grandmother's sister's name. The funny thing was that Dinelli's Café – which existed in Rome for seventy-two hours in total – quickly became a landmark, so much so that the night before we started shooting – when a lot of miserable producers were patrolling the location, wondering what on earth we were doing there, and I was trying to bring the look of the café to where I wanted it to be when we started shooting – an elderly lady ducked under the barrier and sat down at one of the tables. I went over and said, 'Excuse me, can I help you?' and she said – in Italian – 'I'm meeting somebody here.' And I said, 'Well, you can't. This is a set.' She said, 'No, no, no. I'm meeting somebody here for coffee.' And I said, 'There is no coffee because this is not really a café.' 'No, no, no I'm meeting somebody at Dinelli's at six o'clock.' 'There is no Dinelli's here. This is our set, we're filming tomorrow.' But she absolutely refused to move. We were painting and decorating this café around her. Sure enough, at six o'clock somebody came and met her, had a meeting and then they left. So it rapidly became what it was supposed to be – a meeting place on the Spanish Steps.

We had the same problem on *The English Patient* when we built a fountain in the middle of Pienza, Tuscany – a place we went back to shoot in *Ripley*. It is one of my favourite places in the world and has the most perfect square. We built a fountain in the middle of this square and, while we were waiting to blow it up, we went to have a last look – and people were sitting on the fibre-glass fountain, eating their sandwiches and having photographs of themselves taken at this memorial for an unknown soldier that we had erected the day before.

If you put a camera in front of events, you're not just collecting visual information, you're choosing the visual landscape that you are collecting. It's not simply that you show up, because showing up is not good enough. Stuart Craig taught me that more than anybody. He insisted that I stop trying to find things and instead tell him what I wanted to see. 'We're not going to find the location. You have to tell me what you want to see in the location and we'll create it.' On *Ripley*, Roy Walker would ask me constantly, not whether they could find what I wanted, but to describe what it was that I wanted, so that he could help me create it. There is no Mongibello. We have to create Mongibello. What are the elements? We drew a little map on a piece of paper together, saying we need this street and that square. We created a map which we then circulated to the art department, and found the locations to fit it.

It may seem that there's more of Italy, perhaps, in *Ripley* than the Italy that is there to photograph because there's an intensifying that goes on both with the camera and the design. There isn't the time to be wandering around the streets of Italy; you can only collect flashes: a bus journey, somebody walking across a square, somebody sitting in a café. You have to use those moments to compress and distil what it's like to be in Rome, what it's like to be in Italy. So it has to be more than Italian, more vivid – you have to smell the street, you have to have activity in the street which stands in for more than it can be without it becoming intrusive – which is why you get rather overexcited location work sometimes which tries to put every event in front of Big Ben or the Eiffel Tower. It is metonymic filming. You have to both avoid that ridiculous compression of geography with the panning and craning of ur-architectural signifiers, but, by the same token, the frame and the activity within the frame has to stand in for more than the film can show.

We shot the Naples jazz club in Rome and we went to Naples to shoot the Rome opera scene, because we couldn't find a jazz club in Naples and we couldn't find an opera house in Rome which had the right elements. So it's very bewildering, the way that films get put together.

The journey from Mongibello (which was Ischia) to the Rome jazz club (which was in Naples) was via Porto Ercole in Tuscany. It's not a journey that could be made by anybody. But funnily enough, when you see that stretch of road, because you think you're near Naples, everybody – even Italians – assumes they're looking at the Amalfi coast. But there's nowhere on the Amalfi coast which looks like the

Amalfi coast any more. Well, not to me anyway. So it's funny how this fictional landscape of film keeps coming up with both pragmatic and aesthetic reasons to rearrange itself.

A key scene in Ripley's stay in Venice is a visit to his conductor friend Peter's rehearsal of Vivaldi's *Stabat Mater* in the composer's own church 'La Pieta', a scene I wrote specifically because of the location. In fact, an earlier visit to a concert there actually gave me the idea of Peter Smith-Kingsley's character. Naturally, when it came to filming, the church became mysteriously unavailable. With the schedule tightening, we were faced with the prospect of having to shoot the scene in Palermo, Sicily, the next stop on our own journey. I couldn't scout a replacement church myself and had to rely on a hastily assembled selection of photographs. My eye was taken by images of the astonishing Byzantine gilt mosaic work in one of them: the four-teenth-century Chiesa Martorana. Its dazzling iconography of golden saints and angels seemed to offer a perfect backdrop to one of the film's few genuinely romantic moments.

We arrived in Palermo the evening before we were due to film only to discover that the mosaic work was confined to the rafters above the brooding monochrome of its walls. Everybody walked into the church, necks craning to the heavens. The movie camera's aspect ratio crops everything into its rectangular frame, and so there was no way to look at a person and see the ceiling. I have a compact with my cinema-tographer John Seale to resist panning the camera around locations in the manner of a travelogue. The actor dominates the frame and reveals the world of the film. It's a good discipline when filming in seductive environments. In this case, however, the church rehearsal would have photographed as if it was taking place in a large garage. The only solution I could think of, to the dismay of the production design team, was to take the performers to the mosaics. We built a terrifyingly rudimentary platform, and musicians and instruments were hoisted up. The camera has one eye; geography is only what the film establishes. Ripley enters the church and looks up to see Peter rehearsing Vivaldi's *Stabat Mater* in what appears to be an organ loft. The audience can't see the glue and bits of string creating this illusion, the worried faces of technicians, or the director. I was reminded of a still from Fellini's *La Dolce Vita*, which turned the camera round on the famous moment when Anita Ekberg cavorts at night in a deserted Trevi Fountain as Marcello Mastroianni looks on, beguiled. It plays as a moment of intimate spontaneity. Behind them was Fellini and his camera crew and about a thousand onlookers straining to catch sight of the proceedings.

As Dickie, Ripley takes a suite in the Grand Hotel. This hotel, close to Via Veneto, has one of Rome's few genuinely impressive hotel exteriors and lobbies, and so, for once, we were able to shoot an only semi-modified reality. But for Ripley's hotel suite we used the breath-taking interiors, frescoed and ornate, of the Palazzo Tiburna. The same building has a staircase of grim beauty, austere and colossal, like Escher's Möbius etchings. Here we filmed the halls and stairs of Ripley's Roman apartment, where bad things happen, while its evocative courtyard served as the exterior of an apartment belonging to Meredith Logue, a young heiress with whom Ripley has become improbably involved. It was possible, then, to walk out of a door, down some stairs and go outside and have passed through three of the movie's most significant locations, separated in the movie by weeks and miles. And so it went on.

In the end, the landscape that I put together with the help of Roy Walker in *Ripley* is one that has nothing to do with the real Italy, only with my Italy, my sense of what Italy is. It's very personal.

I had similar aspirations in *Cold Mountain*, where I wanted to play on the idea of Cold Mountain being both a real place and a Nirvana. In the same way that the Chinese poet Han Shan wrote about his mountain, 'Men ask the way to Cold Mountain / Cold Mountain, there is no through road,' I wanted to play on the notion that Cold Mountain exists but is also a spiritual goal. In order to hold off actually seeing Cold Mountain for the character's sake, I wanted to properly delineate Inman's journey across the state of North Carolina by beginning on the coast. I deliberately put the hospital on the east coast, as far away from Cold Mountain as possible. This also meant that I could have a much more incremental journey. I don't get to the mountains too quickly, and I can use some of the swamp territory near the coast. I wanted the film to feel as though it were moving. Films have so many literal difficulties: unless there is a change you feel like someone is walking on the spot. You can't go from one mountain walk to another or we would feel that we have come to the same place. We are very literal as viewers; we need to have new geography.

It was vital that Inman be seen to have a journey, so that we think, 'Gosh, he's really come a long way.' I wanted, also, to choreograph a sequence over time which gives us a weather inflection, a journey through the seasons, so the weather deteriorates and we end up with a sequence in the snow where the film brings all the pieces on the chess-board together. This all required careful planning, scouting and scheduling.

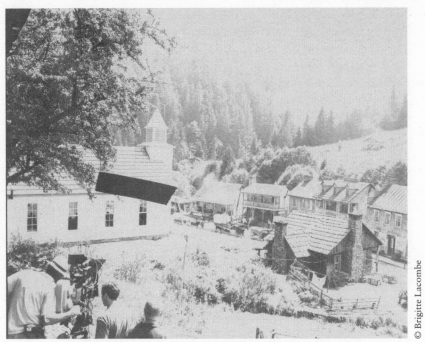

Shooting in Cold Mountain Town, built from scratch in a Romanian valley

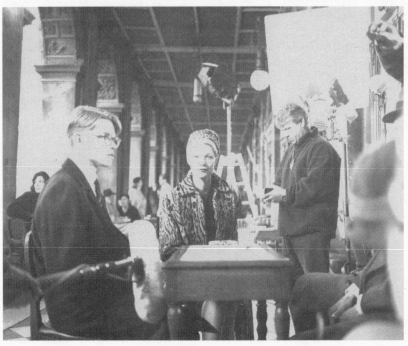

Shooting *Ripley* in Piazza San Marco, Venice

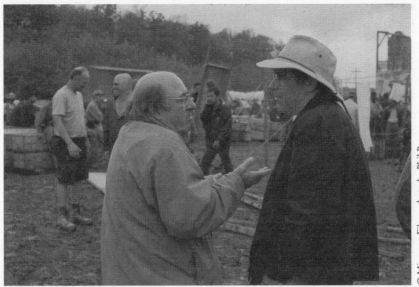

© Miramax Films, photo by Phil Bray

Dante Ferretti, production designer, talks with Bill Horberg, producer

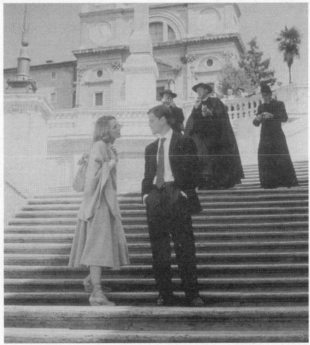

© Paramount Pictures, photo by Phil Bray

Priests on the Spanish Steps in *Ripley*

Casting

My casting choices are informed by an audience's reaction, not an artist's reaction. When you see an actress or an actor whose performance you feel captivated by, you believe that, if they knew you, there would be some spark between you and that something interesting would happen. I get very greedy when I see a great performance. If I see somebody being very good in something, I think, 'Well, I don't want to let that go by – I want to hang onto that in some way.' For example, I wanted to grab hold of Juliette Binoche when I saw her in *Three Colours: Blue*. I wanted, somehow, to get myself into a room with her and a camera and steal some of that.

Hollywood production companies, small or large, studios or independent companies, are defined by the taste of their owners. So, until your own reputation is sufficiently muscular to have a voice, your voice is heard as a distant mumble outside the cathedral. And the cathedral is where the decisions take place. You can think that you're going to cast A, but A has never even entered the cathedral as an option: there's another list, and everybody waits until you start to sing from the hymn sheet.

Despite the fact that, from the beginning, I always thought that *Truly, Madly, Deeply* was going to be a cinema film, what happened was, when people read the screenplay, they offered me the chance to make it into a theatrical film on the condition I changed the location and the cast – a common dilemma for all European film-makers. But I wrote it specifically for Juliet Stevenson and that, to me, was a given. Robert Cooper and Mark Shivas, the producers, both thought that enough people had read the script and liked it to give us a really good shot at an art-house theatrical release, although the BBC were resistant. The feature-film industry was in such poor shape in Britain that the BBC actually felt that it would have a negative impact on the broadcast if the film had appeared as a movie. It's the exact opposite of how they perceive things now.

With *Mr. Wonderful*, I thought I had an absolute free hand in casting, except that I didn't. I had all kinds of ideas about who might be in the film, but finally there was a small list of people who'd get the film made. In the end, *Mr. Wonderful* had a good cast, but it was a long way from where I began. However, at the time, to be allowed to work with any American actor just seemed crazy. William Hurt was

somebody I'd loved as an actor and I wrote him a note saying, 'Would you ever consider playing something in this film?' He wrote back saying, 'Yes, I'll do it.' I was very excited, overexcited to be taken seriously.

One of the few areas of conflict Saul Zaentz and I had on *The English Patient* was not on who to cast but *how* to cast. He's a great *bon viveur* and loves all the social aspects of film-making. I said that I was going start working on putting a cast together, and he said, 'When are we meeting actors?' I said that I didn't really want to work as a team when casting. I don't like meeting actors with other people and I wanted him to give me the room to find the people I really wanted; I wanted to talk about all of them and to collaborate with the producer on the decisions, but I didn't want to collaborate with him on the process. Saul said that he had made a lot of films, that they had been very successful and that he had been in every casting session of every film. He had no intention of changing. There was a real stand-off. Saul takes no prisoners at all; beneath his absolute equanimity is a fierce and extremely inflexible character. But, in the end, I cast by myself, but always in conference with Saul. Michael Ondaatje had some pretty strange and whimsical ideas about casting. My favourite: Rip Torn to play Almásy!

When I began casting *The English Patient*, I had no thoughts about the casting other than Juliette Binoche. I went to France to give her the book and asked whether she would be in the film if I managed to make it. I thought she was an astonishing actress. In *Three Colours: Blue* and in *The Unbearable Lightness of Being* there's something so magnificent, spiritual and honest about her that I wanted that quality in the film. So she was in my mind from the beginning, but Almásy and Katharine were very mysterious to me. Michael had only one stipulation, which was that Almásy should be a middle-aged man and that Katharine should be a young woman, straight out of Cambridge, in a very young marriage. So we began with this notion that we'd be looking for a man in his late forties, early fifties, and a girl in her early twenties. But we ended up casting a very young actor, who wasn't thirty at the time, and an actress who was a few years older than him. It was a process of meeting and talking and trying combinations. When you're casting you're not casting individuals, you're casting populations; it was all about how to make an alchemy from those various people. As I began to settle with one idea for Katharine, the Almásys would change, or an idea for Alamásy then the Katharines would change – it was a real hit-and-miss process. It resolved itself

finally, only after I had met Ralph Fiennes. I had been pursuing Daniel Day-Lewis very assiduously to play Almásy – another person I've loved as an actor and have tried to get into every film I've made. But he had absolutely no interest in playing Almásy; he wanted to play Kip because that was more of a journey and he didn't want to be in the centre of the film. So I was in a rather convoluted dance with him when I met Ralph in Los Angeles. We'd arranged to meet for a drink in the morning and I ended up spending eight or nine hours with him. On my way back to London to meet Daniel again, I thought, 'Well, actually, I've met the right person.' Everything about Ralph seemed to fit perfectly: his intellectual authority; the collision in him of delicacy and coolness; his profound Englishness; the fact that his family were so exotic; that his uncle was an explorer; that he was an artist and had a sort of shabby aristocracy which I thought was perfect for Almásy. That fact that he is also an austere, held, slightly unknowable person really interested me. Once I had settled on him, the possibilities for Katharine fell into place.

Every casting choice is only made sane by its complement, in the sense that your Inman has to make sense in relation to Ada, who only makes sense in relation to Ruby, who only makes sense in relation to Stobrod, who only makes sense in relation to Pangle. There's no point in casting scattershot. You have to keep a photo gallery in your mind, both literally, because you're going to end up photographing these people simultaneously, but also because you're going to have to get chords of performance and those notes have to harmonize in some way. And so, with Cold Mountain, I offered the parts of Ada, Inman and Ruby on the same day because, had one or two of those actors not been available or inclined to accept, it would have meant rethinking the whole casting process. That's to do with physical size, with age, with colouring, and also temperament. Of course, it's also to do with the economies of the industry; I had to deliver a cast that was substantial enough to justify the budget, and I had to deliver a cast that was consonant in terms of performing styles.

I'm temporarily in a place where I'm not entirely in thrall to the economic imperatives of casting and can really contemplate the world of the film. For example, I offered the part of Teague in Cold Mountain to the British actor Ray Winstone. When I was thinking about Teague I kept thinking of the performance that Ray gave in Nil by Mouth, which is one of the most substantial performances by a British actor in memory. His ability to conjure the terrifying brutality of men

coupled with an absolutely transparent and fragile sensibility, so that he made terrible behaviour horribly coherent and understandable, was one of the markers in my mind for how I might look for an actor to play Teague. I had met some well-known and very good American actors, until I thought, finally, 'Well, why don't I just ask Ray Winstone?' Notwithstanding the fact that we had another actor who wasn't a southerner in the movie, ultimately I wanted to cast the actor who was best for the role, not the actor whose passport most fits the role, and that's true throughout the film: a British actor playing Inman, an Australian actress playing Ada, an Irish actor playing Stobrod. But their spirits seemed most perfectly to voice the spirits of the characters that they're playing. Even an American actor would have to go on a journey over time and a journey over personality. There is no Teague, so somebody's pretending to be him, and once you've got pretence involved, the degrees of it seem irrelevant.

When populating the world of *Ripley*, one of the cleverest things we did was to cast a woman who had worked with the Polish theatre practitioner, Grotowski. So much of my own education had involved an obsession with Grotowski – reading about his work and watching films of his productions when I was a student – that just hearing his name voiced in a room made me want to cast this woman. Because of the physical training with Grotowski, I felt she would be perfect in a role whose impact on the film had to be entirely connected with a physical reaction. The actress, Alessandra Vanzi, is so marvellous in Silvana's drowning scene where she leads the charge into the water – which we did many, many times – and gave a signal to the whole community (of mainly non-actors) about how they should respond. It's an illustration of why there is no substitute for professional acting in films and an illustration of why I feel it is important to take such care over the casting of even the smallest roles. I needed someone who's as good as she is to come and yell and grieve, so that a hundred and fifty people could hear that noise, understand it and be influenced by it. When you look at the way the scene is constructed, you'll realize that she was heading the cavalry on that day.

Juliette Binoche in *The English Patient*

Costume

How people look is so much less interesting than what the look has to say about the film. You never simply find a lot of beautiful clothes for an actress to wear or give her a hairstyle that will look great.

I probably paid most attention to costuming in *The Talented Mr. Ripley*. It was such a useful storytelling tool. I was intrigued to find some way of suggesting that, in Mongibello, Dickie and Marge had deliberately absented themselves from being concerned with fashion, that they'd gone to a place where they could throw on a cardigan or a jacket with no regard for the social territory from which they came. Part of their remit in Europe was to pay no attention to their appearance. On the other hand, that particular casualness is predicated on extremely expensive clothes. Ann Roth, the costume designer, would suggest that Dickie's trousers were made on Savile Row, but he's left them in the yacht for a week, they've got salt water on them, they've shrunk and they've discoloured, but they're still great trousers. Most of us couldn't afford to wear the clothes he's throwing away. Dickie's clothes aren't from Marks & Spencers, and it's very important that you understand that. And it's important you understand that, every time Ripley sees a jacket, it's sexual in its allure to him. It's like a skin he wants to assume, wants to inhabit.

The clothes and look are only interesting insofar as they comment on the film's themes and arguments about making people look good. It's about how that becomes a part of the character's fabric, as it were. And so, because Dickie is so resolutely aiming at a lack of convention, we tried to dress him in cheeky clothes. You're aware of his body all the time. He's either taking his shirt off or he's only got one button done up and you're not sure if he's wearing any underwear. I kept talking about satyrs to Ann Roth and Jude Law. The idea of half man, half goat. He took that on physically. You're always aware of his hooves in the film, his ankles and calves. There's a moment when he's walking away from Sylvana when she's in the grocery store, and you're so aware of the bottom part of his body. So that was one of the things that we talked about for Dickie.

For Ripley, we talked about somebody who had seven things in his wardrobe, all of which were carefully laundered, carefully pressed and cherished because there was nowhere else to go. There was no choice. I'd always imagined he had a corduroy jacket, partly because of my

own awful memories of boarding school, a sports jacket that he wore at the weekend. I'd had a corduroy one and I felt that I should punish Ripley with that jacket as well. It's a jacket for all occasions and therefore not really suitable for any. Dickie, for all his disavowal of what people wear, is so conscious of the fact that Ripley's only got one jacket. It's like having a not very pretty friend. Part of what matters for Dickie is to be surrounded by people who reflect his own vanities, and he suddenly contemplates that Ripley's not unattractive, but he has that jacket, and that jacket's really not acceptable.

There's nobody better than Ann Roth to understand the absolute nuance of colour, the message contained in a jacket or the striation of class possible in a ring or a belt. Ripley, as Dickie, wears a belt that has to loop into the trouser, and I had to photograph that very carefully because I knew that this was a detail that Ann felt was something that Ripley had never experienced before.

If you sit down for a meeting with Ann Roth, she won't say, 'I think Cate Blanchett should wear green slacks.' In fact, she'll never talk to you about what the costume design's going to be about. I suspect she would like to withhold any information about the costume design until you see the actor or actress on film. I think her ideal collaborative experience with me would be that I have my eyes closed until I said, 'Action!' and then open them to be surprised by what the actors were wearing. I think she's trying to work with the actor as a director, as a film-maker. Her way of creating costume is to try and find ways into performance with clothes. She knows what wardrobe choices say about character and how you read people, that you're reading them as much as looking at them; you're reading social territory, you're reading aesthetic, you're reading attitude in every garment, in every colour choice, in every shoe choice. She is looking to collaborate with the actor as much as with me, to help them formulate a character position based on wardrobe. She has no interest in showing me a design for a dress. 'How is she going to walk into the room?' she'll say. She'll never let me engage on the level of 'What will she wear?' I'm so prosaic that I'll say, 'I think that she always wears trousers.' 'Why?' She'll want some psychological analysis. She'll want some history in the clothes. That's really what she's into, history. What is the story of these trousers?

And so part of the dance that I have with Ann is to try and get some sense of what she's doing before we begin shooting. The more I pry, trying to know a little bit more than I'm allowed to, the more resistant she is to my questioning. She's not interested in costume; she's

interested in film and what the film is about. She's interested in behaviour in costume. She is a great film costume designer, an extraordinary collaborator and human being . . . and fun.

Ann approaches design as a director, really; it's as if she's playing out a film by speaking only with clothes. If the actors were only sets of clothes walking about, you'd know everything about them by their clothes. So, the way in which a character is dressed will inform the performance. For example, with Ruby in *Cold Mountain*, she made these quilted, heavy, masculine outfits which made Renée – who is tiny – much squarer and heavier than she ordinarily is. Ann emphasized the difference between Ruby and Ada by making Nicole as long as she could and Renée as square as she could. So there's a big hat over a wide jacket, over a skirt, over a pair of pants – she fills out laterally – whereas all of the things she was doing with Nicole helped her grow vertically. I talked to Ann about Laurel and Hardy and other comedy duos because, finally, the film is the tragedy of Ada and Inman reflected in the romantic comedy of Ada and Ruby. Two opposites find each other, learn from each other and, eventually, love each other.

In the classically tragic story between a man and a woman – which is the Inman and Ada story – the film requires them to change so much that they don't recognize each other at the end. Likewise, Ada would not have recognized herself if, when she arrived in Cold Mountain, she could have seen the person she becomes. Nor would Ruby have recognized herself if, on her arrival at Black Cove, she saw the young woman who's sitting at the table at the end of the film. Happily, in *Cold Mountain*, the three central characters have enormous journeys to go on, some physical and some spiritual. And for the actors that's a fantastic challenge because all actors are looking for a journey; the worst thing you can say to an actor is that this character is the same in the last scene as they are in the first. The costumes in the film really helped to delineate those journeys and to tell those stories.

One of the things that I've learned to ask myself in every aspect of film-making is, What is the story? What's the story of these shoes? What's the story of this jacket? What's the story of this room?

AM talks to Nicole Kidman in costume as Ada in *Cold Mountain*

Ann Roth, costume designer, talks to Sydney Pollack on the set of *Cold Mountain*

Ann Roth dresses Nicole Kidman, *Cold Mountain*

4

Shooting

The Crew

I think of directing as an activity with a crew, as an activity as one of a company of people creating a film. But the conundrum is that it's also extremely authorial in the sense that without there being a defining view of the material – defined by one person – the film collapses. By the same token, if the film is the point of view of only one person, it also seems to collapse. Alchemy is achieved when each person is both individually making the film and collectively making the director's vision of the film. And that is very, very hard to achieve, because if there are fifteen heads of department and they've each got their own departments, and you are encouraging all of those individuals to make a personal contribution to the film, it's very hard to corral that into one single, coherent vision. Lots of the problems in film occur when the people are not making the same film; where there are actors in one film and other actors in a different film, or where the production design is not supporting the costume design, or where the camera's not supporting the production design. The task is how you cohere a group of people without inhibiting their own voice, because, chorally, their voices are more interesting than yours is as a solo voice. As a director you must always remember that everybody doing a job on the film is better at that job than you are.

Working with the producer Saul Zaentz, the thing I marvelled at was his confidence in me. He had no reason to believe I could make *The English Patient*, a film of that scale, but he had much more confidence in me than I had. And I felt enormously empowered by him. I felt that, if he had such confidence, there must be some basis for that confidence, so I should go and try to make this film. And he never let me, for one second, think that I was doing badly, which was very smart of him.

One of Saul's many gifts to me was to say, 'Don't be frightened of making this film and don't be nervous, but don't ever make the

mistake of surrounding yourself with people who are less experienced than you are – surround yourself with people who can help you.' One of the features of my films since has been the continuing relationship with a crew of extraordinarily talented individuals I have been lucky enough to carry from one film to the next.

Saul introduced Walter Murch (the editor) and Ann Roth (the costume designer) to me before I started writing *The English Patient*, both of whom he'd worked with before. He had recommended Steve Andrews (the first assistant director) to me on *Mr. Wonderful*. Steve had worked for Saul on *The Unbearable Lightness of Being* and *At Play in the Fields of the Lord*, so I met him in Los Angeles. It was a great meeting. He says that I was holding a bottle of water and a bottle of Advil – which I'm sure is true as, at the beginning of *Mr. Wonderful*, the headaches had started to come with increasing frequency – and he seemed like such a fellow traveller and so perfectly quirky and equally beguiled by the thought of making a film in America. On *Mr. Wonderful* I also teamed up with Dianne Dreyer (the script supervisor) and Mo Flam (the gaffer), who have also become absolute stalwarts of my film-making crew.

If I was trying to find somebody who could nourish me over the course of making a film and be my best friend it would be Steve Andrews. If I am Don Quixote, he's absolutely the Sancho Panza character, very stoic and indomitable. But he's actually more of a Don Quixote himself. He's an Australian war horse.

There's also Ivan Sharrock, the most splendid sound recordist, who has worked with me on *The English Patient*, *Ripley* and *Cold Mountain*. And Paul Zaentz, who is Saul's nephew and a producer in his own right. They are both more alkaline characters. I think it is very important when you have many quite vivid, strong and spiky personalities in a group that you have people who insulate; they're like cartilage personalities. Paul has a wonderful sense of how to provide cartilage in a film, to make sure everyone is looked after and that all the hinges of the film are well insulated.

Sandy Von Normann, who was the line producer of both *The English Patient* and *Ripley*, was such a pleasure to work with. I felt I had tapped into a lifetime of experience of film-making with directors I particularly admire – Fellini, Francesco Rosi, Visconti. I felt that, somehow, he was bringing some of that knowledge and style to bear on the way I made those films.

Saul was able to get John Seale (the director of photography) to contemplate making *The English Patient* with us. I'd tried to work

with John before, on *Mr. Wonderful*, but it hadn't worked out. I'd loved the look of John's films – *Witness* and others. By reputation and result he seemed exactly the right person to do the film and he was the only cinematographer I met.

So Saul put that crew together; I was just happy to see them all arriving and slightly daunted by them all.

I try to hand over a certain amount of empowering to all the people that I collaborate with. Most of us work best when we feel cherished. By the same token, somebody talked about making a film as like being pecked to death by questions. If nothing else, as a director, the one thing you have to exercise is your point of view a thousand times a day. You're colliding with a fictional world that you are responsible for creating, and every single constituent has to have a cup and a saucer and a chair and a table and a light source; the camera has to move to collect the action, the action has to be staged; the actor has to have hair of a certain length and colour, and skin tone of a certain level, and shoes of a certain leather; there have to be pictures on the wall or no pictures on the wall; the camera has to have a format; there has to be a determination about how many extras are going to go right to left, how many left to right, how many extras in total, what ages are they going to be, what gender are they going to be, what are they going to be doing. In each day you probably make a thousand choices, some of which you just don't make. You stop making them and get out of the way of choices. But that in itself is a decision. So I think that lack of confidence to say yes or no – paralysis – is a most common failing with directors.

There's a joke: how many writers does it take to change a light bulb? *Why does it need changing?* How many executives do you need to change a light bulb? *Does it need to be a light bulb?* How many directors does it take to change a light bulb? *I don't know. What do you think?* The root failing of directors is not to know their own minds. All they have to know is their own minds, and that's a very tough thing, because, on the whole, in life, we make very few decisions. We are marginalized from decisions most of the time. In creating a fictional world you are the author of it. It's three-dimensional, and exists in time as well.

I don't think you can ever bore people too much with sitting down and saying, 'The reason I want to make this film is because of this, and because of that.' I'm blessed with a level of collaboration where everyone is a film-maker – no one is there to be my servant. All of my crew are directors in some shape or form, and that's the best thing about

74

them. I always hope to achieve something which is much greater than any narrow scene that I can manage by myself. I want the biggest amount of brain and creative energy working on the film.

There's a story about shooting *The English Patient*. We were working for three days with a convoy and a lot of extras in a sequence where a jeep blows up in Tuscany. There were a lot of army people who'd come to drive the trucks and help us. At the end of the three days, one of them came up and asked me for my autograph. I said, 'Sure.' And he said, 'Are you one of the main directors on this film?' And so we all had badges made saying 'Main Director' because there were, obviously, a lot of creative minds at work on that film. And that's the best thing about film-making, and the hardest thing to do. I have a particularly strong-willed, emphatic and curmudgeonly bunch of allies when I go to work.

There's a great saying: 'When nine Russians tell you you're drunk, lie down.' I always think of that. If enough people say, 'That's a ghastly idea' – and I'm certainly capable of ghastly ideas – then it might be worth listening. You have to listen, and it's desperately important to find people whose opinions you can respect and value.

I've tried to find the people I think are best in their fields. I want to work with the person I think is the best cinematographer. I know I've got the best first assistant director. I know I've got the best continuity script supervisor. I know that to be so; to me, it's indisputable. I'll do anything I can to hang onto them. The team on *Cold Mountain* is exactly the same, apart from the production designer, as on *Ripley*, which was the same team that was on *The English Patient*. And many of those are now on their fourth or fifth project with me.

I've surrounded myself with people who are slightly tougher than my own particular temperament. I am, I think, the mildest of the group. I seem to need to have that noise around me. It's almost as if I need to be in a place where I have to prove myself to those people and satisfy them. They've made me do better work. They are a much harder audience than anybody who's going to sit in the cinema.

I can't imagine making a movie without Walter Murch. He's enormously hard on me. And impatient with me. And bored by what I'm doing. And challenging of me. That dialectic is what makes all of us go on. Walter, more than anybody, has taught me about film. I've spent so many hours in rooms with him now, and I've listened to him so much and admire him so much. I think he's one of the most import- ant film-makers in American film history. He's also done things which have made me crazy, about which I have walked out of the cutting

room. And he's walked out of the cutting room on me. We've knocked heads because it's such an intense relationship. We don't always agree with each other, and I hope we continue not always to agree. We've developed a system where I've got what I call 'The Lego Avid' in another room so that I can fiddle around while he is doing whatever he's doing. And I can make my own investigations of the film.

In post-production, where Walter is such a theoretical person, a person so profoundly cerebral in the way that he works as a film-maker, I'm happy; but when I'm shooting with John Seale there's, quite properly, an emphasis on practicalities – how to make the film, how to get through the film. I'm lucky that I've found a soldier to work with on set and a professor to work with after I've finished filming. If they swapped characteristics I think it would be absolutely catastrophic. The contemplation of editing suits very much the rabbinical qualities of Walter Murch, and the chaos and stamina requirements of shooting suit the soldierly qualities of John Seale – he's a leader in the sense that you feel he's got such tenacity and such determination to collect the film.

John and I meet every Sunday when we're shooting and talk about the next week's work, partly to establish what equipment we're going to need for the coming week. It's quite mechanical – Do we need a crane and what kind of crane? – because you have to order special equipment as you can't have all of it standing by every day in case you need it. They're expensive items of camera furniture. So each week there's a management session as well as an artistic one, where we talk about ways we might shoot a scene, how the light might work in a scene. He is very much a man who wants to talk about the nuts and bolts of the scene. His collaboration and wisdom are absolutely vital. He is not comfortable in the theoretical territory of film, but he's very good at talking about what the scene is trying to achieve dramatically, what's it there for in the film. And just as he extrapolates his light from natural sources, he never tries to fight the natural light source. He always tries to intensify, which is a wonderful technique. He finds where the light is in a room or on a location and works with it. So he will try and work from my articulation of what a scene is about and say, 'Well, wouldn't that mean we would want to have the camera move in part of that scene?' or 'Wouldn't it be that we'd want the camera to be still?' or 'Wouldn't it mean that we should be on longer lenses in the scene?' And often he'll come up with practical solutions to contingent problems, like we can't control all of the points of access on the Piazza San Marco, we can't do crowd control, but I want to shoot

there – what can we do? One of the things we can do, he'll suggest, is to use longer lenses which compress the depth of field, which means that less is in focus in the background, which means that if somebody does stray – as indeed they did constantly when we were shooting – then they become blurred background. That's a very clean example of how to cope with a day's filming. So he would guide me. I find him a really wonderful partner in that respect, but we're not going to spend a great deal of time talking about theory of film. And I like that.

The cinematographer, Remi Adefarasin, was a huge element in the making of *Truly, Madly, Deeply* and the fun of it. He has the soul of a poet. He turned out to be the most gentle nursemaid a first-time film-maker could hope for. I learnt a tremendous amount from him – his experience was vast because, as a BBC cameraman, he had shot almost every day for years.

There are blessings and curses attached to those long-term collaborations. The blessings are manifest, and most significantly connected with a shared language. Establishing a common language in which to discuss what begins, initially, as a dream or as some unarticulated vision is a difficult task. Essentially, the whole process of film-making is about one person communicating a vision to a larger group, and that larger group communicating that vision on to their own teams. And so the importance of a common vocabulary and a common syntax is very profound. When you're not understood, the consequences of that can be extraordinary. Obviously you can't supervise every element of the work that's being done preparing a film, so your vision is being carried like a baton from department to department. By the time the group shows up on location or in a production meeting or on a filming day, many decisions have already taken place. If they're wrong, it's very, very hard to unravel them. You rely on your own skills as a communicator, but also on the fact that you have a common language, and so obviously I am helped a great deal by the fact that I'm working with the same people on a return visit, as it were.

I've surrounded myself with people who are much better at what they do than I am, who on the whole are more experienced than I am, and none of whom suffer fools gladly. As I'm often a fool, I'm often on the receiving end of their lack of tolerance, for which I'm largely quite grateful. I've certainly borrowed and learned from each of them. Sometimes I wish I had an easier ride, but that's, I'm sure, what we all wish for and wouldn't want if we got. I think their indomitable rigour and persistent challenging of my ideas have made me a better film-maker. But they're a curmudgeonly lot, I would say, as a group.

Another huge collaborator is Dianne Dreyer. Just as costume designers design costumes officially, so – officially – script supervisors keep continuity notes and records of the film we process. They will tell you how many times we did that shot, how long the shot was, what camera, what lens size, what were the comments that I made. 'It was always his right hand going into the pocket, the stain always appeared in the bottom left-hand corner of the pocket,' so that, if we were having to pick that shot up later on for some reason, we can all remind ourselves about it. That's officially her job and it's an extremely complex one, and I'm sure there has never been anybody better at it. But that is not why she's on the film. She's on the film to quarrel with me from the moment I arrive on the set until when I leave, about every single decision that I make. Why is the camera there? Why are you calling 'Cut' so early? Why are you letting him put the teacup on that side of the table? Why are you not shooting that line of the script? Why are you letting him drop that line? Why is she ... ? This barrage sometimes makes me feel like I've done ten rounds by the end of a day working with Dianne, but I would feel helpless without her. I've welcomed and encouraged that pummelling because it's a way of galvanizing the process, a way of challenging yourself. Particularly when you're the writer as well as the director, it means that there's a very fine mesh of opinion which everything I do has to pass through. Between John Seale, Steve Andrews and Dianne on the set, there's a lot of resistance to my aesthetic and a lot of support.

I had an experience recently where I was working with a different crew on a commercial. And the level of respect that I was accorded was so disabling, because I just expected everybody to say, 'What do you mean? What do you mean you want the camera there? What do you mean you want to try ... ? What do you mean you want to use a crane? Why? How dull. You're not going to do that? Are you serious? Do you think that's the right shot?' Most of the time this barrage doesn't deflect me in the slightest from what I'm doing. It makes me be absolutely clear about why I'm doing it.

Sometimes I'll jettison an idea because I realize that I am wrong, that I am going off at a tangent. When you're working hour after hour after hour, month after month on a film, there's only one shot in front of you, because you can't really carry the whole film around with you the whole time. You have to think about this next set-up, you've got to believe the next set-up is the most important shot in the film. In that moment it is the most important shot, and you've got to believe the film will be worthless without getting it absolutely right, for it to be the

definitive version of that moment in the film. So you want to have many minds patrolling that moment to make sure you're not missing anything, not forgetting anything – 'Don't you remember when you were in Naples and you said that when he walked in the door it was vital that he slammed it. Well, here we are now, six weeks later. Don't forget that.' And Dianne or Ann or John or Steve will be on my case to remind me that that's what I had said I wanted and that I mustn't surrender. You often surrender when you're filming just because the light's going, because the clock is ticking and you can hear, on every set, the tick, tick, tick of the second hand all day. I must look at my watch a thousand times a day when I'm shooting. That's the gesture of shooting: talking and then glancing at your watch because you're chasing light the whole day. Even in the studio you've got a very prescribed amount of time to get through each piece of work. And so your team are reminding you not only that you have to move on, but that you mustn't move on. There's a strange flexing of pragmatism versus idealism. The First AD, who runs the set, is there to make sure you shoot the film in the time you said you were going to shoot it, that he's scheduled for you to shoot it. By the same token, his job is to protect you from those logistical exigencies – 'Don't do that. Let's go over. Let's have overtime. Let's pick this up again tomorrow. We'll find some time later.' There's a strange tug of wanting excellence and wanting to finish, wanting to make sure you get home.

So the pugilists that I work with get me home, but without compromise. They're an extremely tough group, and that's the one defining characteristic. They're all from different countries; they're Australians, Brits, Italians, they're from New York and the West Coast, they're from all over, an international band. What they have in common is that they're all extremely experienced, hard crusaders.

You need as many people around you as you can who can help you identify how to improve something. And so it's enormously important to have that ear cleaned out and working. One of the reasons why Sydney Pollack and I have formed a partnership is because I love the way that Sydney looks at a movie. I love the way that he instantly sniffs out its fragilities, identifies them, and teases me about them. I know that he sees all of the malfunctioning. It's also the case, of course, that you listen to bad advice and act on it. And you ignore good advice and don't act on it. We're all frail, and hubristic, and screw up all the time.

The analogy with conductors, I think, is a very interesting one insofar as the conductor tends not to be the best fiddle player in the

orchestra or the best bassoonist or the best percussionist. And yet without that waving baton, there's no sense of the music. There's a famous story of Leonard Bernstein giving a lesson about conducting and saying, 'I bet you wonder whether the orchestra really needs me. Probably they can play by themselves. And indeed they can.' So he walked off in the middle of a performance and just sat in the audience, watching the orchestra play. They were absolutely fine until somebody lost time. The musicians tried to compensate, but the music collapsed. Without the conductor the first two minutes is fine, but after three minutes there is absolute chaos. You have to assume that the director, who's the only person on a film set not actually doing anything, not actually in action, is also the person without whom the whole loses its shape, purpose and identity.

The confidence of thinking that your own view of the material is worth everybody else's time, which is implicit in the event, that what you have to say about this material is worth dragging everybody on this strange adventure, has to exist. But at the same time I think it's imperative that you understand that you can get in the way of everybody doing a good job and doing their best work, that you have to give ownership to the entire group so that the costume designer thinks it's his or her film, and the cinematographer thinks it's his or her film, and, when you bring home a lot of film, that it's the editor's now to play with.

The danger signs are when directors start to say, 'Well, I could light that scene. I know what I want. I don't need a lighting cameraman. I just need somebody to operate for me. I should stop getting an editor. I could cut the film. I don't really need a producer because I'm selling the production myself.' The minute you start to imagine that you can play each instrument, you're in trouble. When I go to work I keep reminding myself that I've got experts and I shouldn't impede their expertise.

AM, John Seale, Steve Andrews

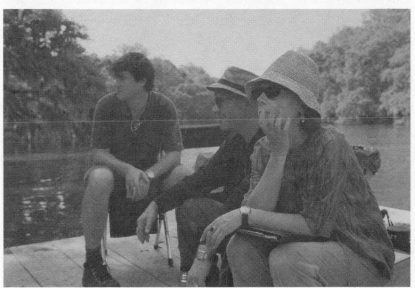

Tim Bricknell, AM, Dianne Dreyer

Actors

I don't have any special pleading about my relationship with actors. I like actors. A lot of directors don't like actors and think that they get in the way of the mechanics of film-making, of the pyrotechnics of film-making. But I'm not attracted to the kind of movies where the actor takes second place.

I know as an absolute fact that the best moments in movies are acting moments. They're not shots, and they're not locations, and they're not effects. When I think about the moments in movies that I have loved, it's always about an actor revealing himself or herself. I'm absolutely secure about that. I know that, finally, that is the thing that's always astonished me. It doesn't matter what you've spent on a film, it doesn't matter how much you've prepared a shot, none of it matters in the end. You end up with a lens and somebody doing something. It's all about that. It can be the lens on a little video-camera recorder or on the most expensive Panavision camera. It's all about somebody revealing themselves and letting you in to something. That's all I'm ever trying to do: to make those moments, or to allow those moments to happen, and to make an actor feel sufficiently comfortable so that they can be emotionally unadorned.

I've lost much of my attachment to rehearsal because I've learned that film is a nastier medium than we like to believe, in the sense that film is cruelly indifferent to how an effect is achieved. So much so that you can steal a reaction from another moment in a film and it feels totally organic and real. It doesn't matter, in the end, that the actor had no understanding at the time that that's what they were working toward.

John Seale and I have a process where sometimes he doesn't turn the camera off, or sometimes it's running for a long time before I call 'Action,' and often Walter Murch and I have chosen those areas on the take in the cutting room.

That said, however, I think rehearsal is vital. You might get an actor who wants to find the performance in the first or second take without a rehearsal, and that's their skill and that's their metabolism as actors, that they're on immediately. They don't want to go through an exploration. They want to be on film and they want to be delivering. And there may be exactly the same scene with an actor who needs to

rehearse fifty times, who needs fourteen takes to refine a performance, who can't go to the first idea quickly.

Rehearsal is useful as an unencumbered forum in which you can talk out some things about the film and share them: share the research, show things, watch movies together and do anything which makes you into a collective team. However, I don't think rehearsal is a place to trap a performance, because you want to trap that on film. What I've come to understand is that you're not looking to repeat anything. In the theatre, you're looking for ways of organizing a performance for repetition. On film, you don't need ever to have the same moment twice: you just need it once, in focus, without any scratches on the film. Then you're all right.

I was lucky enough, for ten years or so, to be a writer who wasn't directing. I worked with a lot of different directors, and I remember one particular incident. I'd written a play that was on in the West End, directed by a wonderful Australian director called Michael Blakemore. He had a technique with me: he allowed me into all the rehearsals, all of the time, but asked me not to speak. But at the end of each day, we'd go for dinner across the street from the rehearsal room, and he'd say, 'Well, what do you think?' And this torrent would pour out of what I thought about the day. There was one particular performance which was very distressing to me because it seemed to be completely missing the point, and I would say at the end of my menu of anxieties, 'And as for So-and-So, I just don't think he understands this part.' And Michael would say, 'Um ... ' and write it down. And the next day we'd rehearse, and nothing would happen.

Finally, we had a first run-through of the play, and all the actors were on-stage in the Aldwych theatre, and I was very excited. Suddenly, this incredible performance emerged from this actor. And so we went for our dinner at the end of the day, and I said, 'Well, what did you say to So-and-So?' He said, 'Nothing. He doesn't like being interfered with when he's preparing his role. Then he gets to a point where he's put it all together, and it tends to emerge when he gets up on his feet.' And I suddenly realized that you can't have a technique with which, like a paintbrush, you paint all actors in exactly the same way. You can't afford to bring too much technique to an actor because it presupposes that every actor can be dealt with in the same way. The thing I noticed about Michael Blakemore was that he seemed to have a technique which altered to suit each actor. Some actors require an enormous amount of invasion of their process: they want to be

directed. Other actors require much more space. If you invade their space, they feel it's impossible for them to work.

You have to work out, as a director, what an actor wants from you. There are some actors who want you to hold them very, very tightly throughout the entire filming process. They want to know everything, and that's what you've got to do – you've got to hug those people. But, with other people, if you go and hug them, they are so alarmed they can't function. Your job is to diagnose the amount of emotional space in which people can work. And you have to determine how much of that space feels comfortable. If it's too big, people feel they're going to fall over – they're not protected. And if it's too tight, some people can feel claustrophobic. Your activity is to try and work out how present you need to be in their process. But that sounds more analytic than I believe it to be. First of all, I think it's very hard in film for an actor to be wrong. If you're playing Count Almásy in *The English Patient*, who is to say what you're doing is wrong? Nobody else is going to play that role. So, in a way, you're definitely correct in every moment in the film. All I can do is to say, of those possible correct choices, which one is more preferable or more in service to where we are in the film. And sometimes I'm not even sure if I know that any better than the actor does.

When we did the scene in *The English Patient* where Hana is swung up into the air in the cathedral to look at the frescoes, I talked to the actors about the intention of the scene. I had talked about the fact that it was a way of making love without there being sexual content. There's some kind of absolute exhilaration, freedom and tenderness; Hana felt like somebody was taking her somewhere to show her something as a gift, and she was liberated by it. I talked a lot with the two actors and suggested this was a way for two rather shy and not particularly sexually inclined people to commune. In a film where there was a great deal of carnal interaction, their love for each other was much more like sibling love. It wasn't about lust, particularly. I was trying to think of gestures of giving. And so there is a sense, in a most prosaic way, of soaring, but mostly of freedom.

Juliette was so alert. By that point, our communication had become monosyllabic, because we simply understood where we were in the filming process and we were so comfortable with each other. There are people whose frequency you feel you're instantly on. She made me feel like I could really direct an actor.

One thing that I've tried to do with actors is remind them of the needs and restrictions of the film in relation to their performance. I

remember when Ralph Fiennes and I were shooting in a monastery for *The English Patient*. Willem Dafoe had leant over and made some accusations, and Ralph's line was: 'You think I killed the Cliftons.' Ralph is the most brilliant actor, the most hard-working, and a good man. And it took 2 minutes and 12 seconds for him to say that line. Every second of it was intense, and real, and true, and accurate, and felt, and painful for him. But it was 2 minutes and 12 seconds, and it just couldn't be in the film. There was no way the world's audience was going to sit and wait for this line. It was absurd in the context of the whole movie, but absolutely accurate in the context of what he was doing in his performance. My job there is simply to say, 'That is absolutely right, and is of no value whatsoever to the film.' I had to take the actor away from a place. It was very discombobulating to Ralph because he felt that I was undervaluing his performance. But I wasn't. I just wanted it to be in the film. I wanted that beautiful thing to occur in the movie and not in some out-take where we'd said, 'Gosh, if only it was a different kind of movie, that could have been there.'

So part of my job is to find ways of saying, 'Just think: it's a cut from here to here. This has got to happen. Try and imagine that music and that dynamic.' I have to reset the metronome sometimes, which is a rather objective thing in a mostly subjective activity. Just imagine the metronome. It cannot be. That is why film is a director's medium, not a writer's medium, not an actor's medium. The director, finally, can cut the performance. The director has the means of making the metronome pulse activate a scene.

Of course, the film is changed radically by who is in the movie and how they are. It is being made in front of you when you're shooting and there's only so much you can interfere with in the cutting room. You often see movies where they've tried to accelerate performances, and the performances seem terribly abbreviated. And that wasn't what I was interested in doing. I loved what Ralph was doing. And he knew that I believed in his choices. I just wanted his choices to fit into the structure of the film.

It's almost always, unfortunately, to do with pacing. What feels true as a generated moment for an actor often doesn't feel true inside the context of the film sentence. If nothing else, what you're trying to do with an actor is remind them that a particular moment is an adjective in a long sentence, or it's the whole sentence, or it's a noun and it's going to be decorated by that adjective, which is a different shot. I try and make actors into film-makers with me so they are not just batting their particular corner.

Inman is a verb: it's a doing part, he is an action. You could write down all the things that Jude Law says in *Cold Mountain* and it wouldn't take up more than a few pages. It's a silent character; you could create his whole performance simply by looking at a sequence of images, of action. Things are done to him; he does things to people.

Jude's preparation was almost entirely physical. There were days when I remember looking out of a window of the hotel when we were rehearsing and seeing him running with his trainer on his back, or digging in the ground, preparing himself for the stamina the role would demand of him. And I think that what Jude discovered was that he could simply *behave* in film, which is not something that British actors get an opportunity to do much because their training is always through language, and British film is still generally language dependent. Behaviour is something that has been appropriated by the American actor because American film always looks more towards action than it does to language. Similarly, very few American actors can manage the intricacies of a line with the flair that many British actors have. And because the camera is most magical when it's collecting the thought of an actor, most exciting when the inner life is teased out by the camera, all the time Jude's focus was on trying to find ways of externalizing an inner moment. He spent a lot of time reading the *Pilgrim's Progress* or the Book of Job, reading a lot of meditational texts about the attritions of the spirit. Consequently, there's a gravitas in the performance that seems to age him. In post-production, when we did our first ADR session with Jude, he was standing in the booth looking up at his performance on the screen, and I looked at him and it was as if Inman's kid brother had turned up to impersonate him: there was no relationship between the face on the screen and his; there seemed to be fifteen or twenty years' difference in age. The heaviness of the spirit that was weighing on Inman has very little to do with the lightness of spirit that weighs on Jude naturally. I think he put many pounds of spiritual weight on in the film. His skin seems pulled so tightly around his features, and that's entirely a generated understanding that Jude developed of the psychomachia, the spiritual odyssey that the character is on. It's the film in which – if you can make such a glib assessment – a promising actor becomes a man, becomes a star. That was fantastic to witness and contribute to.

I sent Nicole Kidman a poem called 'The Glass Essay' by Anne Carson, which had been as big a compass in writing Ada as anything that I'd read elsewhere. 'The Glass Essay' is both a meditation on the Brontës and the writing of *Wuthering Heights*, but also on the loss of a

relationship with, funnily enough, a man called Law. It's also about a relationship with a father who's dying. This convergence of themes in a bleak landscape of snowy Canada seemed to have so many clues, and is also a most beautifully written poem. It seemed to be a real secret text for Nicole, which she immediately understood when I sent it. I even borrowed from it directly, in the scene where Ruby and Ada are lying on the bed reading from *Wuthering Heights*. The quotation 'Little visible delight, but necessary' is the piece of *Wuthering Heights* that Anne Carson dwells on in the poem. The other model for Ada, as I have mentioned, was myself. A certain development of the inner being and a perilous starvation of the outer being, an inability to function in the world and make sense of practical challenges.

Renée Zellweger had lived with *Cold Mountain* for longer than any other person involved with the film. She had tried to buy the rights before we did and had been in love with the book before we'd heard of it. She came with a southern mentality for the material and a very, very firm notion of who Ruby was. In discussing Ruby, what I did was suggest some kind of equivalency with a fruit with a very, very hard skin, just to remind Renée that Ruby was a feeling character whose whole presentation was to resist feeling. There's a constant tension in her performance between the demonstration of personality and this resistance to feeling; there's a sense of a dialectic between what she was feeling and what she acknowledged that she was feeling. So when she reveals to Ada that she had been abandoned by her father for several weeks as a child, and Ada responds in horror, she closes down as soon as any sympathy is offered. We tried to use that moment as a fastener for the rest of her performance.

The only theory that I have about acting is that there's a space to work in, and the more of that space I occupy, the less space there is for the actor. And so one of the things I try to do is reduce the amount of space that I take up when I'm working with them, so that they feel that they can move into it. At the same time, there has to be a perimeter around that space which is entirely safe so that they feel they can jump into the space without falling over. Melanie Klein talked about this in terms of her approach to therapy – that predominantly by listening you might create space in which people can feel safe to explore, to drop their defences. I think that's a very good way of looking at the relationship between a director and an actor. It's certainly true that the best actors I've worked with have functioned with the same alchemy of searching and relaxation.

When we were shooting *Truly, Madly, Deeply*, I always imagined myself as a tailor with a tape measure running around Juliet Stevenson's skills. I felt so confident in her technique and the range of delicious characteristics I could dress. I remember one critic, who was not a fan of the film, saying that the whole movie felt as if I were Juliet's doting maiden aunt following her around with a camera. It was meant as a criticism but I quite liked that idea of dutifully following her talent around through a movie. I don't think it is a fair comment about the film's intentions, achieved or otherwise, which were to examine the nature of loss as best I could, but I accept the insult.

The director's not there to do anything. The director's there to catch somebody, which means that they feel that they can fall without hurting themselves. I don't always know quite how that operates in a filmic circumstance because it's so contingent – often the amount of focus that you can give to an individual actor is predetermined by how many actors are working, how many cameras are being used, how much light there's left. It's never a clean room, it's never a laboratory environment. When you're working, you're always working in a mess. Chaos is the air you're breathing; it's never a pristine place where all you can do is think about that moment of work. One of the things that you're doing when you're filming is trying to silence the ten feet around the actor so that you can both concentrate on whatever it is you're trying to achieve.

Filming the killing of Dickie in *Ripley*, we were plagued by wasps. There's one shot where you can see one around Matt's head; he was extremely disturbed by these wasps. Jude and he both were. There were hundreds of them because the blood make-up had some syrup in it, and it was the wasp season. I said to Matt that, rather than fight it, he should actually use it. So that when he kills Dickie, he shouldn't imagine a human being there but a huge wasp. This wasp should be a threat to him and, just as with a real wasp, he would have to really kill it because, if it's not killed, it's going to sting him very badly.

It was also important to establish that Dickie was capable of more violence than Ripley, that there was some sense that Dickie lashes out. That's what he does – he lashes out. And you discover later in the film that he's almost killed a man before.

Ripley's killing of Dickie was a defensive action. He felt that his own life was in danger. That's where the wasp metaphor came in useful. Ripley was so terrified of being stung that he lost all sense of the fact

that he was battering another human being. He was battering a big sting.

It is moments like that where you realize that half a page of writing in the screenplay can be enormous. I understood that for the first time on *The English Patient*, where I had a collection of actors who were thoroughbreds and who were excavators of the material, who weren't skimming the surface of the parts in any way, shape or form and who burrowed deeply into the behaviour of the characters. Ralph Fiennes and Kristin Scott Thomas were so committed to their characters and so committed to their characters' journeys that a glance could speak volumes. Their evocation of character was rewriting the screenplay without changing any of the lines, in the sense that there was so much gravity in the performances that often the dialogue was the second thing they needed in the scene, not the first. As I found in the rich prose of the novel, where Michael's lines were like those paper worms expanding, so the dialogue, when performed, became that too. There was a concentration in the dialogue by the time I'd reduced the screenplay. The 200 pages of my first draft were still contained somehow within the 120 pages of the final shooting script. Once we started work, the weight went back on. It happened on *Cold Mountain* as well. Irrespective of how long the shooting script is, it contains within it the ideas and the flesh of the much longer piece of material that I had begun with. I feel like I have a rigorously achieved film in the screenplay, but something happens with me because I'm the director of the film. I continue to reimagine and discover the movie when I'm shooting. I think if somebody else directed my screenplays they would emerge very differently. I realize that they're full of shorthands, or rather that I don't write everything down that I'm imagining – I think I do, but I don't – and so what seems absolutely apparent to me on the page often surprises people when I shoot because it was always in my mind that a scene would be this way or have this characteristic. It's just that I don't communicate it perfectly on the page. I get very intrigued by performance and what happens when performers get together, and I invest totally in that process as much as I do in the writing process. And so, inevitably, what happens is a huge expansion. That's the reason why I've walked into a cutting room with Walter Murch, three times in a row, with a truckload of film that has always presented us with a huge challenge. Unfortunately, it's how I work, and one of the things I've learnt to my cost is that you can't fight yourself as a film-maker. You can be exasperated with your method and exasperated with the

problems you create, but you can't deliberately trip yourself up because it's counter-productive.

One of the consequences of dealing with the expansion of the material and the long editing process we, therefore, always go through is that I do a lot of ADR in post-production. I love this process and see it as an extension of the writing process.

Actors deal with ADR in exactly the same way as they deal with their parts. There are very few actors who are different creatures in the ADR room than they are on the set, so any easygoing, obliging, intelligent actor will relish the opportunities of ADR. Some actors see the ADR room as the opportunity to do exactly for themselves what you're trying to do for the film. They've seen the performance; they start to try to balance things out; they wish they'd come into the scene more strongly; they wish they hadn't landed so hard on this line; they can reassess their performance and try and repair it as they see fit. They relish the opportunity to grow parts of the performance using new lines. Other actors who work out of struggle and who work out of a more negative place will bring that baggage into the ADR room and quarrel with why we're replacing this line: 'I can hear it perfectly. Why are we adding this line? I liked what we had before.' There'll be an argument with the process; it doesn't mean they'll be bad at it, it doesn't mean that they won't finally understand why it's been helpful to them, but they are the same creatures wherever they are – in rehearsals, in shooting, in the ADR room or in promoting the film. It's all part of the job and some of them are good at it and some of them wrestle with it. Actors are extremely concerned with truth so they can be alarmed by replacing dialogue. Likewise, they can be alarmed when you've suddenly employed a close-up from scene twenty-six to attend to a missing moment in scene twelve. 'Well, I wasn't in that place in that moment, so how can you use that look?' You can use it because the construction of a performance in a film unfortunately is a scavenging, roguish, indifferent activity, and *The English Patient*, for instance, is full of appropriation of reactions and lines and events from other scenes that we used to upholster some scenes that we maintained. It's full of the artifice of the editing room. The actor gives you a performance, and the film-maker's job is to respect its intention. Beyond that are all the realities of the editing room, where the performance has to be worked into the fabric of the film and where the performance can also be refined. It's rare that a director is trying to damage an actor's work in the cutting room. However, it's understandable if an actor feels aggrieved if what he or she perceived as a

vital moment has been attenuated or cut or repositioned. There is a constant tension between the truth of the work and the fiction of it. You're making everything up and you're manipulating everything.

An actor has to believe that he or she is in command of their particular strut of the manipulation, when, in reality, they're not. Crudely, film is about editing and marketing. It's about what we do with what we shot and what the company does with what we deliver. Those are the only two unequivocal things: how the film is assembled and then how the film is presented to an audience. And no matter how much good goes into the preceding elements, it is all dispiritingly determined by those two things. It doesn't matter how good a speech was during shooting: a performance suffers if the director adds a reaction shot at an insensitive moment. If we keep returning to the reaction shot, that character will be amplified in their significance whether their performance was or not. So actors are very vulnerable in the cutting room, and many of them get aggrieved by what happen to their work; they see it as a series of lies because it was never meant for that. But, of course, the whole thing is a lie in the sense that none of it is real, nobody dies. Our soldiers in *Cold Mountain* were Romanian soldiers in American costumes, grey in the morning and blue in the afternoon. It doesn't mean that their run into the pit is dishonest because earlier that day they were Confederates shooting into the pit; it just means that, at the moment of looking, the film's truth is always going to overwhelm any particular actor's integrity. I say this as a director who has been blessed by actors, dignified by them, rescued by them. It's a conundrum and an important one to acknowledge because there has to be a profound respect on either side of the camera. Surrender to the actor during shooting; surrender from the actor in the editing room.

Juliet Stevenson in *Truly, Madly, Deeply*

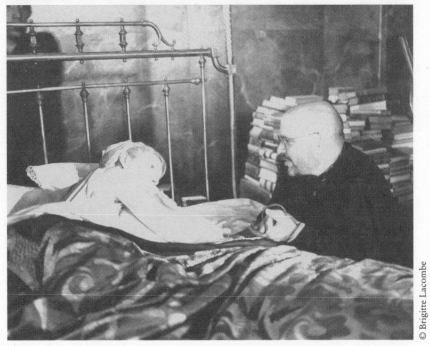

AM with Gwyneth Paltrow, *The Talented Mr. Ripley*

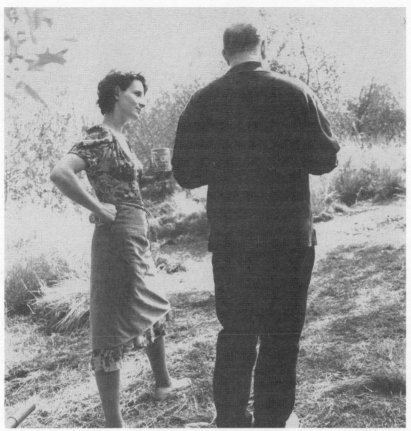

AM with Juliette Binoche, *The English Patient*

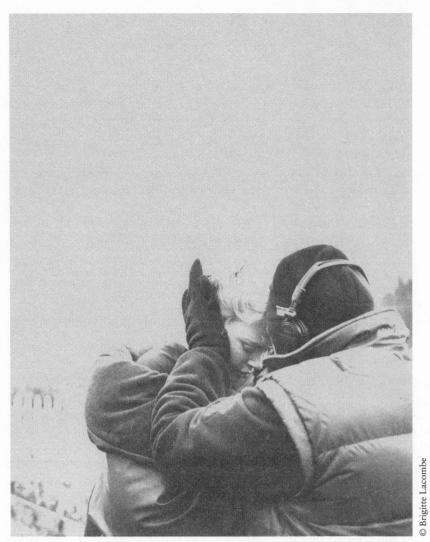

AM with Nicole Kidman, *Cold Mountain*

The Camera

Although I am slightly ashamed to say it, the source of my imagination is not the cinema. Recently I have been in a lot of cutting rooms with Sydney Pollack. We were working with the German director Tom Tykwer. Our company, Mirage, had just produced his film, *Heaven*. We'd be running the film on the Avid and Tom would say, 'Well, that's a quote from Kurosawa. That's the shot, do you remember, in *Rashomon*,' or he'd say, 'This is an Ozu.' And I'm thinking, 'Oh my God, I don't know anything about movies.' Sydney and I often lament the fact we know about five films between us. So, certainly, the imaginative reservoir for me is not film. When I go to work, I'm much more likely to have been in thrall to a painting or to a poem than to a shot in another movie. I just don't find the same oxygen in cinema.

Just as virtual reality requires you to block off every single part of the existing world to go into a fictional world; the process of writing does so as well. You're so disassociated from your physical position that you are inside this moment, trying to see how that oar is coming at your head or trying to feel what it is that makes you want to pick that oar up and strike someone. What are those dynamics? What does somebody have to say to you that hurts enough to want to lash out? That's hard to get back into when you're on set with a hundred other people, standing in the sun in front of some actors. I notice that almost every time I think about shooting, I think about a physical condition.

Obviously my visual style has been mediated – in *The English Patient*, *Ripley* and *Cold Mountain* – by John Seale. As well as the lighting cameraman, he also operates the camera, so a lot of the framing is a strange marriage of the director's and cinematographer's taste. I will set up a shot and John, in the operating of the shot, will have a huge influence on what is collected. He is the witness of it much more physically than I am. How he moves the camera, adjusts the zoom or lens size is not something, generally, that I try and control.

There are, to me, key images in each scene and then there is connective tissue for which John takes a huge amount of responsibility. Because I respect him so much as a cameraman, as long as I am certain that I've put the camera in the right place and that I've choreographed the action properly, I think that there's a lot to be said for learning from his instinct – he's been framing shots his entire working life. I tend to draw key frames before the day's work, and we discover on the

day how to get from the A of that frame to the B of the other. That's worked very well for us.

The reality is that you're constructing an aesthetic language for the film from the first day you sit down with any single one of your collaborators, not just when you turn up to shoot. You're determining, by a process of elimination, how the film is going to look. Obviously that happens with your principal collaborators because you have to give some clues to everybody at the very beginning of the process. The production designer, for instance, will ask you what kind of film you have in your head. Probably, at that stage, you won't have a clear idea of a look that you want, but what you do know is the kind of film you don't want, a kind of look you don't want.

On *Ripley*, we had travelled a long way. We had brought a film crew to Palermo and to Procida, so it was very tempting to say, 'Let's photograph it, it's beautiful.' However, John Seale and I imposed on ourselves the discipline of never coming off architecture or landscape with the camera. *The Sheltering Sky*, for example, is a magnificent film visually. But on occasion it seems that you can actually feel the camera drifting away from the actors to be seduced by the landscape, and that's very understandable – it's a wonderful landscape. But if the film is going to insist on the humanity of its story, then, for me, the camera has to stay on course; it has to be actor- and character-led.

However, the visual style – what I choose to point the camera at – betrays a visual sensibility whether I want it to or not. The fact is that I'm very interested in graphic structures and graphic framings. I don't want to claim style when often what's involved is lack of style. I'm always haunted by technical shortcomings and also certain framing predilections. I see them all over my films and sometimes they drive me crazy, but I do see things in a particular way – they're like ticks, finally. One of the things that I was forced to contemplate whilst editing *Cold Mountain* was the requirement for Inman to be more challenged in the early part of his walk, because the images that I had created were very graphic. I gravitate towards quite balanced compositions. I like using horizontals and 'the road' was the big idea for the early part of Inman's walk, so I was constantly putting Jude Law in the centre of a road – the long road to the horizon – which pleased me in some regard but in another regard gave a wrong message to the audience, which is that he's got a free run on this road. So there was an area where the meta-story and the narrative were in conflict because the meta-story wanted to talk about pilgrimage and this narrow road of morality, but the narrative seemed to be saying that this man was on a very pleasant

stroll back to Cold Mountain. The images were not asserting that the journey was difficult, dangerous, full of privation – that it was a struggle.

In *The English Patient*, the desert supports a lot of graphic visuals because it reduces itself into strong blocks of colour and shape very simply. It's about patterns. There's a horizontal line between the sky and the desert. So when you put somebody in that frame, you have a perfect graphic frame all the time: silhouettes. Everything about it suited me visually. The monastery, however, was more complicated for me, visually, much more of a watercolourist's territory. It's got very bleached colouring and very soft, crumbled edges. It was harder to find the patterns in the frame.

Whilst shooting *The Talented Mr. Ripley*, there was a huge – and very wise – effort from the production team to stop me shooting in the Piazza San Marco in Venice. But the colonnade there, which surrounds the square, is to me the perfect frame of *Ripley* because it's got an enormous depth of field, so you have a framing within the frame of Mr Greenleaf, Marge and Ripley meeting. It's got enormous texture, activity down through the frame, and yet it's extremely graphic. If I was to take one still from the film and say, 'Here's an example of what appeals to me in terms of visual style,' there it is. There's a rather austere coloration and framing which is full of information over and above the foreground. It's got foreground, information about the principals, but there's a huge amount of background activity as well. It sort of vertically stacks up the information in the shot. And I love that. I always have to be nudged away from quite formal framings, and there are a lot of them in all my films.

John Seale and I don't like doing anything particularly fancy with the negative. He likes to collect a very rich negative. On *Ripley* we used a pro-mist filter on the camera, which gives the highlights a sort of halo quality. When we talked about how to shoot the film, one of the things we both felt strongly about was not to allow the film to cool with the action or to allow it to mimic the thematic argument of the film but to keep this insistence on the weather being indifferent to the events of the film – heaven's indifference to man's problems. So the film is often more beautiful than it might be. Conventionally, thrillers and suspense stories use very high contrast images; they have lots of shadows, people barely lit, and there's the use of extremely *chiaroscuro* techniques. We didn't do any of that at all. *Ripley* is most gorgeously lit in the tragic last scene of the film – the golden, caressing light of sunset around him as he is killing the one person who could ever

accept him. They're bathed in this ridiculously warm light. The pro-mist exaggerates those qualities.

Making a film like *Ripley* – which is, I suppose, a thriller – there's a temptation to find a meteorological correlative to the mood in the way you shoot: if the scene's getting tense, let's have thunder. These are the correlatives that film-makers tend to use as ways of saying where we are in stories. They're in love, so it's sunset: the last light catches them. However, I had this image of the sun hitting the water during the killing on the boat because it seemed a wonderful irony. I thought we should shoot the killing as if it's the most gorgeous day – let's get the prettiest boat and let's put it in the bluest ocean. Let the sun come onto the water so that they're caught in this mottled, dappled light. At the most banal level, I didn't want the sun to go in when Dickie died. I didn't want the season to change. I didn't want the film to get increasingly monochrome as it went along, which would have been the obvious visual correlative of the story.

Whilst I feel that often to use the direct visual correlative of the mood in a scene is Mickey Mouse directing, I realize that sometimes Mickey Mouse film-making is vital. If you try and fly in the face too much of what the narrative is requiring, then the audience has no idea where it is. How you show something on film is vital. How do you show feeling? How do you show cruelty? How do you show unions, disavowals or unravellings? What is the effect and the impact on the audience's understanding of the event if you arc tight or wide, if you're above the event or below it? All those positional decisions have an absolute impact on the way an audience appreciates an event. If you have a couple embracing and they are two tiny figures in a square, your sense of that moment is completely different than if the camera can barely accommodate their two heads. Your feeling, as an audience, is entirely prescribed by the relationship between the camera and the action.

So, obviously, I spend as much time as I can thinking about how I'm going to photograph key events in the film. I try to think what the centre of each scene is and where the camera will be in that moment, and fix, as it were, the central image, and then I build the scene out from there, rather than trying to accidentally collide with the centre of the scene.

One of the common mistakes, I think, when you start directing can be illustrated with a football analogy. There's a celebrated French player, David Ginola, who used to play for Tottenham Hotspur. He was always being criticized because people thought he was being fancy. He was a kind of dandy. He was a brilliant footballer, but some

managers accused him of being too elaborate in zones of the pitch where elaboration is of no value. Standing in your penalty area, knocking the ball up in the air and catching it on your thigh and then tapping it over you just means that you're laying yourself open to being dispossessed and setting up a shooting opportunity for your opponents. So people didn't like his style of play, even though when he used it to effect he was the most dazzling player in British soccer. When you start directing you imagine how the camera, the pen of film-making, is going to write a scene. Most scenes tend to have an arrival, an announcement and a departure of some description, or a series of arrivals and a series of departures. That's just the syntax of most dramatic situations. What tends to happen when you start filming is that you locate that the action is at the beginning and at the end, and so that tends to be when the camera moves. So what you do is design a very interesting entrance and a very interesting exit. I remember when I first started directing, I was always thinking she could come in with this crane shot, and then I can track, go right round and turn and then she sits down and then we stop and then we record the dialogue and then she gets up and we do this hand-held pirouette which takes in the entire room. And then you get it to the cutting room and the first thing you do is say, 'We need to get to that moment when she says that line a bit faster, but we can't because we've that crane shot.' So what tends to happen in the cutting room is you start with slicing the first piece of the crane off, then you slice the second. You can't bear to do it because it's the only energy in the scene, but you end up slicing to the point where the actor sits down and says her line. So one of things I've tried to do is remind myself only to be tricky in my opponent's penalty area and not my own.

I've tried to think, 'where is the heart of the scene, what is the heart of this film. Can I build out from those points rather than building towards them?' So if you're going to spend energy, if the camera's going to be inventive, let me find the very centre of the film and exhaust my resources, because I know that those things will be in the film. If there's one memorable moment in this film, it should be that.

In *Cold Mountain*, I feel that I managed to hit a couple of key moments pretty well. When Ada, in the image, which she's seen opaquely in the well, finds Inman, stumbling down the gorge, with the crows flying around his head – that is the moment which most closely conforms to what I'd imagined. That location delivered what I had hoped for and I'm very touched by the performances in that moment. However, it is shot in a pretty straightforward manner. I was slightly

more daring with the camera in the scene where Inman and Bosie shoot each other, and the camera goes on this long, woozy track. That morning, I was in the shower trying to imagine that moment, wanting to make sure that it was as giddy as I felt the moment needed to be and trying to work out how to deliver that when all there is is a man on a horse. It's one of the very few times, I would say, noting this as a failure, that the camera actively creates an image as opposed to records an image; it's one of the times where you couldn't achieve that effect in another medium.

We put the camera on 150 feet of track with an extremely good focus puller, Maurizio Cremisini, a very brave operator, Daniele Massaccesi, and some energetic grips. The camera dolly was run very fast along the track whilst holding the close-up on Inman and adjusting the focus. It was really hard to do: holding focus on a long lens whilst moving is a real skill, as the focal point has to be absolutely constant. We had very little time to do it and the horse was extremely frisky on the slippery ground. We did three or four takes and, amazingly, they were all useable. The face appears to be still but the world seems to be swirling and Dante's trees are flashing by: you get this sense that the world is unravelling, and indeed it is. It's a good illustration of where you should elaborate in a sequence. I was very careful with how Bosie reacted on being shot and I was very careful about imagining you would cut away to Ada in the centre of that sequence thinking that Bosie had died and Inman had survived, so there's a moment where the audience can believe that he's triumphed and that the world is sane again. Then we come back, and again Inman is still completely still, but it's the camera that starts to accelerate. As the camera starts to move you know that something is wrong. In that moment I managed to collect the right elements to be able to tell a story without announcing it, without having to comment on it. I'm thrilled that I managed to do that correctly, but there's also the humiliation of how infrequently I can do it. I know that the next time I make a film I have to try to find ten more of those moments, and remind myself that the choreography of film is an art that is extremely hard to understand and to learn, but if you can master it is the most magnificent tool and magnificent medium for storytelling. The difference between what I feel I have achieved and what I feel could be achieved is what makes me want to keep doing it; there is that perfect film to try and make in terms of the synthesis between the grammar of the film and its content.

There is a logical and hard-to-corrupt process that occurs once you

make the first decision about where the camera is. If you begin a scene with the camera in a certain place, it tends to arrive inexorably at a position. That's why there was a way of making films early on in which you shot a master – a big shot which accommodated all the action – then you shot two-shots, group shots and then close-ups, so that the scene classically cut itself: it began wide, then, as the scene intensified, moved tighter; as it got to its most intense it was at its tightest and often bulged out at the end to remind you of the geography. That's the classic syntax of directing a scene. And, without knowing it, you, as an audience, experience the scene in a particular way, without being too alert to it. Sometimes it's great to do the reverse: start extremely tight in a scene and pull further and further out as the scene goes on.

The killing of Dickie Greenleaf in *Ripley* had many areas of concern for me while we were shooting. One was how to make it an indelible event for the viewer. But the more immediate concern was how to shoot it on a boat in the middle of the ocean. It required a great deal of stamina from all the people involved just to shoot for four and a half days on rafts around this stupid rowing boat. Every single piece of it becomes a major operation – just to clean the actor up and get him back on the boat again, or just to go to the bathroom. It means that you have to have a huge support team. Being exposed to the sun and the swell of the water all day meant people were very sick.

We were trying to do a series of stunts, which both actors wanted to do themselves. Originally, we had designed it so that some of the shots could be done by stuntmen. It's always better to do it with the actors, but it meant that it was dangerous. All you needed was for one person to move in the wrong direction and somebody's broken something or hurt themselves.

We had rehearsed the rough moves on the beach many times with the stunt co-ordinator, but once you get on the water and the boat's moving, it's very hard to keep doing those things – the moment where Matt Damon falls back into the boat is not something you want to do very often. So we got out into the middle of the ocean and did one rehearsal. Luckily, we filmed it. In the rehearsal, the oar bent; it had a central filament but, to be safe, it had a rubber surround. I said, 'OK, let's get a new oar and start shooting.' The special-effects man sidled up to me and said, 'Now, about the other oar . . . ' We were in the middle of the Mediterranean, on rafts, with seventy-five people, and we only had one oar that was useable for the event. And now it was bent. It was two hours back to shore, it was the only bit of good

weather we had had in three weeks and, besides, the mould for the oar was in London. It is a perfect illustration of the extent to which shooting is contingent and, actually, if you look carefully at the sequence, some of the time they're working with this wretched bent oar.

The scene was built around that first moment when Dickie is struck by the oar and his reaction. We designed an effect which was like when you nick yourself with a razor: the razor's cut your skin but you don't see anything, so you think, 'Oh, I thought I'd cut myself but I haven't.' But then suddenly there's a red line and a lot of blood. So Dickie's had a blow, but he doesn't think that the oar has done any harm. But he takes his hand away and there's this line and then it opens. To achieve that, the dream of that moment – the swipe of the oar, a line, a split open – to make that happen in a realistic way was the most technical piece of shooting. We had to have rigs holding onto the oar so that the oar didn't strike Jude, we had to have a prosthetic on Jude's face that worked in exactly the right way, and the angles kept being changed – the angle of the rig for the oar and the angle of the slice on the prosthetic – until we found out what was an organic action to swipe somebody. The incline of the oar was also mitigated by where a prosthetic could be built and how it could be concealed in the hairline. In the end we had to surrender the rig in order to give Matt the freedom to move organically. So there was a technical problem to solve as we were shooting.

Working with the storyboard artist, Tony Wright, prior to shooting *Ripley*, I had been trying to find ways of not being inside the violence. We talked about an idea which, I think, worked pretty well, which was that as the killing really begins to happen, the boat makes its own long-shot. You start right in the middle of the action but, as the boat is moving and the camera isn't, it moves into a natural long-shot. So there's a distancing, not by the camera pulling back, but by the boat leaving us. The light worked perfectly once, and the camera could just let the boat move away, find the light on the water and then use that water to lose focus until the light itself becomes a kind of commentary on the scene – it just sort of explodes. That was a wonderful transition to the next scene, for which I had this almost sexual image in mind of Ripley sleeping with Dickie once he's dead. It's as if the only way he can finally embrace Dickie is to kill him first. So the next image was as important to me as the killing. It's enormously peaceful, and you feel like Ripley wants it to go on for ever. There are two shots: one which is very close, followed by a top shot with the boat underneath the

camera, where you feel it could have gone on for an hour or two, Ripley finally having somebody love him.

In the original screenplay I'd written a scene, which I took out very quickly, where Ripley goes back to the hotel, and the hotel receptionist says, 'Ah, Mr Greenleaf.' I'd had real doubts about that because I thought it felt mechanical. But when we shot it, it felt very, very right. Matt found a particular way of receiving it, and the camera does a very neat thing – which it only does twice in the film – and moves into Ripley. So you're on a static close-up and the camera moves in as the man says, 'Mr Greenleaf.' You hardly notice it, but it works as an intensifier, so that even if you're not alert to it, you know that you're bearing down on a thought that he's having.

The other time we used this effect is when Marge has come to the outside of Ripley's apartment, thinking that Dickie is inside. The policeman comes in and says to Ripley, 'Miss Sherwood is outside.' The camera moves, on a big track, straight in on him as he's talking – 'Let her in, let her in. Why not let her in.' You feel like the camera is the interrogator, literally. It's saying: *you're exposed*. Even though you may not be aware of the move, you have a claustrophobic feeling of the air being taken away and the space closing in on him.

Another significant but equally tiny camera move is in the killing scene. I tried to think of how the camera could participate in the scene when Dickie says the thing which breaks Ripley's heart: 'You're a mooch, you know that. You're boring. You can be boring.' The camera, instead of cutting – which is what you'd normally do, cut to Ripley's reaction – just moves through the air, and you feel the pressure of finding Ripley's face. When you do find it, it's in a different size to the face it's just left. The shot goes from a medium close-up on Dickie and, by the time it finds Ripley, it's in a very, very tight close-up. The move is designed to make what's hurting hurt twice as much. I guess I could have tried to get that in a two-shot, but then the characters would have been too small. I do the same thing several other times, to less effect, in the film. But I knew when we were shooting that, in this instance, it would be very strong.

I was on a train once and noticed the way that it's possible, at certain points, for the reflection of your face to cover somebody else's. I can't remember the trigonometry of where I was sitting, but in trains you often become conscious of reflection – when you go through a tunnel it suddenly spills your image back. And that gave me a thought about how to dramatize Ripley's desire to take over Dickie's life. And once that found its way into the film – on two quite different

occasions – then the idea of reflecting back became a possible motif. It's like finding a cluster of chords that you like, which then thematically start to score the whole film. So then we began to examine all kinds of ways of finding reflections, particularly as water is an ongoing element of the film: there's a boat journey from America to Italy; there's a boat that Dickie owns which is an enormously important icon of his lifestyle; there's a rowing boat in which Dickie is murdered; and there's a boat which sails off into the sunset at the end of the film. So finding a way of handling water and boats became a preoccupation, and there were actually, in the original screenplay, many more witnesses to these reflections and watery images. There's also a key sequence in the film where Ripley thinks he sees Dickie in a reflection when he's riding down a street of mirrors. It's a sort of inversion of the moment on the train where Ripley supplants Dickie's image in the window with his own. I had been thinking about *Macbeth* and about how to conjure ghosts, how to make it clear to the audience that Ripley is haunted by Dickie in some shape or form, but without overelaborating it.

You can't support very many visual intensifiers in a film. I don't think you can overburden a film with visual theory. Just as the sentence in the novel, on the whole, flourishes when it obeys the principles of grammar, I think the same is true of film-making. There's a wonderful moment, in a book by Robert Bresson, where a writer is talking to his son and he says, 'You don't need to sign your letters. I recognize your handwriting.' The attempt to impose a recognizable visual signature on films is, to me, very unedifying and unattractive. I'm much more interested in the camera being an invisible agent of storytelling. On the other hand, it's become clearer to me as I've made more films that there is no such thing as a neutral frame, that you can't simply record activity, that the position of the camera, the action of the camera and the dynamic of the camera is constantly mediating the way in which the story is told and understood by an audience. To disavow that is to disavow the whole medium of cinema. By which I mean that the size of somebody in a frame, whether that person is still or moving, whether the camera is seeing them in long-shot, whether it's choosing to move away from them at a certain point in a speech, where the cut comes – the syntactical apparatus of film – has a critical impact on the audience's understanding of the film, story and argument, and I'm not ignorant of that when I'm making a film. Where somebody is in the frame is part of what I'm directing.

There is no neutral way of recording an event; there is attitude in the camera and the harnessing of that attitude makes the film. Here are three examples from *Ripley*:

1. Going to Dickie Greenleaf in extreme close-up when Silvana drowns on a cut connects Silvana's death to Dickie.
2. At the same moment, having Ripley in the background turn his head towards Dickie in a three-shot means that you infer from the image that Ripley is observing Dickie's sense of guilt at what has happened.
3. If you cut from Onegin, cradling the dead Lensky in his arms on the stage in the opera scene, to Ripley – who is clearly moved – there is both a connection between Ripley as music-lover and the fact that what is happening on the stage echoes the death of Dickie. The fact that the camera moves in on Ripley rather than being static at that moment, means that you feel the event bearing down on him.

When a film-maker uses a deliberate camera move repeatedly, it becomes a visual conceit and the viewer suddenly jumps out of the skin of the film and starts to think about the film-maker, whereas ideally you want, I think, to feel like there is no film-maker, that the camera is only witnessing. I think the same of literature, where the less apparently inflected the prose style is, the more like you feel you're reading something which is true. So the more the camera seems to be dancing, the less you pay attention to what the camera is witnessing. However, in trying again to emphasize Ripley's interior life and interior torment, I used a camera in a very particular way in the scene after Ripley meets Herbert Greenleaf in Venice. Dickie's father's tragedy has touched Ripley in a way that he hadn't properly considered: he has sentenced Dickie to an eternity of blame in Herbert Greenleaf's eyes because his writing a specious suicide letter which contains aggressive references to a poor father/son relationship means that the only document that Herbert Greenleaf has as a testament to Dickie is an accusatory letter blaming him, in a sense, for his suicide.

So, after that scene, the camera is hoisted up into the top of the set and is looking down on Ripley sleeping on a couch. And it starts to spiral down on him, the room spinning round – it's a corkscrew crane and the head is literally spiralling down onto a close-up of Ripley. That's a deliberately bold camera move, but I think if you do that ten times in a film, you start to think there's a director here, there's somebody telling me that he's making this film.

Every time I think about how to film a scene, I'm thinking, first of all, where is the organic place for the camera to be, rather than where is a clever place for it to be. Who do I want to be looking at, and why? Where are they? Sometimes, for instance, when Ralph Fiennes carried Kristin Scott Thomas out of the cave in *The English Patient*, the strongest shot was the loosest one because there's something about the intimacy of carrying somebody when you're a tiny shape in a landscape which makes them much more vulnerable. You're not commanding the image. The image is commanding you. I want there to be purpose in the frame.

There is a strange law, which Walter Murch identified, which is that if you point the camera at someone and you want to see pain, if that's what you want to see then you will see it, the camera will see it. If you don't know what I want to see, the camera won't know what to find. That may sound absurd, but I know it to be true. I've gone looking for things in a scene which are elusive and seemingly impossible to dramatize. But I've gone looking for them and I've found them.

There is a relationship between the purpose of a shot and what an audience receives. Because I'd made a mental note and written in the screenplay, 'The desert seen from above is like a collection of sleeping bodies,' when the camera looked down over the undulations of the Sahara, because of the speed of the frame and because of the way in which the music sat with the image, it harnessed in some way all these elements to say, 'He wants me to think about bodies.' The most elusive part of film-making is when there is a purpose in the witnessing and you have a strange feeling that the witness is acting on the event. Maybe that sounds too aggrandizing, but the reason I mention this is that, when you don't have enough purpose, the audience seems to have a rather flattened response to your visual language. It feels like prose. Whereas once you can intensify the image enough, it starts to feel loaded in the way that words work in poetry. It's not about applauding my eye; it's about mourning how rarely it is that I manage to make those things work in films. But I know that that's what I want to get better at doing: realizing that the collecting device is the least neutral element of the film. The camera, which just appears to be watching, is actually telling. I suppose that's the critical thing: it's not watching, it's telling.

If ten different stills photographers took a picture of the same subject with the same camera, they'd come back with ten completely different photographs because the subject and the photographer have some alchemic relationship, and it either produces gold or dross or

something in between. I have absolutely no doubt that there is an action involved in photography which changes the subject.

So you're trying to find ways that intensify. I think the camera is of no interest whatsoever to me, as indeed dialogue is of no interest to me whatsoever in that I'm not looking to get wonderful dialogue. I'm looking to get something which feels like you're a witness. That you're there and you're experiencing the intensity of pain or pleasure that some other people are experiencing, and you're given the privilege of understanding how it's happening. You're allowed to get a vantage point on a process which you're so rarely allowed to have in your own life.

It is hubris of an extraordinary kind to make the world similar to your dream of it. I read that Bertolucci hopes every night to dream the next scene, to dream what it feels, smells and tastes like so it has a kind of inevitability. If you ever feel like you're pretending, the minute that you're conscious of your own artifice, the scene immediately loses its sense of reality. One of the games that I try and play with myself – if that isn't already tautological – is not to think that I'm fictionalizing. For instance, with *Ripley*, in the Madonna del Mare scene where Silvana's body is discovered, I wanted to create something which felt as if there was a documentary event going on with which my characters happen to collide. The fact is there was no such event, but I tried to deal with it as if it weren't an invention. I staged it differently and tried to find some resource in the community which took over the event and gave it back to me so I was witnessing rather than creating it. I found all the older women in the village, brought them down to the sea front, and they instantly went into mourning mode. The appropriate prayers and noises of mourning came so easily to this group of women, invoking their own understanding of death, that, without my barely speaking a word, they started to take charge of the event. When you call upon a community you get a spirit which is connected as much with the place as with what you're trying to impose on the place. The commune of Ischia was determined to have a role in the film that would be appropriate, so they were teaching me a little bit about how the day would work and how the festival might be. In the end, what you're creating is something which is a mixture of invention, necessity and their own historical references. Partly you're leading and partly you're being led. That, in miniature, is the way that I would wish to work all the time – witnessing something as opposed to being the engineer of it.

It was the most moving day of shooting for me. It was also the most

difficult and exhausting day – there is a certain amount of lunacy involved in trying to direct several hundred people. The sea was up and the water had become extremely cold. The actress playing Silvana – Stefania Rocca, a talented and spirited actress who came into the film as a blessing despite playing main roles in Italian films – kept going in and out of this water. Stefania had to stay underwater until we could begin filming and couldn't wear a wetsuit because she was wearing this extremely flimsy dress. She's also very thin, and by the fourth or fifth take the lifeguard told me she was in danger of getting hypothermia – she had literally gone blue. So it was an extremely difficult day: at the beginning of the day you have nothing and at the end of the day you have to have the scene. It's empirical. You either have the scene or you don't. But I also feel incredibly liberated when I'm working on scenes where there's an absolute investment in the day, in the moment.

I find set-piece scenes great to write and great to shoot. Oddly, because I began as a writer on quite a small scale, I was always described as a miniaturist, and I began to describe myself as a miniaturist. However, the things I find most pleasurable and often most straightforward are the scenes of scale, and the scenes that I always find most difficult are those of two people in a room. I don't like duet scenes as much as public scenes.

Truly, Madly, Deeply, however, began with an idea about a duet. I'd had a friend, who sadly and ironically died just before the film was made. He had a ritual in which he met with another friend once a week to play duets for clarinet and piano. I'd thought that was an interesting notion as a structure – that you'd meet someone on a regular basis to make music with them. And so the characters became a pianist and cellist. And then the idea of using the Bach *Gamba* sonatas for piano and cello, as a musical map, emerged, and so the film inevitably became a series of duets. Those choices, of course, were defined as much by the economic constraints of the film as by the aesthetic, although I've learnt subsequently that the money you have to make a film doesn't always dictate its shape or size. Cleverer film-makers have made epic and decentralized films with no money, but my solution to having no money was to do something very small whose ambitions were about performance. I knew nothing about film-making and so it was very modest in film-making ambition. If they'd have given me $100 million to make *Truly, Madly, Deeply* it probably would have looked exactly the same because I didn't know what else to do.

There's a scene in *The English Patient* where Kevin Whateley's character is blown up at a party where, again, there were 350 people,

all of whom arrived on the day. We had to invent this festival to celebrate the end of the war, and it was a fantastic day's shooting. The Madonna del Mare scene in *Ripley* was a more profound version of that. It's the part of the film which I have most tenderness towards because it feels as though it's bigger than the film in some way. It's also the least written scene in the film and, as always, when I'm away from my writing, as a film-maker I'm always more excited. I love filming music. I love filming people doing things that I don't know how to do. Whereas when I'm filming a scene I've written, it's not as surprising to me as when you're in that free place of inventing with people on the day. If you've written a two-handed scene which is extremely detailed and intricate, it means that you've worked on that scene maybe a hundred times before you come to film it – you know what you have to get from it, you know what it's in service to in the film.

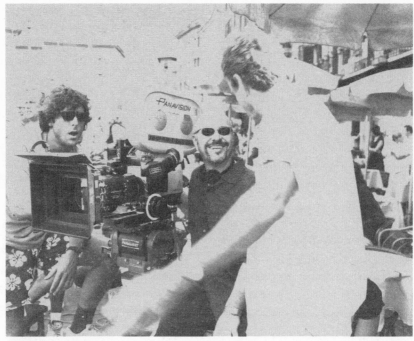

AM with John Seale on the set of *The Talented Mr. Ripley*

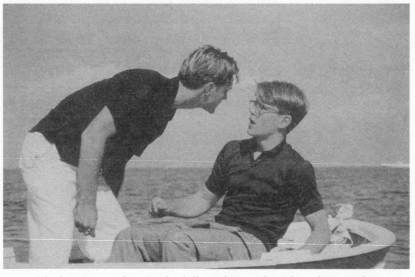

The boat scene where Ripley kills Dickie in *The Talented Mr. Ripley*

The Madonna del Mare scene in *The Talented Mr. Ripley*

5

Finishing

Structure

Architecture, film and writing are all very connected. When you go into a room which hasn't been decorated it looks like a mess, but actually it's all done; it only lacks a paintbrush to make it look sweet. The fact that you've knocked the wall down, rebuilt it, put in the electricity makes the end result inevitable because of all the groundwork that's been done. But if you try and fudge the groundwork, there's no amount of painting that will help you.

When you're writing for three weeks, you can just be trying to find a brick that nobody will ever see: that is your brick. Then you add to your brick and it becomes a course of bricks, and another course of bricks, and another course of bricks. And that is finally what the audience is feeling – the degree of structure, the degree of formality in the structure, the degree of security in the structure, not the grace notes or decorative qualities.

I think any sane person resists the idea that there is a formal and ineffable structure to films, which is what the Americans have diagnosed as a 'three-act' structure. They'll talk about the problems in the second act, problems in the third act. It seems to me to be absurd that such a liquid form should be calcified into three acts.

The screenplay of *The English Patient* was always odd. I remember I sent it to a successful American actress whom I liked a lot, not to be in the film but just as a friend. She wrote back to me saying, 'I beg you not to make this film – it has no third act.' I wrote back and said I didn't think there was a second act either. It was so far away from the hegemony of the American screenplay – Act One, Act Two, Act Three – there's no way to fit it into that box at all. One of those guys who goes around 'teaching' people how to write a screenplay actually uses *The English Patient* as an illustration of how not to, holding it up as a cul-de-sac. He's right, of course.

The English Patient has no acts. But there are units, in the way that a concerto has a discipline or a symphony has a discipline. There are statements and then restatements, and an accumulation of melody and counterpoint. You hope that these disparate melodies and tunes will eventually chord in some way. Gradually, you hope that everything will accumulate a kind of atmosphere and the certainty that there is a controlling hand. You're not just randomly experiencing narrative events. A story without thematic argument is completely redundant.

With *The English Patient* I struggled, from the first day until the last, to shape the material. Right through post-production it was still in flux because everything about the film that makes it interesting also made it a headache in terms of taking the audience on a journey where they feel they're in safe hands. It never felt entirely safe, the storytelling and the narrative. I recently did a DVD commentary, and watching it I was reminded of how kaleidoscopic it is. You could pick up a scene and move it by an hour and it worked; it was possible to shift the pieces on that board in the most radical way without destroying it, and some-times – nearly always – improving it. There was no story imperative that required continuity in description. So it became a film poem, and for some people that was exhilarating, but for others that was hard to embrace. I still believe it was a film that lost as many people as it won because it departed so radically from most of the movies that were being made. And I don't think people finally understood when they were assessing the film what a sleight of hand it was, particularly if they hadn't read the book. It's a marvellous book, and still one of my favourite books, which is completely coherent in its emotional position – that the heart is an organ of fire. I tried to find a way of reflecting that feeling in the film. Its emotional beauty is what I was trying to adapt.

Ripley is much more about a theoretical idea rather than an emo-tional position, and so the story had to be constructed in a way that spoke of what the argument of the film is, however subcutaneously that argument is conducted.

Walter Murch always points out that, at a certain stage of post-production, we are walking the terrain of the film so much that after a while it seems like a big fat mess. But at some point this sense evapor-ates; you lose contact with all of the ink stains and the fragile joins and it solidifies at a point where you abandon it. The film says, 'OK, this is how it was meant to be even if it wasn't meant to be that way.' It's a very bizarre thing. While it's in play everything seems up for grabs, and then you sign off and it skins over like when you've left your coffee for

too long. And that's it, it gels and then hardens into this film document.

To get from a very long assembly (often the case with my films) to the final version, I have needed to delete up to two hours of material. One of the key tools we've used in reducing the film's length has been to take away preparation. I realized in a way that you can only realize when you've made the film – you can't realize when you're shooting or writing – that with a huge number of preparations you will always flag a key event. For example, in *Cold Mountain*, you'd see Ada playing a piano and then there'd be a scene in which the issue of selling the piano would come up. Then there'd be a resistance to selling the piano, and then they sell the piano. In the final version she plays the piano, therefore we understand its significance, and the next minute it's being sold and there's a fallout from that action rather than a preparation for it. If you were looking for one key to the way in which we've managed to slim the film down, it has been to take out the preparing for something. Again, in *Cold Mountain*, we had a whole journey – a literal journey, that Inman made from arriving in Cold Mountain to getting to where Ada and Ruby had holed up in the Cherokee village – that we just lifted out. So now you see Inman arriving at a view of Cold Mountain and the next thing is he stumbles into Ada.

It is often the case, of course, that I have to cut a moment that I love. One of the first things that Walter Murch asks me in the cutting room is, when is the movie most like how I wanted it to be? My reply, on *Cold Mountain*, was the scene when Inman, having offered to slaughter a hog for Sara, who doesn't know how to do it, walks out into her yard and proceeds to kill this hog and burn off its skin while she is dealing with the fact that her child has died. It was the most bleak and terrible sequence. Inman was at his lowest ebb, there was this extremely vulnerable young woman and an ailing child, and the confluence of the weather that just offered itself up as I'd imagined it: this steely grey oppressive light, a yard that was so ruined and trampled, just the presentiment over the whole sequence, and you see Inman walking away with the first spits of snow around him, which came almost on cue. It's got a palette of emotion that seemed to me to be perfectly in tune with what I imagined when I was writing.

That sequence is not in the film any more. But having said that, it's not necessarily a tragedy. What's the expression . . . 'it's tragic but not serious', in the sense that it's tragic because it was a wonderful moment, but not serious because probably the film is a better film without it. Once we had cut out the reference to the hog inside the

room with Sara, it made cutting this subsequent scene inevitable – it looked absurd that he should suddenly decide to go outside and string the hog up.

Sydney Pollack once told me many years ago that everything you do in a film remains in it. Even if the scene is not there in the end, the actor found that moment and experienced it and it's in the next shot, the DP understood that moment and it's in the next frame, the director had that moment and so it's in the next frame. There's a stain of intention and purpose which permeates the whole film. Certainly, experiencing the moments informs everything else in the film as well, and so I'm hoping that some of the qualities that we found in that moment obtained elsewhere or certainly informed the way we cut elsewhere – what we were looking for elsewhere in the performances or in the look.

Music

For me, it has always been easiest to understand film in relation to music, rather than in relation to any other art form. Because music and time are intrinsically connected, both film and music are experienced in a similar way. So whilst I obsess about the actual music in my films, my experience as a musician and of music constantly informs every aspect of the way in which I make films. The understanding of music is my most important tool in the understanding of film.

I wanted to work with Gabriel Yared, the composer, for many years before I finally managed to; ever since I saw *Betty Blue* and – uniquely for me – went and bought the soundtrack the next day. I found the music so delicious and simple and distinctive. I wasn't a director at that point, but I recognized and admired that the music had been woven into the film because people played music in the film which was the score. It was a through-composed film. The score consisted of the most simple voicings of piano, saxophone and guitar, but had that very rare thing in that you couldn't think of *Betty Blue* without thinking of that score. If you stripped the score out, it would be half the film that it is because the music so captured and evoked a mood and a sensibility. I thought immediately that Gabriel was a composer I would love to know and to work with. Those feelings always come from exactly the same place – my jealousy bone. With actors, I see a great performance in a film and I want to steal that beauty, skill or elasticity – whatever it is that was particular about that performance – and employ it in something of my own. It's the same with crew: I want to work with a cinematographer because I think the work he or she's done for somebody else is beautiful. It's all about greed. And working with Gabriel was simply the jackdaw in me trying to collect the most glittering, glistening things.

Throughout my youth, I thought that the skill that I had was to write lyrics and music, but I realized fairly quickly that whatever musical gifts I had were very constrained, possibly by a lack of ability, but certainly by a lack of technique. I heard music very well and I heard sound very well, but I felt that the instrument that I had, in every sense, was a limited one. One of the things that's really so impressive about Gabriel as a composer is that he can do anything musically. He began as a popular-music arranger, working with Johnny Halliday and François Hardy in Paris, and he wrote and arranged a lot of songs for

them. Rather like Puccini, who is a composer he resembles in many ways, there's a combination of being able to turn out tunes coupled with a really profound understanding of the voicing of tunes and of the ways that they can be developed through variation. I know I am working with somebody whose sensibility is very twinned with mine, whose sense of music in a moment is very consonant with mine but whose ability to voice it is beyond anything I can understand or know how to do myself. It's a mixture of recognition and regard.

It's something that happens with actors sometimes for me. When I've written a line and I know how that line should sound, a really wonderful actor whose sensibility is similar to mine will give the line back but in a much richer way than I could have imagined myself. I remember when I first heard Juliet Stevenson performing a scene that I'd written, I thought how close it was to the way that I'd imagined it, but how much more resonant than I could have imagined.

Gabriel, like many of the people I collaborate with, is a very complex person, full of contradictions. As an artist he's very mature, wise and intelligent, but his emotional sensibility seems to be that of a child: he experiences life as a child, he experiences sound as a child. It's the thing that enables him to compose, but it's the thing that disables him from living. He finds the business of living very oppressive and working with him is, consequently, an odd process because of his need for attention and emotional support. The production of music for him, on any film, is always a crisis. That's partly his personality and partly the nature of music in the movies.

Of all the many mysteries of making a movie it's clearly the case that music is the most mysterious. Briefing a composer is the most elusive task, and the personality of the composer is more distinctive and has more impact on the film than the personality of any other member of the production team. It's the loudest noise – apart from the screenplay – that takes place on the screen and it arrives very late in the process. You could make an argument that Gabriel's contribution to *The English Patient*, for instance, was the most signal contribution of the entire project and I think that finally he carried the film to its conclusion in a marvellous, memorable way. The romance of his music was such an addition to the film, but it was a romance that I teased out of him. He is a brilliant composer who is not particularly disposed to the film-making process. He fights his own demons every day as an artist; his relation to the film process and the composition of music to film is, at best, an ambivalent one. I think he feels often that to watch the film too carefully and create music that traces the contours of a

117

scene is not an activity he much relishes. He's more interested in making the music and preferably having someone else lay it up and then give him notes about how it might be better tailored. Gabriel likes to make the cloth away from the film. He used to love composing from the screenplay rather than the footage.

When a score is successful, if you hear twenty seconds of it you immediately think of the film. With *Cinema Paradiso*, *The Mission*, *Taxi Driver* or *The Godfather* trilogy, for instance, all you have to do is hear the first phrase of the score and the film appears in front of you. Recently I had arranged to meet Juliette Binoche in New York, but I saw her across the street as I was heading for the meeting and, as if somebody had put a set of headphones on me, I immediately heard the opening music to *Three Colours: Blue*. And if I say Roland Joffé out loud, I hear *The Mission* theme because Morricone's score was so profoundly in touch with the sensibility of the film that it takes on this enormous burden of encapsulation. The woozy, washed-out, slightly decadent, *noir* sound Bernard Herrmann created for *Taxi Driver* does the same thing. So, given how crippled an activity it is, it's amazing how often the composer pulls off this trick of burrowing into the core of a movie and fishing out its essence. Gabriel and I attempt to subvert the worst treacheries of the post-production process with him beginning to write the music when I begin to write the screenplay, so there are no late arrivals, only an organic process. It requires Gabriel to come into the process much earlier and for much longer than most composers would ever contemplate. The advantage is that it gives him time to understand the spirit of the film and contribute to it. The disadvantage is that the job lasts a great deal longer and nevertheless is still thwarted by all the vicissitudes and alterations to the music and the picture as the film proceeds. However, although it means that he is continually rewriting and re-examining the music he's written, it means that nobody gets this terrible attachment to a temporary score.

A convention has evolved for the creation of music for films, and it's not one I am particularly interested in. I listened recently to a famous and successful director, who was discussing the way that he uses music in a film, and his description perfectly illustrates this convention: the director works with an editor in cutting a film to its shape, creating the film sentences. During that process he or she uses temporary music, music that is felt to contain some of the necessary elements to support a scene or challenge a scene, and over the period of six or seven or eight months of post-production they create a patchwork quilt of different pieces of music, some borrowed from other movies, some borrowed

from classical music, some borrowed from whatever source seems to summon the particular characteristics of a scene or a sequence. And the job of a composer, as it were, is to pick up this quilt and very quickly create a homogenous garment whose shape fits precisely with the map that's been made in the cutting room. The composer has to make a whole cloth from rags; but however beautiful the original material was, you've got these stitched and essentially random pieces of material. That process seems to me to be like somebody stitching together lines from plays that they'd liked and handing it to a playwright and saying, 'Make a play which makes sense from these pieces of dialogue which I've always enjoyed.' I think that explains why so much film music sounds the same. If you've used a Nino Rota score largely in your film as temporary music and you hand it to another composer, what can they do but ape Nino Rota or whoever's provided the large body of the sound that the director wishes to emulate in the film?

The worst effect of using temporary music is that it glues itself in some way to the film, so even though you try to peel it off at a certain point the stain of it stays on the celluloid, so there's ghost music playing alongside the score. The new music is always haunted by the temporary score. You think, 'That's where we had the Tchaikovsky piece. Oh, now we've got the composer's music. It's not quite as interesting or it's not quite as vivid as when she turned and there was that legato moment in the strings,' or whatever it is that you've grown attached to. The advantage of working in the way that I do with Gabriel is that there is no temporary score to wrestle with, but the disadvantage is that every time you make a statement about the music, it's liable to be confounded by the new cut. The scene was 36 seconds long, you wrote a 40-second piece that pre-lapped from the previous scene, the next time you see the film it's 12 seconds long and the perfect cue that you wrote is now redundant. So every time we change a scene, the music has to accommodate it, and after a certain point the music simply cannot be edited and rethought in the way that it was originally imagined.

In a sense, the composer is part of the sound department: while Eddy Joseph or Pat Jackson (or whoever is your sound supervisor) are adding gunshots, thunder or footsteps, the composer's supposed to turn up and add some musical sounds to the sound landscape of the film. The composer's work, which is a huge element in the finished movie, is prescribed by several inhibitors: one is cost; one is that they do, on the whole, too many jobs every year in order to survive. The

other big obstacle for achieving good music in a film is connected to the metabolism of completion on the film. There's a traffic jam in post-production, where a pinch-point of contribution occurs. When we were recording the music for *Cold Mountain*, the picture wasn't locked; we were pre-mixing, grading, recording ADR and still cutting the film. So the director is required to oversee all those elements, and all the while every element is volatile. It's a conundrum: the safest way to do a job as a composer is to wait until everything is locked because, if you're trying to write to the contours of a scene, if you're trying to properly underscore a sequence in a film, you need to know – to the frame – where everything happens so your music can carefully plot its way through a sequence. On the other hand, because the picture gets locked so close to the release of the movie, you cannot wait to record the music, as the final mix begins the day the film is locked. And so there's no sane way of handling the music.

It's extremely frustrating, and Gabriel gets exasperated. He feels assaulted by the process and it's always a shock to him no matter how many times it happens. On *Cold Mountain*, at a certain point I received an email voicing his sense of the tyranny of working to a picture which, every time he looked at it, had altered; the tyranny of creating music and having it ready for the recording sessions when he'd only just seen a new cut, and then to be told that the new cut was also still in play. Every time it happens he says it's never been this bad, and I have to remind him that he'd written me identical emails on the previous two films. Somehow, through all of this discomfort and dismay he creates beautiful, consonant, sensitive and spiritually connected pieces of music for me, and it's a marvellous collaboration.

Another challenge which every composer faces is, do you sit away from the film making coherent pieces of music, or do you sit with the film and trace the dynamics of every scene? If you're tracing the dynamics of every scene, then every piece of music has to have a shape which is contorted by the contours of the scene. It's very hard to make a coherent prelude which dodges between dialogue and sound effects and can also stand as a piece of music in its own right. Most scores sit somewhere in an unhappy relationship with the scene and with the demands of the scene. You sometimes hear beautiful pieces of music, but which are fighting and simplifying the various dynamics of a scene. Other times you hear carefully choreographed underscoring which becomes a wash because it can't possibly maintain its own identity. So it's a bastard activity, composing for film. Given all of those really complex inhibitors, Gabriel has always been able to create beautiful

music which serves the scene, is a character in the scene, but which observes, where possible, the intentions and the modulations of the film.

On *Cold Mountain* we worked harder to actually understand what the film had become, rather than what Gabriel thought it was going to be when he read the screenplay. He started with two very solid melodies. He wrote one for Ada's gift to Inman in the fields, where she plays him something in lieu of a conversation: 'You're saying you might be interested in him when you go up and say hello,' so she plays her piano from her cabriolet as a way of saying hello. He composed that music at my house in the country, in the studio where I was writing, and I had a lot of input into it. He then composed a second piece, which is what Ada plays when she's missing Inman; it's a very beautiful, simple tune in C major which is developed in many ways in the film.

Both pieces are unusually Protestant pieces of music; they sound very American, and that was a conscious decision on his part and mine to try and find melodies which would speak of the period and also speak of the place. One of the jobs I had to achieve in *Cold Mountain* was to disguise the European-ness with some American flavour, and Gabriel successfully created these quite unadorned, simple, un-neurotic melodies. Very tonal, descending scales, that don't surprise you in their shapes. I suppose that's a terrible commentary on our European sense of America: a simple optimism and a simple confidence. Also, these two pieces seemed to speak of something clean, pure and innocent. When the movie was put together, Gabriel felt that those two themes would provide enough material for the score. Because he's such a master of variation and treatment of material, he felt he had enough to investigate all of the various moods and tonalities of the film. I felt strongly that that wasn't the case, that over and above servicing America and servicing these simple interchanges that go on in the film, there are much darker yearning issues: Inman's yearning to get home, but also the film's yearning for the best of humanity in the face of the worst of humanity. I spent a lot of time looking and poking around with him for a theme which had some gravitas and heartbreak in it, which belonged much more to a romantic tradition, a more operatic sound.

Ada says to Ruby, 'All this time I've been packing ice around my heart, how will I make it melt?' because she never really expected Inman to get back. This is the horrible irony of the film – that they both know they're going home to nothing, that he's not going to make it and that she fears he'll never make it. And in many ways he never does

get back; in our version of *Cold Mountain*, he never gets home and so their anxiety is rooted by fact. The music had to reflect that in some way; it had to have an emotional density and despair in it. It needed some theme which would hold hope and despair. And so Gabriel and I had a session where I went over to his house late at night and said, 'I don't think we've written enough music. We haven't created enough.' And he was furious with me and played me all the variations of the two themes again and all the versions he'd made of them, and I said that, notwithstanding how much I liked those themes, there wasn't enough there to sustain the film. He kicked and screamed and then created something very beautiful. It's a theme that's planted in four key places: when Ada looks down into the well, when Inman arrives at Cold Mountain and sees the view, when he meets Ada, and when he dies – the four places where the music really has to deliver. It's a piece of music which does have enough psychology. However, it doesn't finish itself quickly and it doesn't fully voice itself. I think that's its trick. One of the things I'm interested in is in it not quite voicing itself – again this may be the same half-arsed tendency that I have in my writing, where I never want an idea to be fully spoken: I don't want it to be implied, I want it to be inferred. Don't tell me what I'm feeling; let me work it out but give me enough indication that I should be working it out. That's probably where my taste resides: I want to set up the constituents, but I don't want to join all the dots. On the one hand, I'm a sucker for Puccini, for big tunes; that's just the fact of it: my films are 'big tunes'. But, on the other hand, I get nervous of making that tune too articulate, so I suppose my modifier is scraping away some of the assertion of those tunes both as a writer and as a collaborator with Gabriel on the music: don't give me the whole thing, just give me some of it.

There's a tendency for film music to get sad if the audience is supposed to be feeling sad, to get lyrical if the audience is supposed to be looking at something lyrical. It's a very dull way to use sound and it's very dull to use image simply to tell an audience how to look at an event.

Once we have a theme, we set about discovering what instrumentations will give us exactly the right feeling. This is a trial-and-error thing. For example, there was no more articulation of the *English Patient* theme at the end of the film than there was in the very first cue, none whatsoever; it's exactly the same piece, it's just that the treatment is fuller and richer. I have difficulty understanding that the treatment of music is at least as significant as tune; I'm always grasping for tune

whereas Gabriel hears sound and how that sound is created. We discovered in *Cold Mountain* that the harp seemed to fit perfectly. Although it is a very unusual instrument for this film – which is broad-shouldered, gritty and sanguineous – I liked its delicate and airy sound and encouraged its use. I liked the film better when the sound was dispersed. I didn't want to fill in the middle too much, so I kept saying, 'Give me the space and the sound. Don't fill up the whole sound picture with your music.'

When you have cut the whole film in silence, with no music, I am always nervous of the impact of the music. As we get acclimatized to it, perhaps it will be the case that we'll accept a deeper voicing in the actual themes. But, initially, it's as though a stranger turns up and says, 'I'm going to be in every scene with you. You thought it was Almásy and Katharine, but it's actually Almásy, me and Katharine; you thought it was Ada and Inman in this scene, but it's actually Ada, Inman and me. I'm going to sit here and squat in the middle of this film.' You have to get used to that person and throw him out of some of the scenes and make him shut up in some of them and just whisper, and other times it's wonderful when he comes in and just yells at the top of his voice.

I begin to think about music as I begin to think about the screenplay, and each film that Gabriel and I have done together has arrived with the equivalent of a key signature. *The English Patient*, for example, had the idea of playing African and Arabic music against Western music. I remember we listened to *Turandot* very early on because that's a piece of music which is entirely European in its provenance but which tries to listen and echo some of the qualities of the East. I talked about the method of creating the score as being a creation in the way that *Turandot* is, but also listening to this jukebox of swing and jazz that Almásy was obsessed with. So the room that Gabriel was writing in was, as it were, crowded with furniture before he could begin to inhabit it and make it his own. The furniture in *Ripley* was jazz: the extemporizing of jazz versus the formalities of classical music, with this parenthetical notion that classical music is essentially a much more sophisticated form of extemporizing – that Bach's thirty-two variations on the Goldberg aria was a form of early jazz. So a quite developed notion of the musical landscape existed before Gabriel arrived to do his work. When I found Marta Sebestyen and included her not only as a musical idea but as a dramatic idea within the screenplay where the song is disinterred during the course of the scene, his

first reaction was to say that it's impossible to create a score which has to accommodate this very particular and distinctive sound. The triumph of the score of *The English Patient* was how brilliantly he accommodated it, and the triumph of *Ripley* – which I think is a really fantastic score – is that it leant in towards some of the ornamentations and characteristics of jazz whilst maintaining an absolutely classical form. Similarly, the triumph of the music in *Cold Mountain* is that it is thoroughly European and classical in its formation, but listens to the American music of the nineteenth century and manages to find its shape in a room already full of the indigenous music of the mountains of North Carolina and the religious music of that period. There are lots of the sharps and flats of my own sense of how the music should sound before he can play a note. I think he acknowledges the value of the parameters I set him. For instance, I gave him some Arvo Pärt and some Janácek for *Cold Mountain*, and if you listen to the Janácek string quartet and then to *Alina* – which is the Arvo Pärt piece that I gave him – they seem to have nothing in common except that there's an idea informing them. Gabriel found the space and the transparency of *Alina* very interesting – it has a particular sound which is, I think, called tintinnabulation, which is this idea of single notes sounding like bells which resonate in a space without filling it – glass-like, transparent and simple. The music he's written for the love-making scene in *Cold Mountain* I don't think could have been produced without that as a reference; but if you laid those two pieces alongside each other there's no direct correlation.

When I was writing *Cold Mountain*, I again surrounded myself with the music of the period and of the culture. I have great faith that everything is waiting to fall into the film and that you don't have to go looking for it. It's going to be right in front of your nose. That's always happened to me, my instinct delivering something to me. For all my desire to have a wonderfully complex theoretical apparatus to go to work with as an artist, in reality I'm very instinctive, and when, for example, I heard the shape singing I knew there was something fanatically pungent. I was seeking the sound which would say Cold Mountain town. I am always on the lookout for something musically distinctive – Marta Sebestyen in *The English Patient*, and jazz in *Ripley*.

I thought the shape singing in *Cold Mountain* would have an interesting relation to the battle sequence because it's non-Freudian music. It's just four-part basic harmonies asserted very strongly; people sing with all of their voice, all of their lungs. 'I'm glad that I am born to

die' is a pretty extraordinary line to bellow in your community; it's a fundamental Christianity that it's singing of, and that seemed to be specific to that element of American society: the right to do this, the belief of that. It's fervent and apparently not compromised by ambivalence in any way: 'If there's a war we'll all fight.' It's an unequivocal culture at some level.

When I got to Berkeley in California after we'd finished shooting *The English Patient* and the issue of the film's score became more significant, we had, by that stage, already shot a scene in which Marta Sebestyen's music had been used because Almásy and Katharine discuss the song that he puts on the record player, which is an old folk song. I had been obsessed with using Marta Sebestyen's voice in some way because, when I was writing, I had, as always, immersed myself in the sounds of the place and the period. I had been listening to a huge amount of Hungarian and Arabic music when I came across this song, which I'd thought was Arabic and then discovered to be Hungarian, which I thought was perfect index of what the book was talking about – that identity, nationality and boundaries are illusory. It seemed hard to believe that the song came from Europe as it felt so much like the music I was listening to – of Africa and of the desert. 'Szerelem' means love, and the scene I wrote around that track is very important.

I was determined to try and make contact with Marta Sebestyen, and somebody in the editing room said to me, 'How are you going to get in touch with her? What are you going to do?' I said, 'Well, she's Hungarian. I'll have to try and track her down through the record company.' That lunch time I went to a café and sat down with a sandwich and a free Berkeley newspaper. I turned over the front page of the newspaper and the photograph of Marta Sebestyen was there advertising a concert in Berkeley. So that night, Saul, Michael and I went to see her. Forty-eight hours later, she was sitting with us at Fantasy studios in Berkeley discussing a deal for her to sing on the film and watching a scene, which we'd already shot with her voice in, and saying, 'Well, that's very strange.'

AM with mandolin on the set of *Cold Mountain*

The jazz club scene in *The Talented Mr. Ripley*

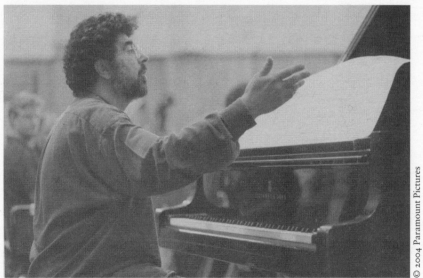

Gabriel Yared, composer

Editing

Anthony Minghella and Walter Murch in conversation with Timothy Bricknell

30 October 2003, during the final mix of *Cold Mountain*

ANTHONY MINGHELLA: Well, it's very important to start by saying that Walter has got his lucky sweater on. Which means you can tell what stage of the movie we're at . . .

WALTER MURCH: It's just unlucky if I take it off! (laughs) This has been my mixing sweater since 1969, so there are many hidden vibrations from all the films I've mixed that are now woven into the wool of the sweater.

TIMOTHY BRICKNELL: Are you generally superstitious?

WM: I think most people in the film business are, because the process is so subject to sudden displacements of chance, from the weather to financing to . . . everything. You grab hold of little talismans to help your footing, and the longer you have them, the more significance they acquire. I have a lucky pencil that belonged to my dad. If I don't know where it is, I get agitated. Sometimes I wear it behind my ear if I feel the need to get some brain activity going.

AM: On this movie your Romanian teacup has been very important to you.

WM: Yes, that's another one. *Cold Mountain* plunged all of us into the relatively unknown world of Romania – Anthony more than me, obviously, because the shooting was subject to all kinds of situations and vicissitudes. Once we – the editing team – found our feet at Cinelabs in Bucharest, we were firmly planted and it turned out great. But there certainly was a little intake of breath before making the jump itself, especially with all the sophisticated computer equipment we were bringing with us. Once we arrived, I began to focus on this particular teacup that has now come with us to London. So that may have the beginnings of a history.

AM: Walter and I have a history in the sense that this is, for me, the third film in a row on which we have collaborated. Obviously, Walter has managed to do some other work in the interim, but he's become the essential part of the film-making process for me. We've probably spent more time together than I have with my wife in the last years –

day after day after day in some cutting room together: Berkeley in northern California for *The English Patient* and *Ripley*, and now in our new building in Hampstead on this film. I think what's interesting is the degree to which what I'd learnt in the cutting room on *The English Patient* came with me into the shooting of *Ripley* and *Cold Mountain*. Although I have to say, before Walter says it for me, that I haven't learnt very much in the process, because if there was one signal lesson to be extracted from the process of cutting *The English Patient* it was that I overshoot. Walter gave me a stopwatch after that film which I could use to time the script of *The Talented Mr. Ripley*, and clearly I can't use the stopwatch either because that film was also wildly overshot. More thrillingly, it was also the case with *Cold Mountain*, although the length of the screenplay has crept down from project to project. It has taught me many things, not least that it's hard to fight your own sensibility. But I have also learnt that there's some elaboration that I add to the screenplay when I'm shooting, despite not being conscious of doing anything other than collecting what I'd written down. I don't feel that I'm developing the idea in any sense. I often feel that I'm shooting very starkly and I worry that there isn't enough there. The process of collecting material sometimes seems quite prosaic to me, but nevertheless something is definitely added and I have to confront this when I come back to the cutting room. I go through the process, which Walter describes as 'not looking at the film you think you've made, but the film you have made' and then having to attend to it. The most significant part of this process has been that we've had to confront a massive first assembly [*Cold Mountain*'s was 5 hours, 10 minutes].

WM: It's liberating, in a way, because you have this wonderfully demonic circle: every scene is holding a loaded gun to the head of every other scene, saying 'only one of us is going to get out of here alive.' You know that certain moments are essential, but then when you're walking home you think, 'Do we *really* need that scene?' Or, 'What if we put it in some other location?' When a film has a shorter assembly, the scenes are smug, in a way, because they all know that they're going to wind up in the finished film, like the members of an exclusive club. So they're all friendly with each other in an often unhelpful way: the film-makers aren't forced to re-examine everything – all our hidden assumptions. Whereas when the assembly is long, it is clear from the beginning that things have to go, and the question is: which ones? That makes you re-evaluate, in filmic terms, all of the reasons, the

juxtapositions, even down to the core ideas. In the last six weeks, for example, we have gotten down to a deeper level than what we thought possible (in this case, by losing another twenty minutes). Something like this has been true on each of Anthony's films, but it's particularly vivid right now because *Cold Mountain* was the longest of all the assemblies and so it's achieved the most compression. Sometimes we're both surprised at what emerges as a result of the intense atmospheric pressure the film is subjected to in the editing room. Frequently, accidental things that Anthony discovered during filming suddenly emerge as talismanic and essential, even though at the time of shooting they seemed tangential and unplanned. *The English Patient*, for example, begins with an image that was a B-camera point-of-view of the drawing of one of the swimmer pictures in the cave, and it ends with another B-camera point-of-view looking up from the truck to some cypresses with the sun going by. I think if at the time of shooting Anthony had tapped the camera operator on the shoulder and said, 'You're shooting the beginning of the film,' or 'You're shooting the end of the film,' (a) they'd have been surprised, and (b) they might have gotten a little flustered thinking they have to make it more significant. But all of this gets revealed in the high pressure cauldron of the cutting room. Godard has a great phrase for it: *the transformation of chance into destiny.*

AM: This process has been remarkable on *Cold Mountain*, because we seem to have reduced the material by 50 per cent . . .

WM: More.

AM: More than 50 per cent, without actually touching the vertebrae in any shape or form. It's a very bizarre process because, as Walter describes, we keep arriving at a point where we feel that we're scratching at the bone of the film and any more would involve some amputation, but somehow we go round again and there's been no amputation of any real consequence, and certainly there's no real sense of harm that I feel at the moment looking at the film. In fact, it's quite the reverse. The last month or so of cutting has been quite bracing because *Cold Mountain* is the most expensive movie Miramax has ever made, so there's an attendant neurosis and anxiety – perfectly understandable – that hovers around the film and therefore around us. Although it has been fairly attritional to negotiate that neurosis and try to keep our compass clear and undistorted, the actual work in the cutting room has been exhilarating. Every time we pushed, the film has enjoyed

being pushed in some way. *The English Patient* was a much more complex organism because it wasn't really a narrative film. It wasn't a narrative book: the beauty of the novel was that at close quarters it was fractured, full of chronological dissimilarities, perspectival dissimilarities, was entirely decentralized; it could shift from one city to another, one country to another, one era to another, one character to another twenty times in a page. And the adaptation, although it veered a long way away from the novel, obviously took with it some of these characteristics. When we came to the cutting room, it seemed that we had a bag of marbles, and every time we moved one of the marbles around the film changed, and we were still rearranging those marbles on the last days in the cutting room. That's certainly not true of either *Ripley* or *Cold Mountain*.

WM: *Ripley* was a linear story, told from a single person's point of view: almost every shot was either of Tom Ripley, or somebody or something that Ripley was talking to or watching: there were no scenes, for instance, where Dickie and Marge went off and discussed Tom in private. And the film was heavily plotted, so it could only be told one short-vertebrae after the other – it wasn't possible to do much scene-shifting. *Cold Mountain*, on the other hand, is some fusion of *Ripley* and *The English Patient*: there are sections at the beginning of *Cold Mountain* where we are in the present (towards the end of a war) remembering the past before the war – just as in *The English Patient*. And yet *Cold Mountain* has this very strong spine of Ripley-like linearity in Inman's story as he walks back to Cold Mountain; and in Ada's story as she struggles with her own dilemmas at Black Cove Farm. Each of those is linear in a way that the mosaic of *The English Patient* was not. In *The English Patient* you could have scenes between Caravaggio and Hana, Hana and the English patient, between Kip and Hana or Geoffrey Clifton and Caravaggio. Every possible combination of characters was allowed, and there were also no obvious chronological rules. And the film enjoyed those different perspectives rubbing against each other in those different ways. Whereas *Cold Mountain* doesn't work at all like that: it cannot have a scene where Veasey meets Ruby before Inman, or a scene between Esco and Sally before Ada shows up. And within Inman's story (and to a lesser extent, Ada's) there is a strong linear element: one event triggers another. So even though the Ada/Inman stories of *Cold Mountain* alternate back and forth in time and space somewhat like *The English Patient*, the film also has something of Ripley's point-of-view linearity.

TB: You were talking about holding your compasses earlier. Do you both have different compasses? Do you have very different views of the material because you've been separated throughout the shooting?

WM: Different – but not very different. Different *enough*. A director casts a film not only in front of the camera, but behind it as well. In that sense, it is a goal to assemble a cast and crew who will all generally be looking at the same material in the same direction. No matter how talented people may be – actors or crew – they will be harmful to the film if they are always seeing things completely off-axis: 'that's not a tomato, it's an apple!' But at the same time I believe its important not to force the vision of the film into monocularity. Otto Preminger was famous for this completely singular approach: my way or the highway. Those kinds of films can be very efficient, but they lack an organic dimensionality which comes from collaboration among people who see things in different ways. But those differences have to be similar enough to be resolvable. Our left eye sees a slightly different image from our right eye, and both images are two-dimensional. Our brain, however, has figured out that if it imposes the concept of *depth* onto these two flat images it can resolve the differences: as a result you see *one deep* image, rather than *two flat* images. But if I cross my eyes, the images are suddenly so different there's no way that my brain can resolve them. The greatest dimensionality happens right when the images are at the edge of being unresolvable.

AM: There's no doubt in my mind that our eyes were looking further apart on *The English Patient* than they were on *Ripley*, than they were on *Cold Mountain*. What happens is, like couples, over time you take on some of the colours of each other's personalities and tastes until they become implicitly your taste. On *Cold Mountain* there have been very, very few occasions on which there's been a substantial differing of opinion about which direction we should go in. Often I've been just about to open my mouth as Walter's gone through a scene and done exactly the thing that I was about to say, and dozens of times we've watched a reel, made notes and our notes almost exactly coincide. That's partly because we share a similar aesthetic about films, and partly because some of the films from which I have learnt about cinema Walter worked on, and partly because over time there's been a converging of taste by spending time together and looking at films together. Walter is a film-maker in every sense: he's directed films, he's mixed many films, he's cut many films and he's written many films, so in that sense I'm not looking for someone to act out my notions of how

to cut a movie, to do that bit of work for me while I'm doing something else. I see the cutting room as an enormously significant part of the film-making process and one in which the film's authoring continues. I'm authoring the film when I'm writing and directing, but I feel strongly that that continues in the cutting room. That process requires, I think, much more of a dialectic in the cutting room; it requires some sense of a crucible where ideas are thrashed out and have to be justified, and where every moment has to be tested. The writer and director cannot feel proprietorial in the cutting room. In the course of reducing a film to a manageable length much blood is shed and there are many hostages to the process. Many of my favourite moments from *Cold Mountain*, which I loved when shooting, were clearly not consonant with what the film required and had to go. The film is clearly better without them, even though the moments, looked at on their own, are often beautiful or apparently vital. Walter has an unusual practice, which is to take something away in order to see whether it demands to be returned. The first time he did it to me on *The English Patient* I almost burst into tears. I came back to the cutting room after doing some looping in London and watched the film, and the sequence in which Hana flies up in the chapel with Kip swinging her wasn't there. It's a mischievous, antic way of working, but sometimes that happens and the scene does not come back in.

WM: Hmm. My memory of that is different.

AM: It is?

WM: I don't remember ever removing the swing scene. I *do* remember removing the first dance between Almasy and Katherine, which was just as significant in its own way. But whatever the truth might be, removing seemingly key scenes is always done in the spirit of 'Let's see what happens if . . .' By taking a scene out – even though we believe it may be essential – we often see more clearly what is left in its absence. And, even if it gets restored, it will go back in a more informed way.

There was a version of *Cold Mountain* where we tried telling the whole beginning in linear chunks: everything to do with Cold Mountain town before the war; then Inman's experiences during the war; then after the war. On the one hand it didn't work: it was too inert, but we *learned* that it didn't work, and why, and as Edison said, that's a valuable piece of information – knowing what doesn't work. But also in some mysterious way there are echoes of that structure in the film.

AM: Scenes never go back together in the same way. I don't think we've ever just said no and then put something back the way it was before – there's always been some stain on the film, some alteration to the mechanism. Some parts of it, some ideas inform your sense of the movie. You're not cutting in a linear way, you're reducing; it's not taking things away, it's distilling them. The image I have in my mind, which is not a very good one, is my mother making *sugo* for pasta: you start with the full saucepan, you don't ladle anything out to get it to the right intensity, leaving it to boil down so everything is still there, but reduced.

WM: Everything begins to permeate everything else. Certainly, that's what has happened over and over again on the films we've worked on. We've managed to remove things, but then often found unexpected ways to tuck them – or parts of them – back in. The film gets shorter but there's more in it.

AM: The idea of challenging the film at all times is something I love. If I worked now with an editor who didn't do that, I would feel very insecure. Also, having an intellectual opponent who you are fairly convinced hits a bit harder than you do is not a bad thing to have at any point in the film-making process. It's particularly useful in the cutting room. I find myself walking home exorcized by what we've done in the day, and every time there is a sense of his dispute with the film then I take it very seriously and worry about it. It's interesting also how our moods affect each other. Walter can disappear into darkness for periods and I find myself wanting to be chirpy. And then, at other times, I go to a very dark place of feeling like I'm looking at my own stew. I can also get into a dark mood because, outside the cutting room, I have to encounter the noise from the studio and the producers and often get beaten up by whatever it is that's going on. But then when I come back in, Walter can sense – even with his back to me – that something's afoot and then he becomes larky Larry. It's the most skinless arena, the cutting room, because you're not going to do any-thing else, you're not going to be able to fix it somewhere else, you're not going to fix the movie in stage four of this process – this is it. When you leave that room, essentially you finish the movie.

WM: Right now, we're a week or so into the final mix and we were still cutting the film the day before we started the final mix. Of course, this is not the way you 'should' do it. In classic film-making practice, you would lock the picture and then invite the composer in, and the sound

effects team, and the visual effects. All of their contributions would then clothe the film. But they wouldn't have an opportunity to alter the film itself. I prefer maintaining editorial fluidity right up until the last minute: let the music, sound and visual effects into the process early, before the film has 'set', and give them the opportunity to influence the film. Which is what has happened on *Cold Mountain* and all of Anthony's films. We did a full sound and music mix in June that we've been modifying as the film changes, but which has in turn also been modifying the film. And the same thing with the visual effects. The longer you can sustain that fluidity, the trickier the juggling gets, but the more information you have to make intelligent choices, even though it can be nerve-wracking. It is both a benefit and a danger of the state of technology at the moment. For instance: the negative is not being cut on *Cold Mountain*. We shot film, but we're making a digital intermediate master from scanned sections of the uncut negative original. This means there is never a moment where we say, 'That's it, the negative is cut, certain kinds of changes can no longer be made.' We could stop right now and go back and do some cutting . . .

AM: Don't say that . . . it's impossible!

WM: I didn't say that! It's impossible!! But the situation is very fluid right now and will continue to become more so the deeper digitization works its way into the film-making process. The danger is that because you think you can always change it later – 'fix it in the mix' – you may not necessarily do all the advanced preparation necessary to make sure everything meshes in an interesting way. And there is no substitute for a certain kind of advance planning.

TB: And all the other elements are trying to catch up with what you're doing to the picture. Is the sound always determined by the picture or is it sometimes the other way round?

WM: It's a dance. When I assemble the film for the first time – when I have the raw images and I'm making them collide with each other for the first time – I deliberately turn the sound off and I listen with my inner ear to what the people are saying to each other – also to the music and sound effects that aren't even there yet. I don't let the existing sound interfere with that inner sound. The trick is to make that inner sound explicit as the film progresses. Even if a scene doesn't have music, the fact that I 'heard' a certain unwritten music will affect many other decisions. The scene may become visually musical, even if in the end there is no actual music under it.

AM: That indicates the extent to which Walter enjoys a certain kind of autonomy, especially at that stage in the process. Conventionally, the director sits in the dailies projection room and gives notes to the editor: 'Take two for the close-up, take one for the establishing shot, the tracking shot should be take five.' I normally get notes from Walter. Certainly I have no interest in intervening in his first assembly or in commenting on which take works and which take doesn't. I love the abdication at that point of the process.

One of the things I've come to realize is the degree of control I exert on a film, much of which I'd been innocent of. I wrote *Cold Mountain* alone in my house in Hampshire and, in the two years since then, there have been eighteen hundred people involved in it whose work, essentially, I've controlled and made happen. I've set up the environment, I've set both the questions and the answers. It's quite tyrannical in some ways. Even though I want the actor to feel that they can readjust and reimagine each moment, essentially I've allowed them a very tiny cubicle of possibility. So whilst Walter puts together his first assembly, I enjoy the idea of giving the film to another mind and have that person reimagine – and in some ways guess – what the intention of the scene is.

Later in the process we'll arrive at a point where we'll go into the other material and look at other takes. Then the film begins to change and the assembly becomes an unreliable template. Although you've got the assembly as a reference point, sometimes you're looking for a different feeling. For example, in *Cold Mountain*, early in the process we were intrigued by certain elements of the love story towards the end which had a contemporary feel. I had done quite a lot of improvisation around the end of the love story. I was very intrigued by those moments of extreme intimacy that people in love have when they're alone together in rooms. Those moments seemed marvellous in the assembly but gradually we went back and examined other takes and fished out the gestures which seem more consonant with the period and with the circumstances. We've quietened down and looked for much stiller and more contained moments.

TB: There's a great deal of science to editing, an inevitable logic to the assembly of shots, a grammatical structure, and of course the operation of machinery to put it all together. But I've noticed that the way in which Walter works has a lot to do with instinct . . .

WM: I tend towards over-organization, so I recognize that's something I have to keep on a leash. I arrange my organizing in a way that allows

me areas where I can be in free fall, where I can completely let go of the organization and operate on instinct. You can get more creatively 'lost' – and I mean that in a good sense – when you have a map of the terrain in your back pocket: if you go into the jungle without a map you will tend to be conservative because there is no backup: you stick to the creek beds because that's safe. But if you have a map, then you know that these two rivers flow together ten miles on and so feel free to climb over the ridge and make some serendipitous discovery. So I take very careful notes about everything – probably 1,500 pages of notes for *Cold Mountain*, with footages marked exactly where things happen. It's obsessional, but this obsession gives me the ability to improvise – to be in creative free fall – and if I ever get lost I can look at the notes and see, for example, that she smiles nicely at 560 feet in take two. I also have a system where I snap representative frames of every slate that Anthony shoots – rarely just one picture, usually two or three, sometimes six or seven of the key moments in each camera angle. And then I print these pictures in fairly large format and mount them on boards, fifty or so to a board. There may have been 4,000 pictures for *Cold Mountain*. When I'm editing, these pictures are staring down at me from the wall so that I'm cocooned in the images of the film. And if my eyes flick over to the right I'll see a whole kaleidoscope of images and, without me even knowing it, my eye will pick out one of them and it'll say '212', and then my notes will say, '212: Interesting exit from the room, camera lingers and then suddenly swings to the left at 347 feet.' So my process is a mixture of the programmed and the random, and I think everyone who works creatively has to come to some balance of that in how they work. But to do *that* effectively you have to have some self-knowledge about your own powers and limitations. Many editors would not warm to this amount of note-taking. They might just put the material up and start cutting it together and see where it goes. I can't work that way because I have to let my obsession have a place, and then I can let go of it. I know the material so well that I can go anywhere and instantly recall where I am. If I didn't take those notes and pictures I would feel lost.

TB: You don't really like coming to the set, do you?

WM: Years ago, I found that there was some dissonance between what I was carrying in my head and what I was looking at on the set. I was trying to come to terms with that when I realized the obvious, which is that the film editor has one of the few creative jobs on a picture where

you can choose *not to know* what conditions were like at the time of shooting. You share that perspective with the audience, who, likewise, don't know how cold it was that day, or how anxious people were, or who had an argument with whom, or who was in love with whom. Everything, emotional or physical, that exists outside of the frame is unknown to the audience at the time of watching the film. So it's good to have somebody – the editor – who only knows what they see on the screen. As a result, I often come to value something that was shot under duress or by accident; and vice versa: something that was tremendously important and took a long time to shoot I'll feel unpressured to include simply as a matter of course. So I joke that if I go on the set I shield my eyes and I look around at the floor until I find Anthony's shoes, and then I look up and talk to him, trying not to see anything else, and then scurry back to the editing room. Editors who spend a lot of time on the set are losing something that they can never regain, which is a kind of innocence about the material.

AM: Walter will often include accidental gestures or trips.

WM: There's a lovely moment in *Cold Mountain* where Ada goes to Inman's rooming-house door: she knocks and then her hand accidentally hits the brim of her hat. That was an accident in Nicole's performance, but it helped show up Ada's nervousness: here she is, knocking on a man's door, maybe for the first time in her life, and there's a sense of not being in control of everything. It's just one of those very small textures that adds a little knot to grain the wood.

AM: This mirrors some sense I have of what the whole business of film – or fiction – does. My family went to Buckingham Palace together about two years ago; it was a big outing for the whole family and, en route, my father, who thought he hadn't been there before, obviously remembered that he had been there and said, 'That's the step where Gioia tripped over.' Gioia, my sister, had been there as a child, and the step that she'd fallen over was what had stayed in my father's mind. It made me think about the extent to which my writing collects mistakes, distortion and times where things don't go exactly as planned. Part of my dramaturgy, I think, is concerned with fracturing of some description and then, subsequently, part of Walter's editing process also identifies with the stumble or the awkwardness. If there are five takes of somebody walking away from a house and in one of them there's an adjustment, then that will be the take that Walter lights upon. What sticks in the mind is what we find significant. People hit their heads in

my films, or they tumble into each other, or things happen which slightly pierce the skin of the moment. And that's in a small way, but in a larger way I think that the whole architecture of my writing does that.

Walter's pointed out many times that I can't just let things be, I can't let my music play for very long without disturbing it. In *The English Patient*, for example, when Almásy and Katharine get together for the first time, Katharine's husband (who is busy tearing a piece of paper trying to make some kind of heart-shaped chain to celebrate their first wedding anniversary) sees her heading off in a cab and follows her. We end up cutting between the two situations: this room of love and passion is tempered and interrupted by this sad man with his paper chain.

Both Walter and I are looking for places of derailment.

6

Showing

The Business of Film

Welcome to Hollywood: Making *Mr. Wonderful*

When I first started writing plays, I wrote plays to direct, not plays for other people. I'd let go of that as I'd begun to develop a real career as a writer, and I was experimenting with returning to being a director when I made *Truly, Madly, Deeply*.

That film was very modest in its ambition and modest in its intentions. It was an experiment to see if I could work with actors again and what it would feel like. It certainly wasn't an attempt to embark on a directing career. But, like ten thousand people before me, I was astonished by the reaction in Los Angeles, which was not to do with *Truly, Madly, Deeply* as a screenplay – in fact, many people didn't even realize I'd written it – but with the fact that I'd directed it. So when I arrived in Los Angeles to begin the process of finding a distributor for that film, I was confounded by the reaction, which was more enthusiastic than I'd anticipated and was articulated by truckloads of screenplays arriving for me to think about directing. I thought this was rather unique to me, and then discovered that every director of any merit whatsoever had had this experience. But I didn't know other directors at the time, so I just thought that this was something happening to me and I was being taken seriously as a director. *Truly, Madly, Deeply* was picked up for distribution by Tom Rothman at Samuel Goldwyn's company and he was determined to secure my next film because, again, that's the practice rather than an idiosyncrasy – it's important to grow relationships. At the time, I didn't see it as any process; I just saw relationships growing and liked Tom very much. They had a library of unfilmed screenplays they had been developing, and he sent all of them to me. I was quite intoxicated by the idea that I would be taken seriously as a director in America. I had never really

worked in America, except briefly as a playwright, and the idea that somebody would give me money to make a Hollywood movie just seemed totally extraordinary. I thought I'd better do one of these scripts as quickly as I could before they woke up and realized that I'm not really a director.

So it was a question of choosing between about half a dozen screenplays. It wasn't me contemplating what film I should do next or whether I should go back and write another film, there was a certain amount of contingency about the decision I made. I thought *Mr. Wonderful*, a screenplay by two young New York women, was the one that I would be most able to direct. I felt I could do something with it because the territory it explored had some connection to me, in that it was about an Italian girl in Brooklyn who was trying to escape from her milieu. Even though I'd grown up on the Isle of Wight, nevertheless the sense of community, the sense of family, the sense of Catholicism in the script reminded me, however remotely, of some of the preoccupations I'd had as a teenager. And it was small and touching. I thought that if I were able to do a pass on the screenplay myself and salt it with preoccupations of my own, then I could proceed with this experiment of being a director. It doesn't really bear much scrutiny as a decision. However, I liked the people involved. The producer, Marianne Moloney, had very good taste and very good values and felt like a fellow traveller. It certainly wasn't a great choice for me in terms of content because it's not a story I would ever have elected to have told, but it wasn't about what I'd end up with, it was about the opportunity: the chance of making a film in New York.

So, much of it was to do with the idea that I could be making a film in America with American actors, which says as much about where I came from and the beacon of Hollywood calling as it does about an adult appraisal of the material in terms of a career. It was just, 'Goodness, I'm allowed to do this. I'd better say yes and get on with it.' Everything about it became a learning curve of how not to work. I'm not a director, finally, I'm a writer/director, and there's such a distinction to be made.

I rewrote the screenplay several times, so any criticism that I have about the project is not to do with Amy Schor and Vicki Polon, who were the screenwriters. It's just self-criticism in the sense that it was faintly silly of me not to understand entirely what I was submitting myself to. If somebody gives you a plane ticket and says you can travel around the world, you don't necessarily stop and say, 'Well, perhaps there are other tickets and perhaps there are other destinations.' I've

always learnt that embracing opportunities has furthered me more than resisting them, and I would still maintain that embracing that opportunity was a good move, finally. I'm not ashamed of the film; it's just not very personal.

I was offered a film to make immediately and then discovered there was actually very little commitment to making it. I realize now that that's something very conventional. I ended up having to fight for the film that the studio had asked me to make, which was par for the course but seemed absolutely astonishing to me: they had pursued me with an overwhelming passion, I said yes, and then it became a big problem. Every part of it became a problem: casting, locations, crew, material, cost. It now seems absurd, because I realize that what seemed unique is ubiquitous. Every part of that process, which I thought was particular to me and that project, I now see every day, as a producer or a director, around other people.

I thought I could make something distinctive in undistinctive territory. The romantic comedy is the weariest genre in film. It's the most difficult to refresh, the most difficult to pull off. It's so trapped in its paradigm, so trapped in its gestures. When Harvey Weinstein was looking at an early cut of *Cold Mountain*, he identified, quite correctly, that the final pass of the cutting should draw out the focus on the protagonists: we've turned up to see the story of a man returning to a woman and, however important it is to identify and develop the characters that Inman meets and the characters that Ada is involved with in Cold Mountain, finally, it would have to focus on two people. That is an observation I would concur with now, but, in *Mr. Wonderful*, my whole presentation to the Samuel Goldwyn company was that I wanted to make a film about the strength of community. My rhetoric was all about how I saw this *Deer Hunter* opening with dozens of Con Edison workers involved: it was an industrial film, it was a film about work, the consequences of being trapped in work and the dignity of work, and so on. But actually what the studio wanted was a guy and a girl. I remember this word 'tertiary', which I'd never really heard of in relation to drama, which kept coming up every time I did a pass of the script. They kept saying, 'Fewer tertiary characters, get rid of the tertiary characters,' which was all I was interested in. I never saw it as a guy and girl tale; I saw it as a community tale and the process was all about deflected encouragement.

Yes Means No

The film community has all these redefinitions of terms, often amusing: net profit means no profit, residuals means no profit, producer equals liar, lawyer equals frustrated agent, agent equals frustrated director, director equals frustrated actor. The decoding mechanism is one that you learn over time. The language is a foreign language, but it sounds like English but the discourse has to be decoded. A decade later, I have a primer of some description for understanding that when somebody rings up and 'they're very excited', what they mean is 'hello', when somebody says, 'I love your work,' what they mean is they know you're a director. There's a rhetoric which is like oxygen – everybody breathes it, but nobody expects you to take it seriously. I think I took everything completely seriously and literally. 'You can cast anybody you like,' means you don't have casting control. 'Of course you're going to shoot it in New York,' means let him think he's going to shoot it in New York and then, further down the road, tell him that, of course, he can't. Or let him think it's about community but, of course, nobody makes films about communities. You're played but it's nothing personal; Tom Rothman wasn't guilty of any deception because he was speaking a language he understood and assumed that I would too. There was no kind of duplicity on his part because he was entirely sincere in his process, just not in entirely the same language. So I kept maintaining a view of the film that was unreasonable and unrealistic, and everyone around me understood that it was completely unrealistic, except me.

You don't green-light a film just because you've given it to a director; you just begin a process. Whereas with *Truly, Madly, Deeply* I got a phone call saying, 'Do you want to make a film for us?' I said, 'Yes,' and they said 'OK' – that meant I was making a film. I learnt that the same correspondence in Hollywood doesn't mean you're going to make a film; it just means that the clock has started on a film which has probably only a 10 per cent chance of finally reaching fruition. I still see it now with Mirage when we're beginning a process of development: when you are working with the unburned, undamaged, never-been-to-battle participants, they are always shocked at every turn by the process. Even Richard Eyre on *Iris* – a very experienced theatre director and an extremely wise man – would be shocked every day by the various indignities, vicissitudes, lack of respect and double talk that is the daily petrol of making movies: 'He said to me that . . .', 'He was told that . . .', 'The budget was always going to be . . .', 'But how

can they . . . ' We have all been, at some point, completely shocked and bewildered at this well-rehearsed, fully established, relatively honourable, big fat lie that is the process of making a film. Hunter S. Thompson's quote about the music industry – 'Welcome to an industry full of plastic corridors populated by pimps, thieves and sharks. And there's also a negative side' – also perfectly describes the film industry.

I began work on *Mr. Wonderful* on the basis that I wanted to shoot the film in New York. It was about a city and a suburb, Brooklyn, staring across at New York – that was the focus of the film for me. However, it was made clear to me early on that it wasn't anybody's intention that I shot the film in New York. I was encouraged, of course, to use a cheaper location – Pittsburgh, Canada, anywhere other than ridiculously expensive New York. So the first big problem I found was that, having scouted in New York and prepared in New York, the idea was to shoot anywhere else. I had to fight like crazy to stay in New York, which I did. Then the preparation of the film in design terms was about studio versus real locations: the real locations were impossible to manage so we designed half a dozen principal sets. Then the budget came in and the sets disappeared week by week, and we ended up shooting everything on location, in tiny rooms.

It wasn't a 'go' movie until the right constellation of cast fell into place. A business model quite typical of small companies is that at a certain cost and with a certain cast there's very little risk of losing money, and so that's where you locate your business. Sam Goldwyn's model, which was very successful and sustained him for a long time, was risk-averse: small margins of profit, small margins of loss. And he was very good at it, very nice about it and a gentleman at all points. He loved *Truly, Madly, Deeply* and, on the basis of that, I was happy to go and make a film with him.

Saying No

The studio bombarded me with faxes. 'Shoot less film' was one of my favourites – I only had one camera! But the argument about the sign is the anecdote which probably has the most tang to it . . .

One of the elements of *Mr. Wonderful* was the attempt by a group of workers to club together to build a bowling alley and get out from under the grasp of working for a big company. Like *I Vitelloni*, it was about five or six guys who all hung out together, all dreamers, all terribly idealistic, who wanted to have this little palace where guys could hang out together and get girls. There was a deserted,

abandoned bowling alley in the story with a ruined neon sign, and part of the storytelling was the resuscitation of this sign to its former, moving, neon glory by the end of the film when they opened their bowling alley. We didn't make two signs as we would do in any other sane process; we had one sign that had to be gradually distressed to ruin, so we had to work in reverse and film the ending with the fully functioning neon sign and then gradually dismantle it. The sign appears in a crane shot at the end of the film going down onto people arriving at this bowling alley – a perfectly ordinary shot: start on the moving neon sign with a man bowling in lights and then move down to the crowd. It was the end-title shot. Presently, I got a message from the Goldwyn company saying that I needed to speak to everybody about what I was doing with the sign: it was $38,000 to design and make – a lot of money. Then I got a message telling me to shoot some material with the principal actors and the sign. I didn't understand the message. So we had a conversation:

'You must do something with the principals and the sign.'

I said, 'Well, what?'

'You're a writer, think of something,' they said. 'Write a scene with some of the principals that involves the sign.'

'What scene? The finished sign is the last scene of the film. When do the principals come in?'

'Well, that's for you to decide. What if, later in the shoot, you need a scene with a fully functioning bowling alley and you haven't got the sign any more? Do you think you're going to come back and ask us for another $38,000? No.'

'But I don't need a scene with the sign and the principals.'

'Well, we think you should shoot one.'

And the more I affected bewilderment, the more they affected exasperation, because it was the dumbest reaction to what seemed to me to be the dumbest instruction. The noise of this became deafening whilst I was trying to shoot – all I got were memos and faxes and calls asking me about the bloody sign. Finally, there was a telephone conversation where it was put to me that they were going to stop the movie unless I agreed to shoot a scene with the principal actors and the sign. Again, I now know that decoding 'This will stop the movie' means 'We're going to give this one more try before you say no to us,' but I hadn't yet learnt that 'no' was an important word to use as a director. I didn't know that part of the contract of the experience is that the studio instinctively or consciously tries to establish the rules of engagement. I was told to do things and I did them. So I thought I had

better shoot a scene with the principals and the sign. There was an absolutely scrotum clenching (if you can do such a thing – shrivelling perhaps) conversation with the actors where I said, 'Look, we're going to have to go down to the bowling alley and have you walk around near the sign.' The actors, being reasonable people, wanted to know what I needed them near the sign for, and I couldn't answer them because I didn't know. So we shot them wandering around with the sign in the background and the studio were appalled when they saw the dailies. They said that I had deliberately subverted their request, that they couldn't use any of this material. 'What's it for?' they asked. And I didn't know because I didn't want to do it. I think that I wasn't supposed to have done it but just didn't know the language. There are a hundred things like that where I ended up making an ass of myself because I didn't understand that my job was to say no and assert myself. Directors have to assert themselves, have to hold the compass. If you surrender the compass to the production entity, they don't know what to do with it, and from that point onwards you're stuffed. Every choice you make is second-guessed and you have to say, 'Stop second-guessing me. This is who I want and this is what I want and you hired me, so let me get on with it.'

There was an issue about the composer of the film. I wanted to work with Gabriel Yared, who's French. I remember discussing this in a restaurant in London and being told categorically that a French composer would not deliver the music for the film, that it was a known fact that French composers were unreliable. I was handed a huge folder of American composers and challenged with the question, 'Are you saying there's not one composer in this book that's good enough to work for you?' 'No, I'm not saying that at all,' I said. 'Well, choose one then.' The good news was that I worked with somebody I'm still friends with now; the bad news is that it was another surrendering of my own taste that I did obediently. I even felt guilty I'd spent so long trying to get who I wanted.

The editing process was torturous and sanitary because I again found myself surrounded by people who had their hands all over the film, reworking it and insisting on a shape, and who were largely unexcited by what I'd achieved or where my own sense of emphasis lay. It's all relative to the experience I had on *Truly, Madly, Deeply*, where nobody came into the cutting room and I showed my cut of the film, which was the cut that got released. I didn't understand, during *Mr. Wonderful*, that the editing room could become a kind of circus; I'd never experienced that. Now, of course, even with 'final cut', I'm

used to anybody who has ever walked past the set being entitled to an opinion and being entitled to express it.

I learnt what the entire process requires of the director. Any failure in *Mr. Wonderful* was my failure, not anybody else's. Nobody behaved badly. I just didn't know how I was supposed to behave. *Mr. Wonderful* was the boot camp of film-making for me. It was the 'if you survive this, you can survive anything' experience: the humiliation of it, the attrition of it and the camaraderie of it. There were very few days I didn't enjoy myself, very few days I didn't like the people around me and very few days where I didn't feel completely blessed, but it was enormously punishing and bracing. The conundrum of *Mr. Wonderful* was that it was a fantastic experience and a disappointing result; I haven't seen the film since, but I know it wasn't the film that I had hoped for. I think there was some good work and some good experiences, but it left me coming back to London thinking I would never make another film, that I would go back to writing plays and do what I knew how to do. Certainly I came away with one clear insight, which was, that if I ever did it again, I would do everything differently, everything. And I did.

Matt Dillan and Anabella Sciorra in *Mr. Wonderful*

I learnt very quickly that, in Hollywood, if things are going well there is nothing you can't have, and if things are going badly there is nothing you can have. It's really feast or famine. It's a place of such polarizations of possibility, it's such a graveyard of ambition, such a

testimony to the rewards of success. It's populated by people who can't get a job and people who live like Renaissance princes living side by side, and the apparent randomness of who gets the palace and who gets the pavement is bewildering.

The day after finishing *Mr. Wonderful* I stayed in bed all day in my pyjamas and read *The English Patient*. I'd had it for a few weeks and had been saving it up like a special treat. I read it from cover to cover and called Saul Zaentz as soon as I'd finished it.

Saul had approached me after *Truly, Madly, Deeply* to do something with him. I'd met him a few times and had been, as everyone is, totally beguiled and was determined to find something to do with him because I felt that he was such a force and a positive spirit. I read the book and felt that he might get it, he might understand it. One of the things that I completely embrace is that when things are right, everything falls into place immediately. If you're set correctly, the whole constellation lines up immediately. I called Saul and said I've read this book by Michael Ondaatje called *The English Patient* – he'd never heard of Michael Ondaatje or *The English Patient*. He wrote down the name of the book and called me back saying that Michael Ondaatje was reading in Berkeley the following week, and between the phone call and Michael's reading, he had read the book. A week later he was with Michael in Berkeley, and the following week I was in Los Angeles with Michael and Saul and we had the rights. The lining up of the planets was instantaneous.

The thing which Saul gave me – which is absolutely the most significant gift that anybody's offered me as a creative person – was faith. He was unwavering in his belief in the film and his belief in me. I have very little self-confidence and he provided all the ballast I could ever want from the beginning of the film to the end; he was always absolutely terrifyingly certain of the value of the film.

He's the most present producer imaginable; he was on set every single day, all day, with his *New York Times* and *Herald Tribune*. But he's not an invasive producer. He was a silent witness, like your dad's come to visit. He is a patriarchal character, larger than life and full of goodwill to all men when he's working. It was hard to know what he was doing, but you knew that he was the heartbeat of the whole event. He never second-guessed me and was really not attached to the mechanism of making the film at all. He's not interested in the shot or the event or the performance, he's just into the 'it' of it.

Saul's whole career has been at odds with Hollywood. He won the Thalberg Award for *The English Patient*, which is bestowed on people

who've made a substantial and unique contribution to the Hollywood film industry, but he could not be further from Hollywood, he could not be more of a renegade from the studio mentality of methodology. He'd always, up until *The English Patient*, finance his own films, risk his own money. He's pursued very unlikely projects and carried them off. He's made films from material that bears no scrutiny as a potential film project: films about composers, about lunatics, about incidents in Czechoslovakia. And the way he's made these films work is by doing them as cheaply and as unconventionally as possible. There's a mentality he generates which is oddly consonant with 'the glue and bits of string' world of small theatre projects and tiny movies that I had experienced. I'd never been involved with anything with any money, so none of it was foreign to me, but to the American film scale it was entirely foreign. So he was able to help me in attracting a crew who surrendered whole chunks of their quoted salaries.

Saul was so convinced of my talent that he made it possible for me to make that film. After *Mr. Wonderful*, I could very well have just gone back to London and carried on writing plays. In that sense, *The English Patient* was as much a manifesto as it was a film. I felt that very consciously when I was working: this is the kind of movie I want to make; I'm not going to compromise. In the casting of the film, for example, a lot of people felt that I was jeopardizing the movie with the choices that I was making, that it was making it impossible to ever get the film financed. But Saul is guided entirely by a passion to see a film made rather than by any business imperative. So he presided over my assembling a cast that had no commercial value whatsoever for an epic, large-scale enterprise.

My wife, Carolyn, tells this very funny story. We went to Bali some years ago, and she was buying some T-shirts in a market. She went to the lady who was selling the T-shirts, and the lady said, 'That's ten baht,' or whatever the currency in Bali is, I can't remember. And my wife dipped into her purse and gave the lady ten baht. And the woman said, 'No, no, no, no, no!' Carolyn said, 'I thought you said ten baht?' She said, 'No, I say, "Ten baht." You say, "Two baht." I say, "Nine baht." You say, "Three baht." And then you pay five baht.' And so they wrangled, and Carolyn gave her five baht. Movies are like that. Movies require somebody to decode the currency exchange – you have to know that when they say you can't go and shoot in New York, what they mean is, they want to know how desperately you want to shoot in New York, not for you to say, 'All right then.' When I first came out to Hollywood, basically as a playwright who'd made one glorified home

movie, I thought when somebody said it was ten baht, you were supposed to hand over the ten baht. And it took me some time to learn. *The English Patient* is much, much more of my saying, 'This is how much I'm prepared to pay, as it were, for this experience. This is how many compromises I'm prepared to make.'

The difficulty of film's relationship between art and commerce lies in the constant marriage between those who make films and those who have to sell them – and the essential misunderstandings and dysfunctions of that relationship, on both sides. People who are making films never really want to address the imperatives of how you sell a film and what it costs people to make films. Often the very thing that attracts a studio or a producer to a film-maker is the thing they try and annihilate once they've got that film-maker onboard. They don't want the thing that they bought. They want something else. They're frightened.

The hardest problem if you run a studio is to say 'yes' to a film. If you don't say 'yes' to any films, you don't have any problems. And so 'yes' is the worst thing for a studio. The 'yes' word is a horrible word, because the problems all start to happen once you green-light a film.

As a film-maker you have to be very careful not to try and bend your own taste or lose your own compass in the process of trying to attract financing or trying to get the approval of the studio because, again, I would go back to the 'ten baht' exchange: they don't want you to pay ten baht, they want you to pay the right price. And part of the currency struggle is to make sure that they really are dealing with somebody who does have an opinion, does have a sensibility, and they've invested wisely. If you bend too much, and if you submit too much, you're defeated by the industrial imperative.

I do believe that, however much Hollywood wants to believe the general will be safest, they don't really want the general. It's an odd conundrum: they don't want there to be an aggregation of taste; they just feel safest if there is one.

The only way I've ever been able to navigate the industrial process of film-making is to have a 'hearing ear' and a 'deaf ear'. You have to be respectful of somebody who's marketing your movie because they know a lot about something you know nothing about. But at the same time I am wary of listening to them too much because they don't want you to. They may think that the easiest thing is to have the same film they had last year, which grossed $200 million, but on the other hand they don't want it because they know it wouldn't gross that money this year. They don't need you to conform – they just hope you might because that worked before.

So I don't mean to be critical of people in those jobs. It's just a function of those jobs. They're industrial jobs. It's much easier for them to say, 'Oh look, *Cold Mountain* has just won the National Book Award, let's make a film of it!' than it is to say, 'Oh, you've got an idea for an original screenplay.' But my status in the film industry has altered, albeit temporarily, to allow me the position of being able to make anything I want for the time being. But film-making not only takes a long time to do and isn't something you can practise, it's also so costly. I think that people relax when they give you $50 million or $40 million to make a film if there's some consensus on the quality of the idea. With a novel, for instance, they've already got some reviews they can read. However, the number of successful adaptations of novels is so paltry. There's no relationship between a successful novel and a successful film at all. *Beloved* and *Captain Corelli's Mandolin* are just a couple of high-profile adaptations that have been financially catastrophic.

It's been an interesting procedure for me to go into the world of producing and having business responsibilities for films because then you have to sit across the table from somebody who wants to make a film, and you find yourself behaving exactly the same way as people have behaved towards you. You're listening, carefully, trying to detect whether there's passion in the film-maker because, in the end, the only thing you can invest in is real passion and will. You also try to adjudicate whether that passion will transform itself into something that an audience might want to see. And you're using very similar criteria to the ones that have frustrated the hell out of you when you've been sitting on the other side of the table, saying, 'But I believe this movie in which a burnt man lying on a bed talking to a nurse in Italy will be very important!' How hollow it sounded as I was saying it in the rooms of Paramount or Fox or wherever it was that I was trying to enlist support. 'So, let me get it clear: he's burnt, so you can't really recognize him, and he's lying there. And there's a nurse, and she's not American, either – and then what?' 'Well, then he dies, and everybody sort of dies, and ... But it's really important, you know.' I've heard that coming back at me, and often it sounds crazy. On the other hand, sometimes the craziness is intoxicating. That is why Harvey Weinstein was a very important part of the jigsaw puzzle for me. He is somebody who is prepared to give up common sense in the face of encountering real passion. That's why, I think, he was prepared to gamble on *The English Patient*, *The Talented Mr. Ripley* and *Cold Mountain*.

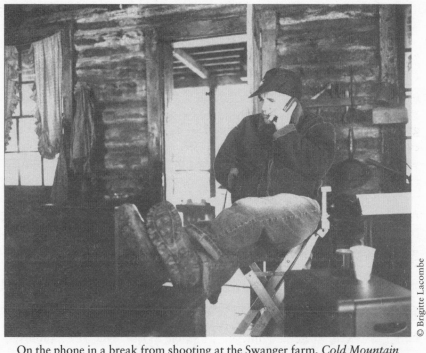

On the phone in a break from shooting at the Swanger farm, *Cold Mountain*

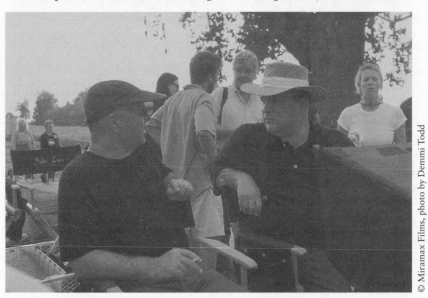

AM with Harvey Weinstein on *Cold Mountain*

152

Showing Your Hand

Of the many delusions that we all have, one of them is that the film is only for yourself. All film-makers are, I think, trying to make themselves happy, to make pieces they're proud of and that their peer group, their collaborators, are happy with. You can't really project the event beyond that, beyond whether you feel satisfied with a moment or whether you feel you've done your best in a moment. You can't make movies for other people, you can't second-guess an audience. And it's a torment to come into contact with the reality of film-making, which is that somebody has to go and buy a ticket, that a lot of tickets have to be sold to justify the negative cost of the film, and that you are finally delivering a chunk of material onto an industrial conveyor belt.

No director wants to hear that. Nobody wants to know that. The first time you sit with a marketing person and they say, 'Well, we can't programme it that week because we're opening against *Saving Private Ryan*,' you're horrified that somebody's even talking about *another* film. But it's the truth of what you've done, as opposed to the fantasy of fashioning your little imprint in the sand, whatever that is.

It is a very difficult transition to make when your work ceases to be a piece of art and becomes an industrial activity. You have to try and find ways of using that transition to profit the film. And I think that what finally separates those people who survive from those who don't is finding a purchase position where you can say, 'I can use this process because I can make the movie better. I mustn't be intimidated by this.' Previews can be used as a way of killing a film. But they're also very important tools. And like all tools, if they're used correctly, they're very valuable, and you have to find the place to be where you can survive them. However, it is certain that life is shortened incrementally by previews. They're horrible, horrible, disgusting things.

One of the laws of film-making is that a movie plays at one tempo when you're watching it in the cutting room. It then decelerates by about 10 per cent in front of five people, by 20 per cent in front of twenty people, and by about 3,000 per cent in its first preview, where it seems as if somebody's playing a 45 single at 33 revolutions per minute: everybody seems to be talking so slowly and moving so slowly, and every shot seems so leaden. And that's why you put a movie in front of an audience, to do exactly that: to hear a collective metronome rather than the rather generous one that operates in the cutting room.

It's very rarely you go back and say, 'We should slow that sequence down.'

The preview process also allows me to understand how the movie is working for different kinds of audiences. I was very aware when we made *Ripley* and started previewing the film of how uncomfortable the audiences felt with the homoerotic elements of the movie, which, to me, were of no consequence whatsoever. I was entirely unpreoccupied by them. But as soon as the movie came out, it was as if the volume control on that area of the film was suddenly flipped to a distorting level. People were obsessed by what, in the movie, amounts to a few frames of the film. And if it had been a heterosexual series of preoccupations, people would have mourned its absence in the movie.

I realized that there was a certain amount of information being read into the film that I wasn't sufficiently aware of when we were making the film. I wouldn't have changed anything; it just illustrated the fact that films are documents as well as pieces of art or pieces of industrial portfolio. There are all kinds of things going on in the movie theatre which have got nothing to do with what your intention as a film-maker might have been.

If I'd recut *The Talented Mr. Ripley* to satisfy audiences, I would never have made the movie because the audience didn't want the movie to end in the way it did. They found it alarming that the character seems to escape. To me, it was so evident the character was in the worst kind of prison, the most defeating and unendurable prison of being alone with yourself and having to account to yourself and having distanced yourself from any possibility of intimacy. That seemed a fate worse than death; a policeman coming in and putting his hand on Ripley's shoulder, saying 'You're caught' seemed rather prosaic. But the audience desperately wanted me to do that. They wanted closure. And the whole film was about there not being any closure. So it was a very tricky preview procedure.

Even though the audience may have empathized with Tom Ripley, they didn't like themselves for empathizing with him. There is a reductive element to film-making where, finally, the reception of the film retreats back to its core elements, however much you embellish, adorn and realize them in a film; if the elements are disagreeable, that will be what you end up facing. The film-making of *Ripley* seemed to gloss a resentment that many people in the audience felt towards a film that asked them to go on a journey with somebody they felt tarnished by, some of whom felt tarnished by their own sympathy for him.

Back in the cutting room, after these previews, we would keep challenging the end until we came up with what I thought was the best version of it: rearranging and playing the key element of the last sequence in voice-over, with Ripley sitting in the cabin having to digest the consequences of killing the one person who might have loved him for who he was. By playing this over a blank and affectless man in a room, it was stronger than actually seeing him kill the guy. So we kept working on the end of the film in a way that finally helped us with the audience, but without changing the terms of my own investment in the story.

I have final cut on my films, but that doesn't mean anything if you're collaborating with a studio. As much as you're collaborating with an editor or the director of photography or an actor, you're collaborating with a whole group of other people, and it's ridiculous to be in a war with your producers and the studio, because they're your allies in the film-making process. Paramount, on *Ripley*, were fantastically supportive, notwithstanding, perhaps, the sense they had that there was a different version that might have been more commercial. They got behind me, but they also challenged me and said, 'What do you feel about these reactions?' At one stage an executive suggested I change the ending. I said, 'If I change the ending, the audience will hate me.' He said, 'They hate you anyway.'

I remember the last preview of *Ripley* was on the lot at Paramount. Finally, I left the theatre – I couldn't stay in there. I was so nervous and anxious. I believed that *Ripley* was the best work I'd done (in terms of achieving something close to what I'd set out to make), but I was in absolute despair. I had absolutely nothing on me, except my cell phone. And I rang a friend and just said, 'What am I doing? What's the point?' I just wanted to cry, because I thought that after so many years of work it seemed so stupid and banal to end up in a room with popcorn. And that's the last time I watched any part of *Ripley*, other than to do the DVD commentary.

There always comes a point, when we begin to preview a film, where I come close to the point of loathing myself; where I see the film as an aggregation of my lack of skill and my lack of ability to articulate on film all of the things which prompted me to get involved in making the film. Invariably, that's where my head is, and I try to calm that noise down and look clearly and say, 'Well, what would help the film and what is just me dealing with my own self-disgust?'

The great mystery is that even the most fragile intention is interpreted by the audience. The audience can see through all of your

poorly composed, poorly written, poorly constructed and poorly choreographed work and still pick up some glimmer of the intention, and perhaps forgive you your clumsiness in presenting it to them.

I've developed this clear policy of not using temporary music (as is usually the case when you preview a film) because otherwise you've made friends with the wrong people. However, the danger is that the decorative impostors of temporary music are the things which often save your bacon in the preview because a bit of finished music – particularly if it's a piece of familiar music – beefs up some sequences which need beefing up. But, if you've got nothing – even though the audience doesn't know why – the film doesn't feel supported. We had so much trouble with the battle sequence in *Cold Mountain* in successive viewings by producers and friends until we did the sound. Then they all said, 'Well, it's great that you've recut that scene and you've reordered it and it's now beginning to earn its keep,' or 'It's now wonderful,' or 'It's now really shocking.' All we had done was to add the thing that was missing – sound. And I had almost been persuaded to begin really chopping into it. So it's a tricky business, trying to learn from a preview, trying to learn from a screening of your unfinished film. It is like looking at a cluttered house in which everything seems wrong: it is hard to scour out all of the crap and say, 'Well, actually the shell and the architecture and the intention of this property is perfect, it's just that we have to do so many things to get it right.' It doesn't even look promising the week before the decorators arrive, when it's just a naked sequence of rooms. And then suddenly comes a coat of paint, a few chairs and tables and a picture, and the room says, 'Oh, I like myself now, I feel good.' When you're making the film, you've got to keep anticipating that and not lose faith in the design, because the design seems enfeebled until it gets finished. You have to keep faith.

We had a very, very bad preview of *The English Patient* in New Jersey: the film broke, but in a way, I think, that was just letting me off the hook; the film forgave me by snapping because it was not going well and the audience was not with the film at all. We got very poor scores. We then tested the film again and it was better, but not substantially better. Then we took the film to Berkeley, in northern California, and we had a wonderful screening. Part of me is suspicious of that. Saul Zaentz is a legendary character in the Bay Area and here was a film of his. He'd had a track record for such films, and I think we got a lot of the reflected glory of his other films seeping into ours. We stopped previewing immediately. We had one good preview and that was it; we stopped before we got ourselves into any more trouble. In

fact, Walter Murch and I went back after that preview and recut the film quite dramatically, which was a very interesting experience and, I think, very indicative of the fact that, for us, the preview process is not number-oriented, it's lesson-oriented.

The Quiet American, which Mirage produced, was a very interesting process in that I think we profoundly improved that film in the cutting room, and the scores went down at every preview. Film is the messiest, most volatile collision of circumstances. *The Quiet American* was hostage to 9/11. We started previewing before 9/11 and carried on after it, when the world was a different place and appetites were different – what *The Quiet American* had to say was both more urgent and less welcome than it was prior to 9/11. People can take a harder look at themselves when they're in a period of calm than they can in a period of duress; you don't want to be told in the middle of some new world phenomenon of long-haul terrorist activity that some of that might be the dividend of your foreign policies. You want to celebrate the values of your culture. I think that the figures in *The Quiet American* were entirely attributable to the changing climate of the country.

Regardless of the audience's reaction, I think it is the job of film-makers to go out with their movies, in the same way that it's the job of actors to go out and support the movies they're in. We get paid for what we do and we ask people to spend a great deal of money making films on our behalf, and, in most cases, we never put our own money into the film. We take somebody's cheque and we spend it. So I believe it's absolutely appropriate that you go out and stand by the movie you've made, for good or bad. It's easy when the film is working really well. When it's not working so well, it's a tough forum to be in. But nevertheless, I'm very happy to explain what my intentions were, what my motives were. At the very least, it puts you back into the place of being an artist in front of an audience, not hiding behind the film. And I think that's a good thing to do.

Ripley started to defeat me after a while; I got to the point where I was sick of talking about frailties, about how all of us want to abandon ourselves, how all of us are sick at heart, how all of us suffer from bad faith. After a while that noise began to exhaust me. All that talking about people who take recourse to violence to achieve what they want. I love the fact that, for *Cold Mountain*, I was able to talk about valour and commitment and loyalty and honour – all those good words.

Notwithstanding the facts that I'm enormously proud of *Ripley* and its financial results were very good, its critical results were very

ambivalent. Even though we got our nominations and our fanfare, it was a fanfare with a great deal of reservation. I hope that in time that film will surface. It's a film that prompts people to keep coming up to me and saying they've watched it again and how much they liked it, how much they missed the first time. However, film-makers often console themselves with that kind of reaction; you don't get people coming up to you and saying, 'I've watched it again and I hated it even more than the first time!'

I never set much store by the result of the film. I remember beginning to screen *Cold Mountain* and being very tormented, not because I was invested in the reaction, but because I so hated the fact that the process – which had been almost completely joyful – was reduced to a reaction about some element or not. The film becomes a document, and the document is always less interesting than the process of creating it. The reduction of your effort into something which lasts the period of a couple of hours, even if an audience still finds that too long, is such a tiny sliver of an iceberg of endeavour. It's five years of good work, and nothing that happens to the finished document will ever reflect that life experience. If it's a huge hit or a huge failure, neither will educate me about the doing of it or modify the doing of it.

Previews are quite a bruising procedure, I think, if you care as much as most film-makers do. You don't care who loves you when you're making a movie, and you so much want to be loved when you've made it. I think it's really as simple as that. You have enormous courage in the process, and no courage whatsoever with the result.

Sadly, the process of showing your hand to the audience and digesting their reaction doesn't really change anything. If only we could learn from our mistakes, how clever we would all be. We don't really. You just make a fresh set with each movie.

7

Final Thoughts: Theories,
Poetry and Morality

I haven't watched many movies, but I've watched some movies many, many, many times. There are some movies I go back to like food – *The Tree of the Wooden Clogs, I Vitelloni, Three Colours: Blue* and the Taviani brothers' movies I watch repeatedly. Each time I go back to great films, I see something I feel I've never seen before. Obviously, all you can do as a film-maker is aspire to make the kind of movies which you've been excited by as an audience member. What you want is to be part of that process of making pieces that work, which repay analysis and revisiting, and which have their own poetry.

Poetry and film share a realm of mystery and secrets, an intimate purpose. In that regard film is different to theatre in the way that poetry is different to the novel. There's a suggestion in both film and poetry that the audience is gaining direct access to the author's inner life, despite the fact that film is the product of several people's work – sometimes three or four hundred people's work. They also both share a sense of being close to dream states, creating from a condition which conjures the working of the unconscious.

Film, as a descriptive medium, can be extremely inefficient and pro-saic. It's oddly banal in some ways. For instance, imagine the difficulty of representing a straightforward idea that could be a line in a bad novel: 'Every morning he left home at the same time; it was nearly always raining.' These kinds of ideas torment film-makers. How do you get 'He left home every morning'? How do you get 'At the same time'? How do you get 'It was nearly always raining'? All of this you can write in one sentence of a novel.

Equally, verse is uncomfortable with the overt. For instance, the news is rarely read in verse because we find transparency and poetry to be unhappy bedfellows. Poetry is much better at secrets than it is at news. This door to the 'inner-being' quality of film and poetry is

achieved in the same two ways: distillation and ellipsis. Robert Bresson said that one doesn't create by adding but by taking away. By contrast, ellipsis is not the chief weapon of the theatre or the novel because language, particularly in the theatre, has become a kind of action. The language of theatre is a much more chewable, active, rhetorical event and depends on a kind of completeness, whereas both film and poetry are marvellous at speaking through image and the relationship of images. There is a kind of phosphorescence that is released in images, particularly when they are stuck up against each other, and this juxtaposition, this aggregation, is one of the other things that poetry and cinema share.

Poetry saved my bacon at school because I was a pretty inadequate pupil and, like many fourteen- or fifteen-year-olds, I thought that literature was something to be avoided like a car crash. But I was very interested in music. A supply teacher in English came into school and produced a Dansette record player, which we all suddenly paid attention to, and he put on a record. It was 'Suzanne' by Leonard Cohen: 'Suzanne takes you down to her place by the river . . . ,' which certainly piqued our interest. The next day I bought a collection of Leonard Cohen poems and that began a whole process of archaeology for me: investigating poetry away from the school curriculum. 'School curriculum bad, everything else good' was my philosophy. And I also found a collection of Penguin Modern Poets – I think somebody some day should write a hymn to whoever came up with that idea because I collected every single one – and ever since I've read poetry on a daily basis. It's the rigour of poetry that I most love and am most affected by.

The poet writes in relative freedom and relative obscurity, and the film-maker works in chains, albeit often golden ones. I think it's noteworthy that when you come across poetry written out of obligation – which is generally the condition of film-making – when you come across poems written for the Queen's birthday or for funerals, you often glimpse some of the conditions that make bad films. Films, unfortunately, cost too much and have an industrial imperative. Poetry costs nothing and is often read by nobody.

The only cinema worth talking about is the cinema which aspires to poetry. The poetic cinema of Kieślowski, Tarkovski, Cocteau, Buñuel, Olmi, Fellini is often seen by very few, and I think it's an indictment that it rarely happens in the English language. While the American cinema is far too concerned with transparency – because transparency is exportable – poetic cinema celebrates the opaque, it doesn't

genuflect in front of clarity. Transparency really obsesses most American and British film-makers, and with good reason, because we're storytellers and we need to tell our stories; it's just that there are so many different ways to tell a story, and we've confined ourselves to the very middle of the road. If you're always trying to raise money in America for film-making, as I am, the worst thing that anyone can say about your film is that it's an art film. 'Are you talking about an art film?' people will say, using the word 'art' pejoratively.

In film, you start by writing the film on the page, then you write the film with the camera, then you end up writing the film all over again, reimagining it in the cutting room. That's not dissimilar to the business of writing poetry; a great deal of important work in poetry is done beforehand, before you start writing, and a great deal is done after you've written. The first cut of *The English Patient* was 4 hours and 35 minutes long, *The Talented Mr. Ripley* was 4 hours and 45 minutes, *Cold Mountain* was 5 hours and 10 minutes; subsequently you see how much you can take out before the whole thing implodes on itself. I'm sure that's a process all poets know. You also, once the initial collection of the material is complete, try and find out where there are rhymes. Obviously, rhyme in film is different to rhyme in poetry, but they work in the same architectural way: they become hinges or supports for how you construct the whole film, the phrasing of the whole event. A great deal of what is pleasurable and poetic about film language is transition. While film is not particularly adroit at saying, 'Every morning he left home and it was nearly always raining,' it is brilliant at pushing you forwards in time and making poetic transitions. You can use these as visual rhyme.

One of the disturbing aspects of contemporary cinema is that it does all the work for you and so you feel passive in relation to it. Whereas with, let's say, Kieślowski there's an obligation to involve yourself in the making, filling in the dot, dot, dot of ellipsis. In film, each sequence of individual shots and the relationship between each scene is constructed by ellipsis; the verbs at the very heart of making a film are cutting and juxtaposing. Films made ten years ago increasingly look very slow because we, as an audience, require less and less information, whereas the poet working today is not so removed in terms of what he or she is doing from Chaucer or Dante.

What's often most startling about a poem or a film is the *idea* of the poem or film. We are over-infatuated with language in film, with dialogue, as if meaning is carried in dialogue, whereas meaning is nearly always carried in context. The example which springs to my

mind are the words 'I love you', because if I write in a screenplay 'I love you' we think we know what that means. But actually it is constantly modified by context. If I say 'I love you' to a large group of people, that means one thing. If I pass a mirror and say 'I love you' to the reflection, that means something else. And if I sit in the men's toilet and every time someone comes in I say 'I love you', it would probably get me arrested. There are no beautiful lines in a film and no beautiful actions except where context and necessity make them so.

Film, of course, is a moving picture, twenty-four still frames going past the shutter in a second, which means by definition that a part of that second is taken up with blackness. Somebody, probably Walter Murch, has calculated how much of the time you're watching black when you're watching a film. The *not* seen is one of the factors which make it hypnotic. Film, like dreaming, has the ability to flex in shape, in size, in speed. Continuous shots are rare in the cinema and strangely disturbing. Cutting became a convention created to accommodate limitations on how much negative could be fed into the camera. And so the camera stops and starts again, and in the process people work out what's happening. Images follow each other, and we connect. We are guided by an unseen hand that controls what we see and hear and makes it natural for us to see an elephant and a Christmas tree in the same room with a Puccini opera as soundtrack. It's exactly like a dream, except it is always someone else's dream. The greatest weapon that film has is the relationship between image and sound. That is the thing that most preoccupies me when I'm making a film.

Poetry has borrowed some of the techniques of cutting and juxtaposing from film. If you think of Thom Gunn's 'On the Move', which begins: 'On motorcycles, up the road they come / Small, black as flies hanging in heat, the boys.' That's a classic developing shot in a movie. It's like the long-lens shot of Omar Sharif in *Lawrence of Arabia*. Or the beginning of Larkin's 'Mr Bleaney': 'Bed, upright chair, sixty-watt bulb, no hook behind the door, no room for books or bags. I'll take it!' which is somehow Michael Caine in a British movie of that era. Look at the beginning of Ted Hughes' 'Thrushes': 'Terrifying the attendant sleek thrushes on the lawn,' which is obviously a close-up, drawing the attention of the reader to something which is particularly significant by abandoning usual syntax and beginning with the word 'terrifying'. That's also what you do in film: you alter syntax so that information is understood in the way the director wants it to be. The film sentence is constructed with the size and length of shots.

The dream state that cinema creates is exemplified by the sensation you have when you leave a cinema in the late afternoon and walk out into the street: you feel so disorientated because reality seems so much less vivid than the world in which you had just participated. But somehow, through purpose (which the poet and film-maker share) – when you point the camera with purpose, when you write a line with purpose, however opaque, however transparent the line – then somehow the audience and readers understand something. It's that strange mysteriousness of purpose that I think film and poetry most have in common and that we should most celebrate and preserve.

There's a shot in *The English Patient* where Juliette Binoche is swung up in the air in a cathedral to look at some murals. I've been in various countries and I've seen people react in the same way to that moment. It is clear to me that if there is a very focused intention in a shot, if there's purpose in a shot, it is absolutely catholic. Everybody will understand it. When you achieve that transparency of purpose, it's the most marvellous thing. It absolutely transcends boundaries of language or creed or ideology. People just know what it's about. They know to be moved. They know to laugh.

I love the intimate playing out against the public. It is more interesting, more unusual and more dynamic.

It's absolutely natural to me to think of a larger canvas. An example of that is one of the first collections of plays I had published, which was called *Interior Room, Exterior City*, a title my publisher loathed so much that it got very quickly thrown to one side. But there was one printing before these plays were collected, which was called, *Interior Room, Exterior City*. It was called that because I was interested in behaviour, but only insofar as it was impacted by what was going on outside the window. Or rather, I was interested in what was going on outside, but only as it was mediated through what was happening in rooms. Film is so adroit at flexing between situating people in a public landscape and situating them in a private world. The theatre is always confounded by that grammar. However, in movies, when you cut from a woman's neck to a desert landscape, the syntax is perfectly agreeable. In that respect, it seems a natural way of using and exploiting film, in terms of my own thematic interests and preoccupations.

When the periscope comes up, we've got to understand exactly where we are in history and what's going on in the world, so that, when we go down again, the situation is informed by that periscope's

look at the exterior world. That's a sort of film manifesto in a way: make sure that, when you go out into the public space, there's a narrative function, that it's not decorative, but feeds back into those private moments.

If you put two boxers in the ring, you know one of them will fall down eventually. There are certain routines that have to take place once you narrow down the parameters of the game. If you put five fighters in a ring the outcome is unknown. This is why the games of the gladiators became more and more complex. More types of weapons and creatures provided some variety in the possible outcome of the contest. On a very mundane level, that is what my instincts are as a dramatist: never let the thing you want to happen, happen.

For example, I am allergic to sex scenes in films. Not because I am a prude or I don't think a film should have an erotic landscape; it is just that once you get to a man and a woman naked in a room it becomes impossible to achieve variety. Suddenly you walk into the realms of ritualized behaviour and the constraints of what can be done on film. You collide with convention. I am always trying to find different ways of handling intimacy. *Cold Mountain* presents its own challenges in terms of the required romantic encounters between Inman and Ada. One of the most remarkable scenes from the novel is the scene in which Inman sleeps with Sara but they don't make love. That is the kind of scene I really like writing: where what we expect to happen doesn't and where the tension is about people trying to stay with what they feel to be the right course of action.

I think that I try to create operas using prose, that I'm looking for an unabashed scrutiny of the heart, not apologizing for it but yielding to it. *Cold Mountain*, when all is said and done, is about a man desperate to get home to the woman he loves and a woman desperate for the man to return, both of them clinging to their hope while believing in the hopelessness. The tension in the film comes from both of them wanting something and neither of them really believing it can happen, and so you've got one person who stumbles forward wondering what he's stumbling towards, terrified that he's stumbling towards nothing, assuming that it will all end in tears but, as in Tennyson, 'His own thoughts drove him like a goad.' I keep thinking of those lines, in 'Morte d'Arthur', when I think about Inman, the warrior returning home to ashes: 'Dry clash'd his harness in the icy caves and barren chasms, and all to left and right the bare black cliff clang'd round him, as he based his feet on juts of slippery crag.'

I prefer to infer rather than imply in my writing, and I am suspicious of what I would describe as primary colours. The American industrial film deals pretty exclusively in primary colours for a reason: primary colours travel better than more complex palettes. If you look at my writing from a dramaturgical perspective, what carries from film to film is that I can't deliver a scene that is exactly what it's supposed to be. I would like to think this is a quality, but often it is a failing. I remember having an argument with Walter Murch about *The English Patient*'s dramaturgy: he said to me, 'There's never a scene in which you give us an undiluted chunk of one tone or another.' For example, there's a moment where Katharine comes over to Almásy's apartment and they have this odd skirmish where she hits him, he tears her clothes off and they end up in bed. Then it gets very sweet in the bath scene, only for it to immediately go tart when they're talking about what they love and what they hate, and Almásy says exactly the thing he's frightened of, which is exactly what's happening: possession, ownership – 'I don't like that' – and the whole scene sours. I do that all the time. This is why finally it's not opera, it's not primary colours, because whenever I get close to that there's a wicked or, I think, true spirit that says that isn't what happens, that isn't true. In *Cold Mountain*, Ada and Inman finally get themselves into a place where they can speak. They're sitting around a campfire and they start to tell the truth to each other: 'If you could see my inside, my spirit or whatever you want to call it, you would hate me, you wouldn't accept me. I'm ruined, I think I'm ruined.' And she's saying basically you're not ruined and I love you, and I remember everything just as you remember everything, it's all fine. But then out comes the demon – Ruby – who says, 'If you want to get three feet up a bull's ass then listen to what sweethearts whisper to each other.' There's no version of that in the book; it's a comic device, but it's also my feeling that that's how things go. There's always a jester scoffing at the court. It happens in the next scene: Ada comes into the cabin, Inman follows her, and she says, 'There's some religion where you say I marry you three times and you're man and wife.' 'I marry you, I marry you, I marry you,' replies Inman, and she says, 'No, I actually think it's divorce, isn't it? I divorce you three times and you're not married any more.' That's the antic in me.

An ongoing characteristic of my writing is that there's never a free ride in a scene; the scene always has a tripwire in it and the characters inevitably trip over. Ada and Inman are typical: even though they began, like Almásy and Katharine, as someone else's characters,

they finally *are* my characters and they graze against each other rather than rush into each other's arms.

Relationships are finally never very successful, don't really work and are always full of disappointment. All human exchanges are coloured by animal instinct. We're all struggling against ourselves. The more I want to believe in the potential goodness in people and the potential of people to love and be decent, the more I'm also conscious of my own shortcomings and of my own warring appetites and desires, and they reflect themselves into my work. Again that's a Catholic thing, I realize, full of guilt. And as always with most writers and people who make things, you learn a lot about yourself from what you've made.

However romantic I might be, I am also full of contradictions about the real possibilities of romance. There seems to be no evidence that romance as a panacea really is obtainable – or, perhaps, I don't think I'm worthy of it. It's an argument that is repeated in scene after scene of my plays, right through to *Cold Mountain* – this failure of nerve or, rather, the belief that what's true is not simple.

I have this theory, which probably doesn't bear any scrutiny whatsoever, which is that you should try and understand the terms of the film in the first few minutes. This is true of *Truly, Madly, Deeply*, where you understand the terms of the character's dilemma in the first minute and a half. It starts off with a woman walking home and a voice-over rehearsing the details of going home, letting herself into her room and brushing her teeth, and all the things she does when she gets home. You realize that she is telling this to an analyst; she goes on to tell her analyst about her lover and what he says to her and what advice he gives her and that he speaks Spanish, which is strange because he couldn't speak Spanish but now he can. You discover at the end of the first speech that her lover is dead. That is the end of the first loop of the film. I remember my brother, who is also a writer, read it and said that I had given the whole film away by the end of the first speech. I realized that that is what you should do. You should, at least, state the terms of the film as quickly as possible. *The English Patient*, *The Talented Mr. Ripley* and *Cold Mountain* do exactly the same thing.

Telling stories can often be like teaching. I don't mean that it should be didactic or pedagogic, but that the famous structure of teaching where you say, for example, 'Today I'm going to tell you why democracy is a great thing, but it has implicit within it a form of tyranny because democracy relies in a way on a consensus that has to

be enforced, that freedom for everybody often means disempowering individuals.' You might begin with some statement that had an oppositional idea in it and then illustrate that through a series of facts or observations. I think that when you begin a film story there's an obligation to tell the audience what the theme of discussion is or what the story is going to be about: on one level, in *Truly, Madly, Deeply*, that it's important for your spiritual health to let go of pain and to make peace with it; on another, simpler level, that it's a story about a woman who thinks her dead husband is still with her. Or, in *Ripley*, this is a story about a man who is ashamed of who he is, pretends to be somebody else and suffers the consequences. The opening shots of *The English Patient* should suggest that this will be a story about an event that happened in a desert, where no identity and no boundary can be trusted. The beginning of *Cold Mountain* tells you that this will be a story about war, longing and return – you'll see a man staring at a picture of his sweetheart and, despite the battlefield setting, you'll know that this will also be a love story. The opening of a film can also make a statement of tone: you're going to be able to laugh in this film even though it's serious. So, in *Truly, Madly, Deeply*, you laugh in the first monologue because the story she tells the psychiatrist ends with a joke about this ghost trying to learn Spanish, which allows the audience to know that during the telling of this story they'll be able to laugh as well as cry.

In *Ripley*, if you think the central character is getting away with murder, you're not watching it. It's the most radical departure from the book. A legitimate gripe that fans of the novel might voice is that I entirely missed the point of the book, because the book celebrates an amoral central character who gets away with murder and doesn't seem to suffer for it. And part of the fun of the novel is that he doesn't seem to care. He plans to kill Dickie. He plans to kill Freddie. You know that he'll have no remorse about killing other people to get what he wants. And there's a kind of glee in seeing him do it. But it's not a glee that I wanted to transform into the film, partly because of the nature of the way you experience film. But, if that's my technical position, it's also my moral position: I don't want to tell a story about a man who gets away with murder and doesn't care. It doesn't interest me. I don't want to make films in which there's a sort of delight in malice, a delight in the dog-eats-dog kind of world.

Violence is often so simple in films. People take a gun and fire around, and other people fall over. It's done on the run. You don't stay

with the consequences of violence and you don't acknowledge the fact that killing people is an extremely difficult activity. When I was a child, probably in my early teens, a friend and I were driving up the High Street in Ryde and, as the car's headlights hit the top of the hill, we saw a man kicking another man in the head. We watched this man stamping on another man's head until the car reached him. Even when we got out of the car, he just kept stomping on this man's head. It made me feel nauseous. I'd never seen that kind of violence. We went to the police station. The ambulance came. The police came. This man was completely unconscious and there was a river of blood round his head. I assumed he'd died. About three days later, this man came into our shop to have a cup of tea – the same man who'd been lying on the pavement dying. He had a very bruised face, his ear was all swollen up, his lip was like a balloon – but he was going about his business. That was very much in my mind when filming *Ripley*: you can't simply dramatize an act of violence and assume that it's somehow clean. There should be something about killing in the film which is primal and taboo-like, as if the character were crossing some divide. Once he has the mark of blood on him, he can never go back.

It seemed to me that the more human and the more indelible an experience it was, the more valid the film would be. But it's not a film in which life is cheap in any sense, because I don't want it to be. I remember getting to the end of George Sluizer's *The Vanishing* and wanting to throw something at the screen. I hate the idea of a universe which has no mercy and no morality.

The attraction of *Cold Mountain* was that it is a war film without very much war in it – or rather, mostly only its impact. It seemed that the real spurs to conflict were issues of prejudice, suspicion, fear and the wrestle between the past and the future; the past as demonstrated by a great deal of land ownership and human labour as opposed to less land ownership and more employment of industrial might: machines making money as opposed to labour making money. What gets tugged along in the wake of these theoretical conflicts are simple human vices: fear of the unknown, excuses to fight, the need to be on a side, the sense of having a cause to fight for. You see in the film that the bloodshed and cruelty extend way beyond any battlefield of men with guns firing at each other, that the real damage is done hundreds of miles away.

I made sure, when we were shooting, that there were no generals in *Cold Mountain*, no officers, no strategists. Robert E. Lee doesn't ride by, Ulysses Grant doesn't ride by, you never see the tents of the digni-

taries, the people looking at the war through a telescope. I've tried not to objectify anything and that's a very deliberate perspective in the film. I'm much more interested in what it's like to be a woman with a child who says, 'It's pretty much what you'll find if you knock on any door in this war – man gone, woman left.' Those stories interest me, stories of what it's like in the 'away' as opposed to what it's like in the 'it' of it. You couldn't get a more simplistic denial of the value of violence: 'If I had my way I'd have metal taken altogether out of this world, every blade, every gun.' It's not in the book; it's me wondering why we feel obliged to do that to each other just to make a point. I'm not sure if America was in the market for a bit of ambivalence about the value of war. Did it want a hymn to patriotism, a hymn to American spirit or did it want a lament to the time when the American spirit was most fractured, most warring with itself, most uncertain of itself, most cruel to itself?

Another thing that provoked me to take on *Cold Mountain* was an interest I've had for many years in psychomachia, the tradition of medieval literature where life is laid out as a journey in which you elect to deviate from the straight and narrow road. You are tempted by vice, and your job is to elect to continue down the straight road or to be tempted off it by various appeals to your lower instincts. The film is quite Catholic in that way: people live with and are haunted by the consequences of their actions. Inman is ashamed of the person he's become by the time he makes it to his destination. The spiritual elements surfaced in the finished film in a way that they hadn't in longer, less focused incarnations of the film. The movie constantly plays with ideas about the natural order in the animal kingdom. There's a sense that at times human beings are much closer to the animal world than they are to any higher form of life. In the battle, you see men reduced to creatures, lashing out. There's a sort of bestiality in the behaviour of Teague; after the Swangers have been killed there's a look he has which has an absolutely dehumanized glee – cold, in the way that you see a cat studying a creature it's about to kill. The film attempts to go on to say that what dignifies humans is their capacity to love and have compassion, and when compassion is removed we retreat into just being another species of the animal kingdom.

There's something about the camera as a window into other people's souls and other people's experiences. As an audience we want to watch other people engage in activities that we do ourselves and in activities we are afraid or unable to do ourselves. Why do societies all over the world make up stories of people doing things we do ourselves

in one form or another? Why is it that we need to re-enact those things? At some level, it's a requirement for us to be able to experience without danger. We need to be able to stare at death and stare at love and stare at sadness and stare at violence and stare at fear – with a safety belt on.

The camera is not a neutral observer. The camera has nothing neutral about it whatsoever. Where you put somebody in the frame is as critical as what they're doing. You have to acknowledge that as a film-maker you are orchestrating the way that their action is being perceived. It's not just a neutral action which you are giving to somebody else. You are making a hundred decisions: how you will see it, how you will hear it, how long you'll see and hear it for. It's my job to manipulate every single one of those images so that it has the impact I think it requires. I think there's a moral way of doing that. There's a truthful way of doing it and there's a lying way of doing it.

In the end, directing movies is entirely about stamina. It's got nothing to do with anything else. It's about making sure that you can stand up at the end of every day. One of the main things going through my mind on set is, how can I sneak off and lie down for five minutes? That, to me, is the only activity going on. Directing is survival and stamina, because, I believe, once you're on set, your creative work should mostly be done. Everybody's there and you've narrowed down the avenue to such a tight course, that you can just run down it.

I have never seen my movies again since delivering them. I have no interest. I have no interest whatsoever. I think that in purgatory we'll be required to watch our films repeatedly. I'm happy to wait until then.

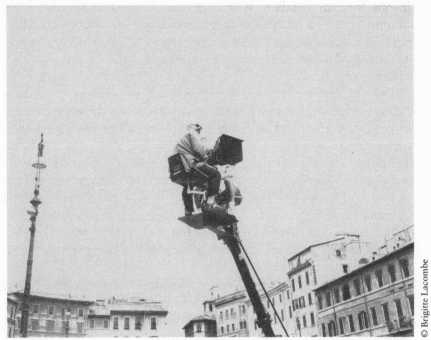

The Talented Mr. Ripley

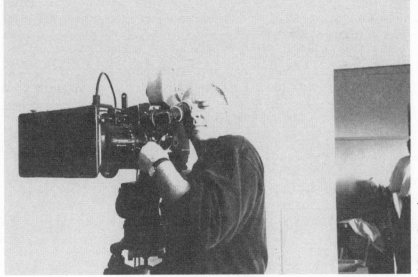

The English Patient

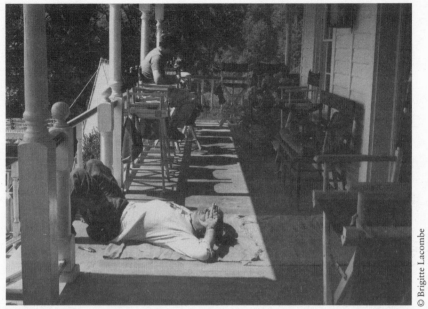

'How can I sneak off and lie down for five minutes?' Lunch break, *Cold Mountain*

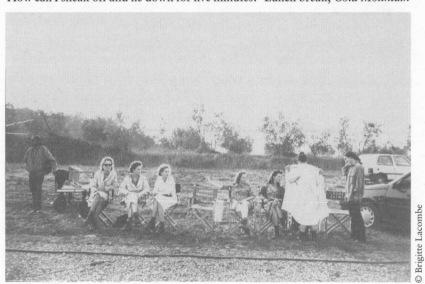

No time to sit down: *The English Patient*

Index